BEYOND ADORNMENT

JEWELRY AND IDENTITY IN ART

Yvonne J. Markowitz and Susanne Gänsicke
with a contribution by Emily Stoehrer

J. PAUL GETTY MUSEUM
LOS ANGELES

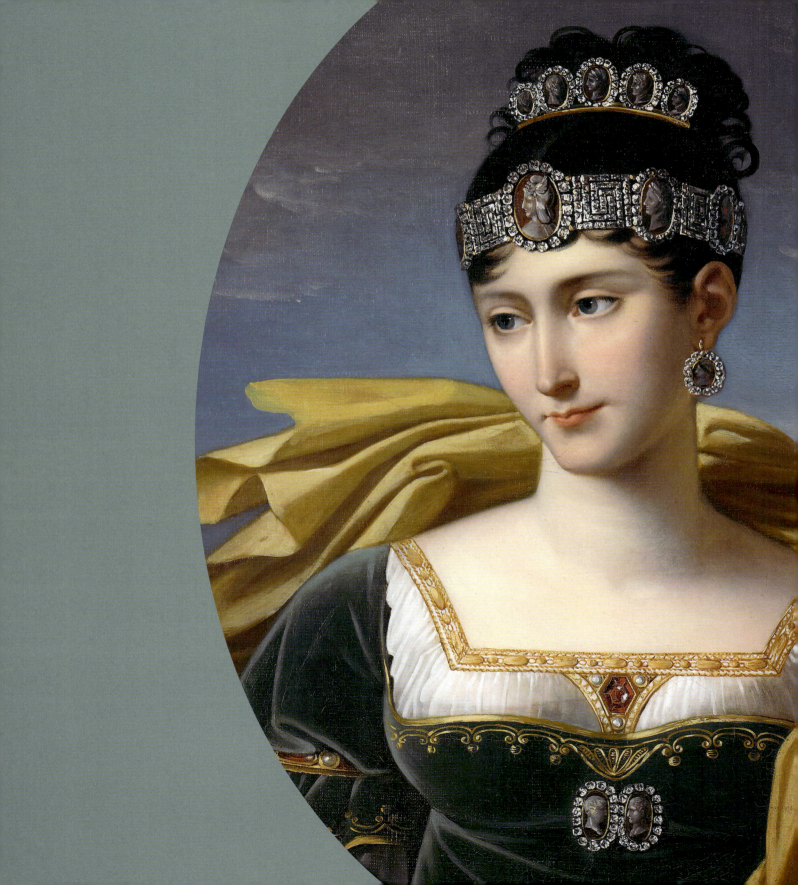

CONTENTS

Foreword xi
TIMOTHY POTTS

Introduction 1
YVONNE J. MARKOWITZ AND SUSANNE GÄNSICKE

CHAPTER 1
Projecting a Powerful Presence 6
SUSANNE GÄNSICKE

CHAPTER 2
In Search of the Spiritual 38
SUSANNE GÄNSICKE

CHAPTER 3
For Those We Love and Mourn 60
YVONNE J. MARKOWITZ

CHAPTER 4
An Illustrious Past Serving the Present 82
SUSANNE GÄNSICKE

CHAPTER 5
Fantasizing the Present 108
YVONNE J. MARKOWITZ

CHAPTER 6
Who I Am 128
YVONNE J. MARKOWITZ

The Theater of Everyday Life: Dressing the Part 148
EMILY STOEHRER

About the Authors 165
Acknowledgments 165
Illustration Credits 166
Index 167

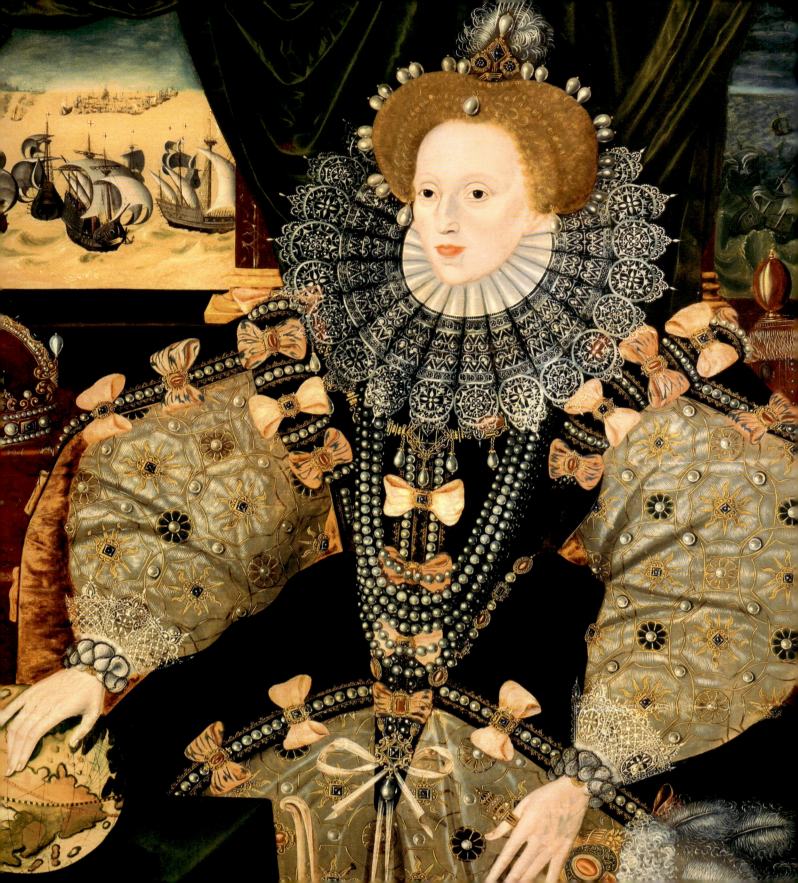

FOREWORD

Timothy Potts
Maria Hummer-Tuttle and Robert Tuttle Director
J. Paul Getty Museum, Los Angeles

JEWELRY IS THE OLDEST OF THE decorative arts, and its study has much to offer in our attempt to understand the human condition. It is a fascinating and sometimes glamorous subject, and much has been written on its creation, artistry, and historical significance. This publication takes a different approach, focusing on jewelry's multifaceted functions, such as its ability to convey the wealth, power, and influence of the wearer or, in the case of religious emblems, as an outward expression of an individual's spiritual self.

This book also examines jewelry's role as a cultural messenger. In some of the vignettes presented, the authors propose that personal adornment can serve as a "stand-in" for a person, group, or idea. This was the case recently with the late Supreme Court Justice Ruth Bader Ginsburg's decorative collars, such as the Dissent Collar that signaled her position on key legal debates and issues. Napoleon Bonaparte, the French Revolutionary army general turned Emperor Napoleon I, drew on ancient and medieval traditions to create his regalia, such as the opulent golden laurel wreath, the sacred golden scepter of Charles V, and the newly created so-called Crown of Charlemagne beset with ancient gems, thereby developing a new visual language with which to project his imperial image. Although most of the ornaments in this volume reference actual jewelry, one adornment—the necklace depicted in Frida Kahlo's *Self-Portrait with Thorn Necklace and Hummingbird*—is the product of the artist's imagination and symbolizes her inner anguish and physical suffering. It is fittingly included in a chapter entitled "Who I Am."

Beyond Adornment relies on works of art to provide the material and cultural context in which the jewelry was made and worn, revealing and enriching its hidden meanings and messaging. The publication also complements the Getty Museum's program, which over time has highlighted luxury items and jewelry from diverse ancient and historic contexts, as illustrated in the recent exhibitions *Golden Kingdoms: Luxury and Legacy in the Ancient Americas* (2017) and *Nubia: Jewels of Ancient Sudan* (2022).

Authors Yvonne J. Markowitz and Susanne Gänsicke are uniquely qualified to undertake this cross-cultural examination of jewelry. Both have spent decades researching and publishing jewelry, have each fabricated jewelry of their own designs, and have together authored *Looking at Jewelry: A Guide to Terms, Styles, and Techniques* (Getty Publications, 2019). I would like to express my gratitude to them and to the Getty's superb publications department. We hope the book will provide readers with a broad overview of the use and functions of jewelry across the globe and throughout human history.

INTRODUCTION

*Yvonne J. Markowitz and
Susanne Gänsicke*

RECENT ARCHAEOLOGICAL EVIDENCE SUGGESTS that personal adornment is one of the oldest of the decorative arts, and that from the very beginning it served multiple, overlapping purposes. Studies of early cultures support the idea that a single ornament can simultaneously be magically protective, indicative of the wearer's wealth, and emblematic of the individual's affiliations. Contemporary explorations of jewelry's multifaceted functions have expanded, focusing on its role as a form of propaganda, its ability to satisfy the pent-up desires of the masses, and instances when personal adornment has served as a tool of democratization.[1] This layered approach to the study of jewelry across time and cultures is now recognized as a valuable method through which the power of adornment can be understood and appreciated.

How is it that some personal adornments become so identified with an individual or a group that merely seeing them conjures up images of the owner(s) and thoughts on their place in society? Where do those images originate, how are they disseminated, and to what extent are they manipulated? Sometimes the answer is straightforward. An ancient Egyptian pectoral depicting the reigning king smiting foreign enemies would have originated in a temple workshop and been worn by royals during court events attended by foreigners, and its imagery would have been reiterated strategically on monuments throughout the Nile Valley.[2] Its cautionary message: the might of Egypt rests solely in the figure of the ruler and extends beyond its borders. For the ordinary Egyptian, the image signified the well-being of the state and its inhabitants, and could be worn as a replica in miniature on a scarab.

The messaging behind other adornments is more subtle. This is the case with George Washington's Diamond Eagle of the Society of the Cincinnati, a diamond-encrusted badge featuring a bald eagle that was designed by Major Pierre

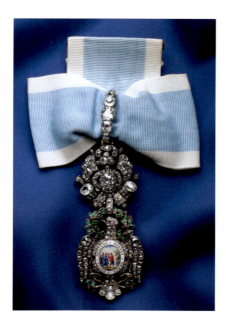

FIGURE 1 • Major Pierre Charles L'Enfant, designer (French, 1754–1825), fabricated by Nicolas Jean Francastel (French, active 1784–86) and Claude Jean Autran Duval (French, active late 18th–early 19th century), Diamond Eagle of the Society of the Cincinnati, 1784. Gold, silver, enamel, diamond, emerald, and ruby, 11 × 7 × 1.3 cm (4 5/16 × 2 3/4 × 1/2 in.). Washington, DC, The Society of the Cincinnati Collections, M.1811.001.1

Charles L'Enfant (1754–1825) and presented to Washington in 1784 by French naval officers who had served under him during the Revolutionary War (fig. 1). The jewel takes its name from Lucius Quinctius Cincinnatus, a Roman senator, farmer, and military leader of the fifth century BCE. Twice called from his farm to lead the Roman forces in battle, he returned each time to his farm rather than assuming dictatorial power. Washington, who was often compared to Cincinnatus, was unanimously elected the first president-general of the society, which originally had around 2,200 members in the United States and France and was founded to preserve the ideals and fellowship of US Revolutionary War officers who fought for independence. Membership was hereditary, and those officers who opted to join were eligible to wear a gold and enamel version of the diamond eagle.[3] Some Americans, including Benjamin Franklin and Thomas Jefferson, opposed the badge, as the very concept of a decoration passed on generationally signaled exclusion and elitism. Washington's gem-set version was especially objectionable, as it was reminiscent of European orders and badges made of precious materials and worn exclusively by the ruling classes.[4] As a result, Washington never wore his dazzling badge, choosing instead the modest gold and enamel decoration that is sometimes depicted in his postwar portraits and sculptures (fig. 2). For him, and for others aware of its history, it is an ornament symbolic of a triumphant democracy—a core identity of the new republic.

The idea for this publication came about during the authors' research for a guide to jewelry terms, styles, and techniques.[5] In our attempt to define "jewelry," we ended up with a cross-cultural, multidimensional approach that considered jewelry's inclusion in the decorative arts (furniture, ceramics, textiles), its place in the larger scheme of body ornamentation (tattooing, scarification, piercing, cosmetics), and its capacity to project messages (symbols, emblems, text).[6] This publication focuses primarily on that last aspect of jewelry, sometimes as expressed by the item itself and sometimes as expressed in works of art spanning painting, drawing, sculpture, the decorative arts, prints, photography, and film. It considers jewelry's capacity to serve as an emblem of power, a symbol of spirituality, an expression of love and loss, a wearable link to the past, a manifestation of Hollywood glamour and escapism, as well as a personal identifier of the wearer.

The vignettes presented in "Projecting a Powerful Presence" focus on jewelry as an emblem of wealth, authority, status, and propaganda. They trace symbols of power employed by rulers and elites from antiquity through the twentieth century—and in one case, a symbolic rejection of adornment in the name of egalitarianism—often drawing on global interconnections spurred by trade and colonialism.

The importance of jewelry and its visual representation in different traditions of faith is explored in "In Search of the Spiritual." One cross-cultural phenomenon that emerged during our research is the intertwinement of secular and sacred powers, each requiring the endorsement of the other or even becoming embodied in the same person or entity. In this respect, images of rulers and images of divinities may share similarities, and potent symbols may traverse those boundaries freely. It is also the case that devotional emblems sometimes serve as tangible evidence of a specific personal experience or group identification.

"For Those We Love and Mourn" examines jewelry's potential meaning as an expression of love, friendship, personal grief, and collective mourning. The tokens of affection and remembrance it examines range from highly personal elements hidden

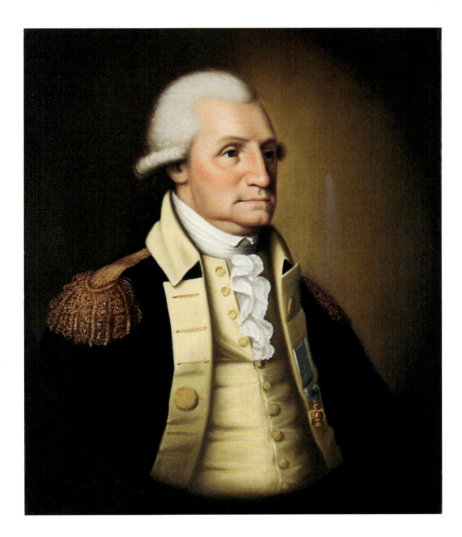

FIGURE 2 • Edward Savage (American, 1761–1817), *George Washington (1732–1799)*, 1790. Oil on canvas, 77 × 64.5 cm (30 5/16 × 25 3/8 in.). Cambridge, Massachusetts, Harvard University Portrait Collection, gift of Edward Savage to Harvard College, 1791 H49

Several paintings and sculptures of George Washington show the former general wearing the gold and enamel version of the Society of the Cincinnati badge.

from public view, such as love testimonies engraved on the insides of rings, to messages worn proudly, designed to be broadcast to a wider community.

For centuries, cultures have drawn on symbols from a perceived glorious past or "golden age" to legitimize current power structures or politics. "An Illustrious Past Serving the Present" hones in on the nineteenth-century phenomenon of historical revival jewelry, its relationship to contemporaneous archaeological discoveries in the Mediterranean and the Middle East, and its function as an expression of national and/or personal identity.

Hollywood in the 1930s and early 1940s—the era of the Great Depression and World War II—witnessed a concerted effort on the part of writers, movie producers, and directors to provide an escapist outlet for the masses. "Fantasizing the Present" explores the Hollywood glamour machine and the extent to which filmgoers sought solace through the on- and offscreen lives of actors wearing high-style jewels.

"Who I Am" reinforces the intersection of jewelry and identity through the ages, from ancient Nubian sculpture to self-portraits by Frida Kahlo to the collars of the late Supreme Court justice Ruth Bader Ginsburg.

The book concludes with a look at jewelry from a sociological and material culture point of view. To date, jewelry studies have not kept pace with other fields of study in the decorative arts when it comes to understanding the powerful role adornments play in messaging and nonverbal communication. It is our hope that this publication will stimulate further research in this area.

Throughout the text, jewelry and notions of identity intertwine in two important ways. There are those who see, respond to, and assimilate the multilayered meanings of adornments worn by others, and there are the wearers whose personas are projected via identifiable symbols; the latter type of jewelry performs as a stand-in or messenger for a person, group, philosophy, or movement. For instance, the golden ram's head necklace worn by a seventh-century BCE Sudanese ruler would have identified the wearer as one of ancient Nubia's kings, while the jewel itself, the personification of the god Amun, symbolizes the divine nature of his kingship. Even an ornament as simple and ubiquitous as the wedding band in Western culture serves multiple purposes, as a contractual token of affection between lovers and as a marker of the wearer as among the married. It expresses a core element of who we are and shapes how we are perceived by others. This book's vignette-style approach explores the worlds of both responders and wearers through the lives of notable individuals and religious icons whose adornments have come to represent their essential selves.

NOTES

1. See for instance Yvonne J. Markowitz, *Artful Adornments: Jewelry from the Museum of Fine Arts, Boston* (Boston: Museum of Fine Arts, 2011), 12.

2. Cyril Aldred, *Jewels of the Pharaohs: Egyptian Jewellery of the Dynastic Period* (London: Thames and Hudson, 1971), 194, plate 41.

3. Martha Gandy Fales, *Jewelry in America 1600–1900* (Woodbridge, UK: Antique Collectors' Club Ltd., 1995), 132–34.

4. For example, in the United Kingdom, one of the emblems of the Order of the Garter—Britain's most senior order of chivalry, founded in 1348—is a bejeweled collar denoting lineal descent from one or more Knights of the Garter.

5. Susanne Gänsicke and Yvonne J. Markowitz, *Looking at Jewelry: A Guide to Terms, Styles, and Techniques* (Los Angeles: J. Paul Getty Museum, 2019).

6. For more information on the meaning of signs, symbols, and messaging, see Daniel Chandler, *Semiotics: The Basics* (Oxfordshire, UK: Routledge, 2022).

CHAPTER 1.

PROJECTING A POWERFUL PRESENCE

Susanne Gänsicke

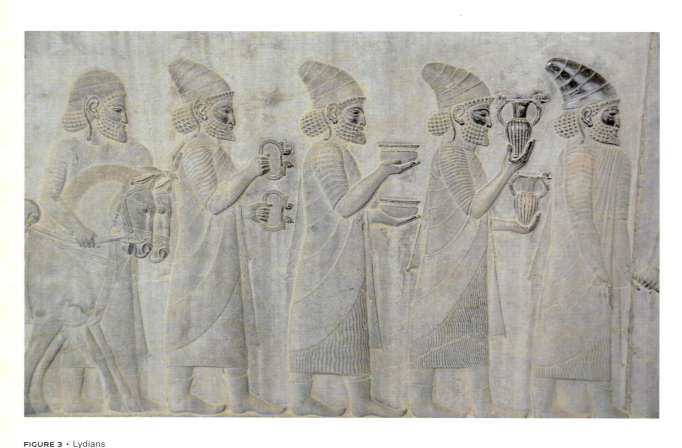

FIGURE 3 • Lydians presenting luxury items as tribute, including large, perhaps golden bracelets, carved in relief on the eastern stairway of the Apadana, Persepolis, Iran, Achaemenid, 6th–5th century BCE. Limestone. P 22268

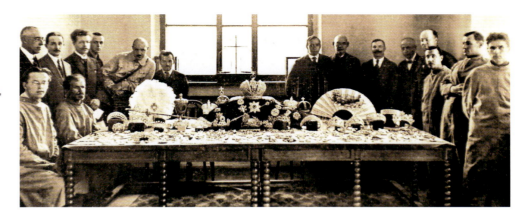

FIGURE 4 · The Russian crown jewels, safeguarded during World War I in the Kremlin Armory, fell into the hands of the Bolshevik Committee after the Russian monarchy ended on March 15, 1917, with the resignation of Emperor Nicholas II. Here the Soviets display them in 1922.

THE NAVIGATION OF HIERARCHY AND DOMINANCE is a central theme of life, and not limited to the human experience. But indeed unique to humans are uses of jewelry and insignia as markers of status, royalty, rulership, military rank, loyalty, and religious potency.[1] Over millennia, luxury goods, valuable coins, and jewelry have been offered cross-culturally as tribute and gifts of state (fig. 3). And regalia and important jewels, coveted as treasures and as tokens of power, have been plundered and sometimes reappropriated, as was the case with the Russian crown jewels seized by the Soviets about one hundred years ago (fig. 4).[2] Public displays and depictions of spoils of war or loot may signify victory or subjugation over neighboring kingdoms, domination during colonialism, or the results of coup d'états. At the highest level, the power of sovereigns and regimes depends on control of physical and political authority—of territories, resources, and ideologies. In many cultures, kingship has furthermore been associated with the divine, and was endorsed and sustained by powerful priesthoods, resulting in entwinement of the secular and spiritual realms. Today we remain fascinated by ancient imperial treasures, which provide visual evidence of legacy, continue to inspire, and even shape new narratives.

POWER FOR ETERNITY: TUTANKHAMUN'S COFFIN

CA. 1323 BCE

ACROSS CONTINENTS AND TIME, humans have always prepared for and attempted to secure status and power for life after death. Such preoccupations were central to ancient Egyptian culture and mythology, and the creation of funerary arts and burial goods flourished over three millennia. Living pharaohs in Egypt navigated and guarded the realms of life and the spiritual; they were associated with Horus during their lifetimes and with Osiris, lord of the underworld, after death. King Tutankhamun (ca. 1341–ca. 1323 BCE) died at nineteen years of age. His brief rule followed a tumultuous period in Egypt during which his predecessor and father, Akhenaten, demoted the ancient gods

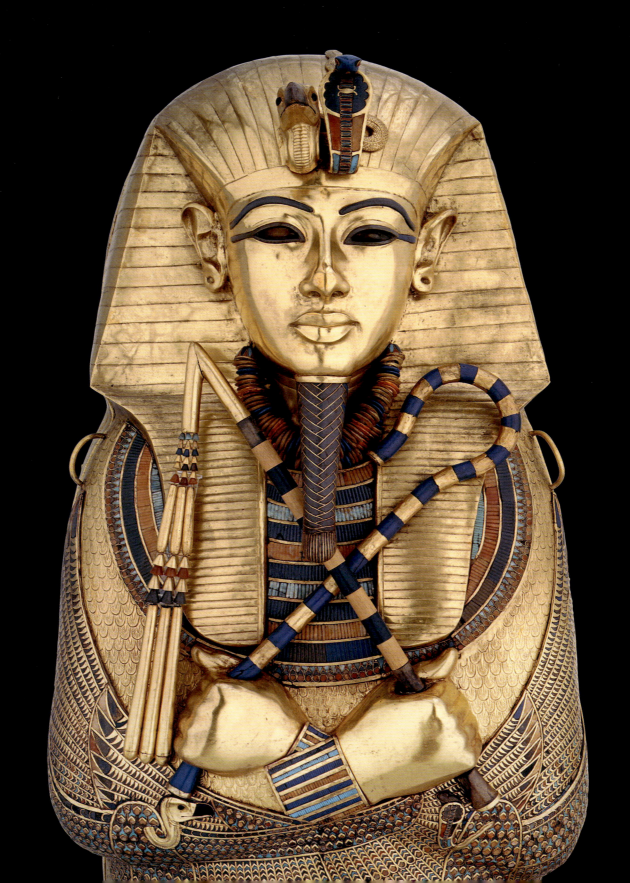

FIGURE 5 · Innermost coffin of King Tutankhamun, Tomb of Tutankhamun, KV 62, Valley of the Kings, Egypt, New Kingdom, 18th Dynasty, 1323 BCE. Gold, lapis lazuli, calcite, obsidian, carnelian, Egyptian faience, and glass, 187.5 × 51.3 × 51 cm (73¾ × 20⅛ × 20 in.). Cairo, Egyptian Museum, JE 60671

and instituted the worship of a single deity, Aton. Represented by the sun disk, Aton provides life, and in images literally so: the sun's rays terminate in small hands holding ankh signs, the ancient Egyptian symbol for life. During Akhenaten's reign, the capital was moved to Amarna, a newly built town remote from the previous centers of power. The boy king was born and named during that period as Tutankhaten, but he later changed his name to include the name of the god Amun to convey a return to previous belief systems and restoration of older traditions. It is surprising that from a time particularly rife with changes and iconoclasm, Tutankhamun's tomb survived virtually untouched to provide us a glimpse of the magnificence of the Egyptian royal funerary arts, most of which were lost to theft and plundering in antiquity.

Tutankhamun's mummified body was encased in three nested coffins, inside a stone sarcophagus, inside multiple layers of large, gilded shrines. On all three inner sarcophagi, the king is pictured clad in royal regalia. The innermost and most precious one contained the mummified body, its head covered by the now-famous golden mask. This third coffin (fig. 5), itself fashioned from gold weighing 110 kilograms, was found covered with layers of darkened organic compounds—evidence of libations (liquid offerings) applied during burial.[3] Its facial imagery mirrors the beauty of the gold mask. The headdress and beard are inlaid with blue glass in imitation of lapis lazuli, and the golden surface is further encrusted with inlays of stone such as lapis lazuli, carnelian, and turquoise. The eyes are framed with lapis, and the neck is encircled by a necklace of thick, colorful faience disks. Royal insignia include the rearing cobra attached to the headdress, the beard, and the crook scepter and flail— that last referring to the driving away of flies as a metaphor for the protection of the people of Egypt. The king's face rests in the flawless, serene beauty known from other portraits, straddling the worlds of the here and the underworld, a ruler in both: golden, bejeweled, and powerful in perpetuity.

QUEEN LIBBALI-SHARRAT IN A GARDEN

CA. 645–635 BCE

PRINCIPAL PATRONS OF THE ARTS and of luxury goods have always included royal courts, elites, and religious orders. The inventiveness across cultures in the creation of insignia such as scepters and other symbols, and particularly headdresses and crowns, is boundless and astounding.[4] The unification of Upper and Lower Egypt—the Nile Valley in the south and the Nile Delta in the north—was represented via a quintessential symbol of kingship: the white crown and the red crown, often worn united as the double crown. Other types of royal headgear existed in Egypt, and among these, perhaps the most mysterious is a blue crown, also described as a flat-top helmet, worn exclusively by Queen Nefertiti. Her most famous portrait, in the Neues

CHAPTER 1

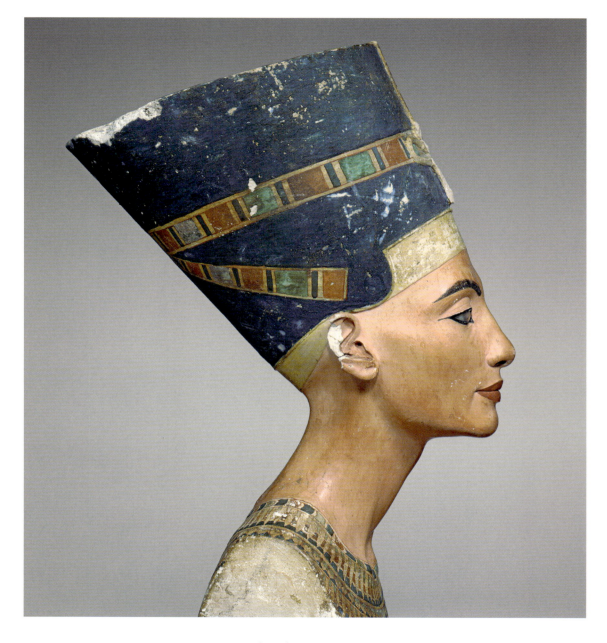

Museum, Berlin (fig. 6), is an exquisite, well-preserved painted limestone bust from the workshop of the sculptor Thutmose in Amarna, who served the court and is known for his individualized and exaggerated portraits in the emblematic Amarna style. The headgear represented by the blue cylinder was likely in real life encircled by a golden diadem inlaid with colorful gemstones. Yet the true material nature of Egyptian crowns remains unknown, as none have been excavated.

FIGURE 6 • Nefertiti bust, excavated in 1912 in the workshop of the sculptor Thutmose in Tell el-Amarna, Egypt, New Kingdom, 18th Dynasty, ca. 1351–1334 BCE. Limestone, painted stucco, quartz, and wax, 49 × 24.5 × 35 cm (19¼ × 9⅝ × 13¾ in.). Berlin, Staatliche Museen zu Berlin, Ägyptisches Museum und Papyrussammlung, donated by James Simon, ÄM 23100

FIGURE 7 • The Banquet of Ashurbanipal (detail), neo-Assyrian, Iraq, ca. 645–635 BCE. Gypsum, 58.4 × 139.7 × 15.2 cm (23 × 55 × 6 in.). London, British Museum, 124920

Evidence of another mysterious piece of royal headgear, providing an equally impressive narrative on the power and potency of ancient royalty, was found during excavations of the palaces at Nineveh, the ancient Assyrian capital of the seventh century BCE, within the modern-day city of Mosul in northern Iraq. Massive stone carvings of bulls and lions lined the gateways, and enormous alabaster slabs covered with reliefs formed the interior surfaces of the thick mud-brick architecture. Now uniformly brown and gray, these panels in ancient times would have been painted to provide a colorful wallpaper of royal propaganda: scenes of battles and conquests, rituals, lion hunts, lions in quiet natural settings, divinities, courtiers, and kings. Even without color, the imagery is richly textured, show-casing clothing, fanciful beards, and other hair fashions as well as copious amounts of jewelry: diadems, necklaces, heavy earrings, luxurious armbands, and bracelets worn in pairs on muscular arms.

Among the many images, one stands out due to its unusual motif. In the Banquet or Garden Scene from the North Palace (ca. 645–635 BCE), Queen Libbali-Sharrat is seated on an embellished throne facing her husband, King Ashurbanipal, who is reposing on a couch (fig. 7).[5] It is the only known image of an

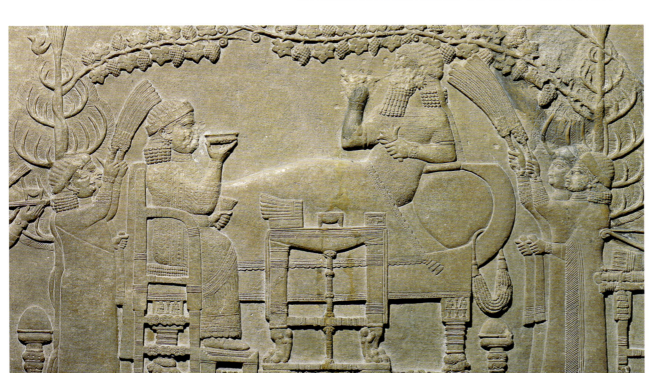

FIGURE 8 • The Beauty of Palmyra funerary bust, Palmyrene, ca. 200–250 CE. Limestone, 57 × 39 × 20 cm (22 7/16 × 15 3/8 × 7 7/8 in.). Copenhagen, Ny Carlsberg Glyptotek, IN 2795

Assyrian queen seated on a throne and apparently holding court. In this lush setting, surrounded by trees and other plants, servants are presenting drinking vessels to the couple. Despite the idyllic surroundings, there are also signs of successful combat and the cruelties of war, including severed heads of defeated foes on display in the trees. Yet more remarkable is the regalia worn by the royal couple, and their relative positions. This singular presentation puts focus on the queen and her crown. This "mural crown," in the shape of ramparts, elevates her to premier status. Detailed analysis of the king's garments, hair, and beard have led to conclusions that he is indeed not the dominant personage in this composition; although dressed in garments appropriate for a king, he is wearing not a crown but a simple diadem, usually an attribute of a prince.[6]

While sumptuous jewelry has been found in slightly earlier queens' tombs at Nimrud (the Assyrian capital of the ninth and eighth centuries BCE) that is similar to Libbali-Sharrat's heavy earrings with pendants, necklaces, and rosette-motif bracelets,[7] a mural crown has never been excavated. The relief is fascinating, but it leaves open questions about what certain aspects mean. Ancient texts illuminate the queen's life and her status in relation to other family members—for instance that she was criticized by her sister-in-law for not being a good enough student at a time when literacy was held in high esteem.[8] We have no answers yet as to whether the room depicted here was the queen's official reception chamber, what her status was at the time of her depiction, whether she actually wore this kind of crown, and what status or identity the crown was intended to signify.

THE BEAUTY OF PALMYRA

CA. 190–210 CE

THE FEATURES OF THE YOUNG WOMAN are arresting (fig. 8). Her smooth, round face is flawless, with almond-shaped eyes and a dimpled chin, framed by abundant layers of textiles and jewelry. The sitter for this image has become known as the Beauty of Palmyra; her true name is lost and no further information on her life is known. She belonged to the elite of Palmyra—an ancient city in the Levant, now in modern Syria—and the luxurious limestone relief is her funerary marker, which served to seal her tomb niche in Qars Abjad in the Valley of the Tombs, one of the large Palmyran cemeteries, in which grave chambers were set into funerary towers.[9] Not only pharaohs but also private citizens in Egypt and other ancient cultures strived to maintain their status in eternity, incorporating representations of jewelry and luxury goods into their burials and related depictions. Some three thousand funerary reliefs from Palmyra dating from the second and third centuries CE tell the story of its wealthy inhabitants along the cosmopolitan crossroads of the Roman and Parthian Empires, who often melded traditions of different

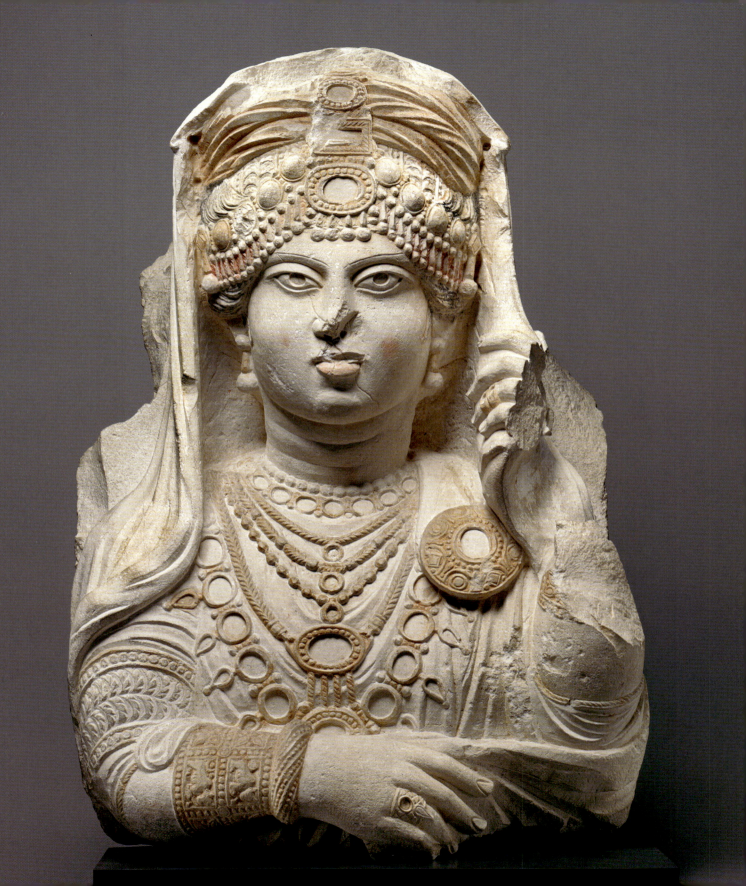

origins, including extravagant jewelry.[10] Some stelae provide names of the deceased, allowing family connections to be made, along with indications of their trades.

On this woman's head, a wide golden headband is laid over a turban consisting of linked elements and beads; three large golden bezels surmount her forehead. A veil frames the head ornaments and face, falls softly over the shoulders, and is grasped by both hands. Seven necklaces are draped around her, the thinnest near the neck, with increasingly larger links and pendants toward her chest. Both lower arms are wrapped in wide armlets and bracelets, each hand shows one finger beset with rings, and a large round brooch secures her mantle. The armlets are of particular interest and may provide possible insight into her origin, as they display humped bulls known from Indian contexts (in India, Nandi has been revered as the sacred bull of the god Shiva for more than two thousand years). Scholars have furthermore interpreted her facial features as possibly pointing to her origin in the subcontinent.[11]

The original surface of the stone was carved, colored, gilded, and inlaid to suggest an almost lifelike appearance. Still today we can discern residue of yellow paint on the jewelry, intended to evoke the actual gold of the necklaces she owned in life, and her cheeks carry red accents. Closer technical study has discovered specks of gold in points of the jewelry and further traces of black, red, and pink hues in the textiles, and has allowed a full-color reconstruction of the surface.[12] The now-empty bezels once held stone or glass inlays, as did her eyes, rendering the relief yet more vibrant.

The woman was facing eternal life beyond life, perhaps as she enjoyed it, in wealth—a life she may have hoped to continue at a time when millennia-old funerary traditions continued to thrive and evolve during the Roman period in the ancient Near East and Egypt. At the same time, details of her jewelry allow scholars today to develop a deeper understanding of the ancient world and its interconnections.

EMPEROR CHARLEMAGNE AS ENVISIONED BY ALBRECHT DÜRER

CA. 1511–1513

WE ARE INFORMED BY PORTRAYALS OF RULERS in various forms of art: in paintings, drawings, reliefs, sculpture in the round, even minute precious objects such as gems and coins, and more recently photography, moving images, and digital media.[13] Often created under the direct patronage of the ruler in question, such images, in which emblems of power are prominently featured, are meant to convey command and strength—although not always with scrupulous accuracy. Written records are not available from some eras and regions of the world to supply us with nuances of practices and events, and while visual representations offer historical clues, they also leave gaps, and our conclusions sometimes must remain speculative.

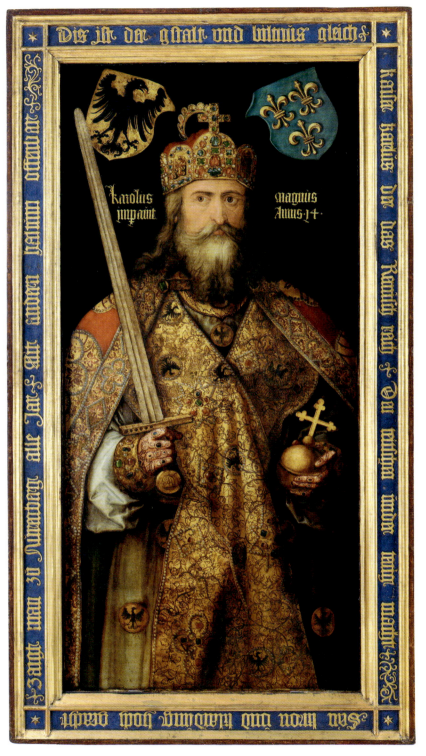

FIGURE 9 • Albrecht Dürer (German, 1471–1528), *Emperor Charlemagne*, ca. 1511–13. Oil on linden wood, 215 × 115 cm (84⅝ × 45¼ in.). Nuremberg, Germany, Germanisches Nationalmuseum, Gm167

Charlemagne, or Charles the Great (748–814), was painted by Albrecht Dürer (1471–1528) circa 1511–13, more than seven hundred years after his coronation at Saint Peter's Basilica in Rome (fig. 9). As the first emperor of the Holy Roman Empire, he controlled the newly united territories of central Europe, which would persist as a political entity until the Napoleonic Wars of 1803–15. Dürer imagined Charlemagne standing tall and proud, wearing ornate royal vestments of silk and brocade—gown, stole, mantle, gloves—partially embellished with pearls and embroidery.[14] Charlemagne's actual features remain unknown, but Dürer gave him a unique mien, with one eye seeming to look slightly away and the other directly at us. He is also wearing a crown that indeed exists, but that he could not have worn in real life, as it was created in 962 for King Otto I. It is octagonal, its eight golden panels connected by hinges and having rounded upper edges. Four alternating panels are set with pearls, sapphires, garnets, almandines, emeralds, amethysts, chalcedony, spinels, and more—172 gemstones in total.[15] The other four carry golden plaques bearing images of Christ, the prophet Isaiah, King Solomon, and King David, executed in champlevé enamel (cells were carved into the metal and filled with fused, powdered glass). Its shape, created by these eight distinct panels and the use of gold and uncut gems en cabochon (smoothly polished but without cut facets), displays influences of earlier, sumptuous Byzantine jewelry. That Dürer included the crown in his magnificent painting serves as evidence of the power of emblems to retain their symbolism over centuries— in this case, bestowing legitimate imperial power granted by the power of God to the wearer.

The occasion for the painting, part of a diptych of emperors (the second one was of Sigismund, Holy Roman emperor from 1433 to 1437), was a commission from the city council of Nuremberg, Germany, likely to replace earlier paintings in the Schoppersches Haus at the central market square, which served as the treasury for the holy regalia on the night prior to its yearly public display on the first Friday after Easter. Starting in the previous century, the regalia were safeguarded for the rest of the year at the Church of the Hospital of the Holy Ghost, but in 1800 or 1801 they were moved for safekeeping to the Imperial Treasury at Hofburg, Vienna. Today the imperial crown of the Holy Roman Empire, the Reichskrone, is one of the most important items housed in the Imperial Treasury of the Kunsthistorisches Museum, Vienna.

THE POWER OF ROYALTY IN WEST AFRICA

CA. 1550

THE POSSESSION AND SOLIDIFICATION OF POWER has often been directly linked to control of commodities, trade routes, and natural resources. Gold, gemstones, and pearls have been among the most valued materials throughout history, but organic materials such as ivory, shells, and other animal parts have likewise been prized. The significance and value assigned to raw materials varies greatly across cultures. Diamonds have traditionally been particularly esteemed in India,[16] while in China's early history, jade held a value that elsewhere was assigned to gold. In many societies, the privilege to wear and display a particular material was regulated.

In the Kingdom of Benin, located north of the Niger delta in what today is southern Nigeria, the figure of the oba combines supreme powers as both state ruler and spiritual leader who embodies the divine. The Benin monarch guaranteed material stability and spiritual safety for his people, controlled trade and jurisdiction, and was chiefly responsible for maintaining the cult of his forebears. Sacred rituals performed by the oba allowed the redirection of power from the deceased ruler to the living one and ensured continuity of kingship.[17] Commemorative bronze and brass heads of previous obas, represented with idealized features and often surmounted by ivory tusks, were central to religious practices and featured on altars in ancestral shrines.

The bronze oba heads wear impressive amounts of jewelry, as is the case with the head in figure 10, which is covered by a cap formed by a net of coral beads. Strands of coral drops stream down his face on both sides, and around his neck is a thick collar made from layers of coral strings. In Benin, as in many cultures, red coral is believed to embody magical, amuletic, and protective functions. Indeed, the oba's identity is directly associated with coral, whose red color symbolizes blood, peril, and ultimately power. Regalia such as the fly whisk (fig. 11) were also fashioned in coral. A ruler's head, thought to be a repository of wisdom and spirit, was never to be uncovered, and a coral headdress was to be worn during official functions. Emblems of power were based on sacred symbols as much as on sacred materials—coral, ivory, and brass—shaped by skilled craftspeople organized in powerful guilds. Access to these materials and their use was a privilege of the oba and celebrated his prowess, which in turn was propagated in images created from the sacred materials. Oba Ovonramwen (r. 1888–97) was described by the English anthropologist Henry Ling Roth as "covered with masses of strings of coral, interspersed with larger pieces.... His head dress...was composed wholly of coral of excellent quality, meshed closely together, and must have weighed very heavily on his head, for it was constantly being temporarily removed by an attendant."[18]

PROJECTING A POWERFUL PRESENCE

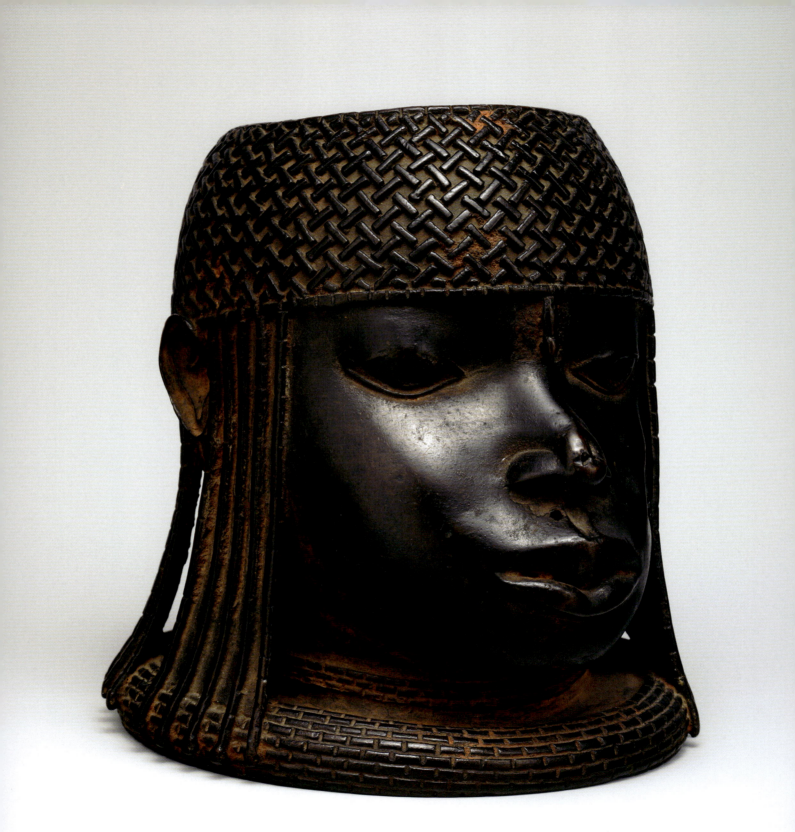

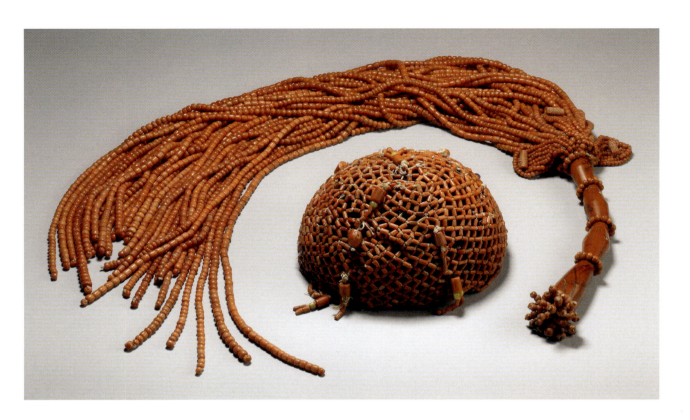

FIGURE 10 • Head of an oba, Nigeria, Court of Benin, Edo peoples, ca. 1550. Bronze, 21.6 × 19.7 × 20.6 cm (8½ × 7¾ × 8⅛ in.). New York, Metropolitan Museum of Art, Michael C. Rockefeller Memorial Collection, gift of Nelson A. Rockefeller, 1972, 1978.412.324

FIGURE 11 • Crown and fly whisk, Benin, Edo, ca. 18th or 19th century. Coral, agate, and glass beads strung on cotton thread, crown 15 × 17.5 × 23 cm (5⅞ × 6⅞ × 9 in.), fly whisk 103 × 24 × 4.7 cm (40½ × 9½ × 1⅞ in.). London, British Museum, Af1898,0630.5, Af1898,0630.3

According to mythology, the beginnings of the Benin Empire trace back to the twelfth century. Contact with European traders began in the sixteenth century and lasted until the British captured and sacked the royal city in 1897 in retaliation for the ambush of a British embassy. Benin City's palaces and sacred sites were destroyed, and the oba was deposed and sent into exile. Thousands of bronze and brass artworks, which have become known as the Benin bronzes, were carried off to Europe along with innumerable ritual and luxury items, and since have been dispersed into many northern European and eventually US collections. In addition to heads such as the one described here, the plundered goods included heavy brass plaques, created by lost-wax casting, that decorated pillars in Benin's imperial palace. They bear imagery that supported royal and spiritual powers and provided historical narratives. In one plaque, a standing oba has mudfish hanging from his belt and twirls two leopards by their tails—both symbols of kingship and divine protection. The king is embellished with the fringed coral bead cap, necklace, bracelets, anklets, and small bells at his belt. Even the leopards' collars are decorated with bells.[19]

In recent years, negotiations and agreements with Nigeria and the ruler of Benin have begun to establish a path toward

returning cultural heritage to West Africa.[20] Some traditions continue despite severe disruption, and to this date, the opulent use of coral and sacred regalia persists at the court of Benin to sustain the image and identity of the king.

ELIZABETH I'S ARMADA PORTRAIT

1588

SOME CROWN JEWELS ARE PASSED DOWN unchanged over generations; emblematic of past rulers, they are thought to extend previous authority and endorse the present. But sometimes the reworking of royal jewels and insignia is viewed as a legitimate and allowable aspect of their life cycle. The sheer volume of court jewelry in circulation in previous centuries in Europe, and the importance of who wore what and when or who gave what to whom, can seem confounding to us today. Yet, following the death of Queen Elizabeth II in 2022, the world experienced the active use of such historic regalia. The Imperial State Crown was displayed on the casket during the funeral procession and as the queen lay in state in Westminster Hall, but was removed before her interment.[21] At the subsequent coronation of King Charles III, her son and heir, the full court regalia was at the center of the ceremonies. Britain is the only European country still actively employing crown jewels, while equally uniquely its ruling monarch remains nominally head of state and head of the Church of England.[22]

Queen Elizabeth I (1533–1603), daughter of Henry VIII and the last ruler of the British House of Tudor,[23] focused throughout her rule (1558–1603) on expressing and cementing her status, wealth, and power via a skilled use of images, including carefully chosen dress and ornament. The House of Tudor crafted its public image by drawing on ancient classical, natural, and neo-medieval motifs and symbols in a vibrant environment that drew the best artists of the time to England.[24] Elizabeth I is known to have dazzled visitors with her embellished appearance. Jewelry took on multidimensional meanings beyond proclaiming prosperity and political messages: as mementos and gifts, elements of dress, even bestowers of protective forces. These assemblages have been memorialized in paintings and remain available for our study and enjoyment today. The depictions of the jewels are presumably factually quite accurate, while—in contrast—the queen's face was often not painted from life.[25]

One iconic image of Elizabeth I, the *Armada Portrait* at Woburn Abbey, represents the queen after a decisive victory over the Spanish Armada in 1588 (fig. 12). This was during her third decade as monarch, and she would have been fifty-five. Even by the standard of her other profoundly decorated images, the *Armada Portrait* is exceptionally opulent and laden with symbols. Three versions of it exist, yet the painter of the one at Woburn Abbey remains unidentified. The queen is seated

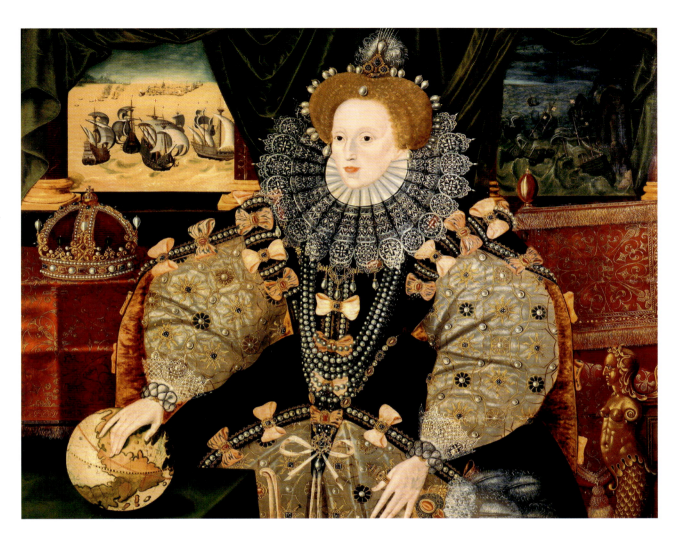

PROJECTING A POWERFUL PRESENCE

FIGURE 12 • Unknown English artist, *Armada Portrait*, 1588. Oil on oak panel, 52.3 × 105 cm (20⅝ × 41⅜ in.). Woburn, Bedfordshire, England, Woburn Abbey

in front of a backdrop highlighting her recent military victory, her right hand on a globe with her fingers extending over the Americas in, perhaps, an expression of further ambitions fueled by success. She is clad in an exuberant dress, embellished with bows and embroidery and an elaborate neck ruff. Pearls are everywhere—in her hair, stitched to the garment, and in a curtain of necklaces covering the front of her bodice— declaring her wealth and regal status. Known as the Virgin Queen, Elizabeth I early on pledged not to marry and rejected suitors over several decades, and pearls served as a frequent symbol of her chastity and purity. She went to great lengths to acquire pearls of the finest quality, for instance securing the famous Medici pearls after her cousin Queen Mary of Scots was executed. Given that they were usually obtained at great cost by trade from afar, pearls attested to England as a colonial

power—one whose reach was expanded through Elizabeth I's founding of the East India Company in 1600.

Images of Elizabeth I inspired new jewelry items too. Pendants, cameos, and miniature paintings of her were created by court jewelers and awarded as political gifts, serving as tokens of remembrance of the English military triumph.[26] The Heneage Jewel (ca. 1600, fig. 13), a large and astoundingly multifaceted locket holding a miniature of the queen by Nicholas Hilliard, belonged to Sir Thomas Heneage, privy counselor and vice chamberlain.[27] The front shows the queen's stern profile, worked in golden relief, surrounded by an enameled frame studded with diamonds and rubies. An enameled image of an ark on a stormy sea is on the reverse, in a reference to the armada. The interior cradles another, gentler and younger portrait of the queen. Such stunning and bold propaganda (certainly not limited to practices by Elizabeth I) was meant to support the monarch's reach and power. Yet it was likely also an expression of deeper personal relationships. We imagine the Heneage Jewel's owner—a subject of the queen, whose

FIGURE 13 · Nicholas Hilliard (British, 1547–1619), Armada Jewel (Heneage Jewel), ca. 1600. Enameled gold, diamond, ruby, and rock crystal, 7 × 5.1 cm (2¾ × 2 in.). London, Victoria and Albert Museum, M.81-19351935. Given by the Rt. Hon. Viscount Wakefield CBE, through Art Fund

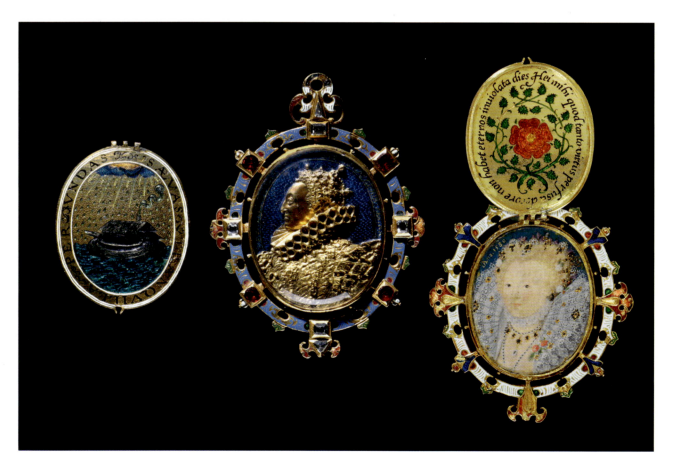

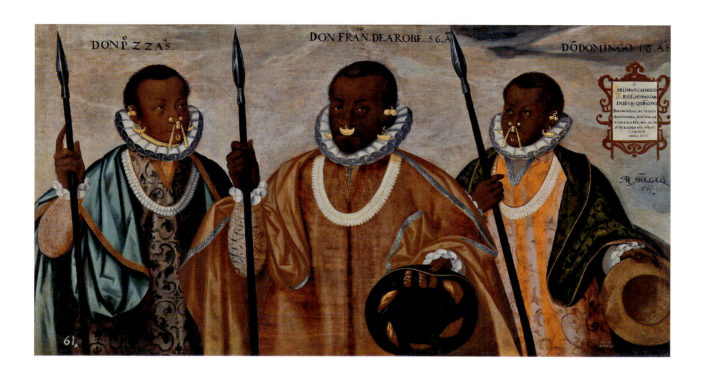

PROJECTING A POWERFUL PRESENCE

fortunes and identity were closely tied to those of the court—safeguarding the small treasure, occasionally holding it and opening it.

DON FRANCISCO DE AROBE AND HIS SONS

1599

AN EXCEPTIONAL PAINTING WAS CREATED in 1599 in Ecuador by the Indigenous Ecuadorian artist Andrés Sánchez Galque to be presented to King Philip III of Spain (fig. 14).[28] It captures a particular moment during the colonial period in the Andean country and the political realities faced by its inhabitants, about seventy years after the arrival of the conquistadors. The central subject, Don Francisco de Arobe (born ca. 1560), was not of local lineage. His father was Alonso de Illescas, born in Senegal and enslaved, sold in Seville to a merchant, then shipwrecked near the coast of Ecuador, who was able to escape and form a community with people of African origin and from the coastal region of Esmeraldas; he married a woman from Nicaragua. Don Francisco in 1599 represented a growing population of considerable power, outside the reach of Spanish rule and in opposition to it, and thus a threat.

In an audience with the Spanish official Juan del Barrio de Sepúlveda in Quito, who on the occasion commissioned the painting, Don Francisco and his sons Don Pedro and Don Domingo were given gifts of elaborate fabrics similar to those seen in the painting: brocades from Europe, and perhaps

FIGURE 14 · Andrés Sánchez Galque (Ecuadorian), *Portrait of Don Francisco de Arobe and Sons Pedro and Domingo*, 1599. Oil on canvas, 92 × 175 cm (36¼ × 68⅞ in.). Madrid, Museo Nacional del Prado, P04778

silk from China. The three mixed-race men appear as citizens of a global world, which they were by origin and status, visually cemented by materials, symbols, and jewelry from different continents. The spears in their hands, European hats, ruff collars, and garments layered with European mantles and Andean tunics all form a luxurious mélange of materials and meanings. Long shell necklaces and multiple golden facial ornaments—nose rings, lip rings, earrings suspended from different parts of the ear—identify their homeland, Esmeraldas, and its natural riches.

The meeting between the leader of an autonomous community and a representative of the Spanish Crown aimed to support an amicable relationship, and so the painting would have both commemorated the event and demonstrated to the king of Spain proof of progress and political stability.[29] Yet, to us today, the image of Don Francisco and his sons might seem more a commemoration of a period of domination, subjugation, and irrevocable losses. But we can appreciate the jewelry, precious and bold and central to the carefully staged composition, as a proud demonstration of the men's local lineage and power outside of European-imposed order and dominion.

FATH ALI SHAH IN DIAMONDS AND PEARLS

CA. 1805–1806

FATH ALI SHAH (1772–1834) WAS THE SECOND SHAH of the Qajar dynasty (1779–1934) in Persia. During his reign (1797–1834), following a period of instability and fragmentation of the country, he focused on cementing the authority of the dynasty and projecting stability and vigor.[30] Carefully crafted representations of himself aimed at confirming these values. Several court painters were commissioned to create staged and idealized life-size portraits of him as a warrior or hunter, or an emperor in the traditions of the ancient Persian kings.[31] These grand images display different settings, for instance palaces and hunting lodges, as well as costumes, while the insignia remain a constant, and the overall impression they provide is of richly ornate splendor, leaving no doubt that this is a powerful persona with resources at hand.[32] Gift giving played an ever-important role in international and diplomatic relations for Fath Ali Shah. Newly designed insignia and enameled royal miniatures encrusted with diamonds, some showing him wearing a tiny diamond-studded crown, were distributed as political tokens to contemporary leaders. Larger gifts included luxurious portraits, one such being a painting dated circa 1805–1806 by Mihr ʿAli, one of the foremost painters at the Persian court, presented to Napoleon and now in the collection of the Palace of Versailles (fig. 15).[33]

In this image, Fath Ali Shah wears a fine traditional garment with embellished sleeves and shoulder pieces, high heels, heavy matching armbands, a pearl necklace, and a bejeweled belt

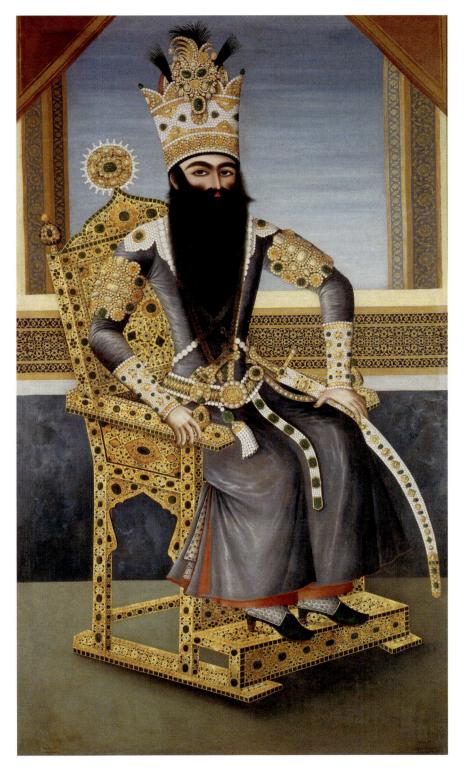

FIGURE 15 • Mihr ʿAli (Persian, active 1795–after 1830), *Portrait of Fath Ali Shah*, ca. 1805–1806. Oil on canvas, 240.7 × 145 × 5.3 cm (94¾ × 57⅛ × 2⅛ in.). Versailles, France, Château – Domaine national de Versailles, held in Paris, Musée du Louvre, MV 6358

suspending an ornate sword. Most significantly, on his head he sports a heavy, bejeweled Kiani crown, now in the Treasury of National Jewels, Tehran, Iran.[34] As one of the Persian crown jewels, the Kiani crown was worn in coronations by five kings until the twentieth century. At the coronation of Reza Shah Pahlavi in 1925, the second-to-last crowning of a Persian shah, it served as a ceremonial relic even if it was not worn as the principal crown. It was a creation by Fath Ali Shah's predecessor, Agha Mohammed Khan Qajar, and altered under Fath Ali Shah. Its helmet-like shape of red velvet, measuring 32 centimeters tall with a curved, scalloped upper edge, is covered with 1,800 pearls, 1,800 rubies, 300 emeralds, diamonds, and a large red gem, the so-called Aurangzib spinel (named after the Mughal emperor Muhi al-Din Muhammad [ca. 1618–1707], also known as Aurangzib). An aigrette (a plumed ornament reminiscent of turban ornaments) could be attached to the upper edge. The gems form a dense, dazzling, colorful mosaic.

Fath Ali Shah led a reformation of Iran's army and educational system following Western examples. Yet he also drew from the opulent treasures of the country's long history—the riches of the ancient empires of the Achaemenid (550–330 BCE), Parthian (247 BCE–224 CE), and Sassanian (224–651 CE) periods—to invent a distinct visual identity for the dynasty. Succeeding rulers would increasingly favor an international, Western style that called not for robes, crowns, and gems but for designer suits.

QUEEN VICTORIA AND THE KOH-I-NOOR DIAMOND
1850S

OVER HER REIGN OF SIXTY-FOUR YEARS, Britain's Queen Victoria (1819–1901) employed images and jewelry to project her authority, to commemorate significant political and martial events, and to express private sentiments pertaining to the different stages of her personal life: coronation, marriage, motherhood, widowhood. She sat for artists on seventy-two occasions just in the year prior to her coronation![35] The rise in printed media and news distribution during the first half of the nineteenth century provided her with new platforms and methods of propagation. In her 1838 coronation portrait by Thomas Sully, the eighteen-year-old queen is shown in a three-quarter view from the back as she is stepping up to the throne. The jewels she is pictured in are heirlooms, such as the diamond diadem fabricated for George IV eighteen years earlier and large diamond drop earrings (which she did not actually wear during the ceremony due to her coiffure).[36] Her face and crown glow in the center of the painting, while the background remains obscure.[37]

Thirteen years later, an 1851 family portrait by Franz Xaver Winterhalter on the occasion of her third son's first birthday depicts her as a beautiful and tender mother (fig. 16). (She

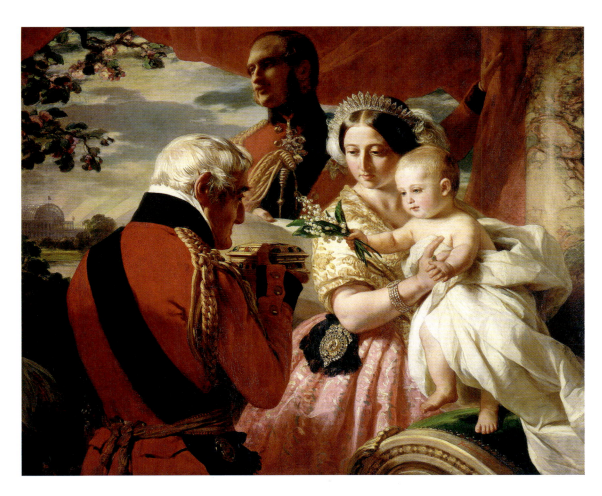

FIGURE 16 • Franz Xaver Winterhalter (German, 1805–1873), *The First of May 1851*, 1851. Oil on canvas, 106.7 × 129.5 cm (42 × 51 in.). London, Queen's Gallery Buckingham Palace, Royal Collection Trust, RCIN 406995

would bear six more children with her beloved husband, Albert, pictured here elevated and at center.) The multilayered composition recalls images of Mary and the Christ child, emphasized by the presentation of a jewel box by the Duke of Wellington, the boy's godfather. The depiction of a jewel box rather than the gift the boy actually received, as was at some point intended for the composition, was a choice the queen later regretted, thinking it staged and not truthful. But the image is also laden with political significance: Albert gazes into the distance toward the pavilion of the Great Exhibition of 1851, in whose planning he had been heavily involved, and Victoria wears a sunray diadem fashioned from a diamond fringe necklace that once belonged to her aunt, Queen Adelaide.[38] She wore the same dress and diadem to the opening of the fair on that same day—May 1, 1851—making this both a touching family scene in celebration of a child's birthday *and* a commemoration of one of the grandest public events of the decade.

Strategic displays of spoils from the British Empire at the 1851 exhibition included large, exquisite gems from India, many of which would soon be part of the British crown jewels. The most famous of all, the Koh-i-Noor diamond from India, had been obtained by Britain in 1849, relinquished by the ten-year-old Maharaja Duleep Singh of Punjab, who had been ordered to surrender it to representatives of the East India Company.[39] Known also as the Mountain of Light (translated from its Persian name), the stone had been cherished and coveted for many centuries, and changed hands many times. Its early days remain unknown, although large diamonds are featured in historical Indian texts. Legend has it that one of its first owners may have been the Sultan of Delhi, Alauddin Khalji (1266–1316), who withstood repeated Mongolian invasions. After India was defeated by the Persian Nadir Shah in 1739, the diamond was seized and is said to have been used as one eye of a peacock in the legendary Mughal Peacock Throne, also part

FIGURE 17 • The Koh-i-Noor armlet, ca. 1830. Gold, enamel, rock crystal, glass, ruby, pearl, and silk (the large diamonds are modern replicas), 10 × 15 cm (4 × 5⅞ in.) (excluding fittings). London, Queen's Gallery Buckingham Palace, Royal Collection Trust, RCIN 31734

FIGURE 18 • Franz Xaver Winterhalter (German, 1805–1873), *Portrait of Queen Victoria*, 1856. Oil on canvas, 88.8 × 73.1 cm (35 × 28¾ in.). England, Royal Collection Trust, RCIN 406698

of the bounty, although originally produced for Emperor Shah Jahan, builder of the Taj Mahal.[40]

The diamond arrived in London as a traditional Indian piece of jewelry: a golden, enameled armlet with a traditional silk-cord closure beset with three important gems: the Koh-i-Noor flanked by two large drop-shaped diamonds (fig. 17).[41] Nonetheless, in 1851 in London, the Koh-i-Noor disappointed the public, lacking as it did the familiar brilliant sparkle of diamonds cut in the West. In fact, due to its flat surfaces and lack of a pointed base, people thought it had a black hole in its center. The gem had been shaped in a so-called Mughal cut, based on an Indian tradition of cutting gems in a fashion that strove to preserve their weight and volume. Now, Prince Albert led the quest to reshape it. Following examinations and discussions with scientists and gem cutters, it was recut to provide the desired brilliant reflection but, in the process, lost about two-fifths of its weight.[42] In an 1856 portrait by Winterhalter (fig. 18), the diamond is seen set in a brooch displayed at the queen's

FIGURE 19 • Maharaja Sir Bhupinder Singh (1891–1938) was rarely photographed wearing the impressive Patiala necklace, but after his death it was frequently sported by his son Sir Yadavindra Singh (1914–1974), pictured here.

chest. She was pleased by the painting, yet it seems that even she felt regret about the new cut, as she is said to have never accepted another diamond. In 1874, Queen Victoria was made empress of India, and in 1877 India officially became part of the British Empire—the so-called jewel in the crown—until its independence in 1947. The metaphor of forcing the gem into a Western shape by physically altering and reducing it has been compared to the British exploitation of India more broadly.

A curse may even hang over the Koh-i-Noor, as it is assumed to bring misfortune upon male wearers. Since Victoria's death, the gem has been set only into the crown of a British queen consort (wife of a ruling male monarch). However, on May 6, 2023, during the coronation ceremonies of King Charles III, Camilla, Duchess of Cornwall, did not wear a crown containing the diamond, as Queen Elizabeth the Queen Mother (Elizabeth Angela Marguerite Bowes-Lyon, 1900–2002) had in 1937 for the coronation of King George VI.[43] That decision reflected current dialogues regarding ownership of the Koh-i-Noor, and the reevaluation of the relationship between England and India after centuries of colonial history.

A LEGENDARY NECKLACE FOR MAHARAJA BHUPINDER SINGH

1928

"A NECKLACE FIT FOR A KING," as it was later referred to, was commissioned by Maharaja Bhupinder Singh (1891–1938) from Cartier in Paris during the 1920s (fig. 19). Singh was the ruler of the state of Patiala in the Punjab region of northwestern India, one of 565 sovereign entities in the British Indian Empire. His story, if different in some respects from that of Maharaja Duleep Singh, who handed the Koh-i-Noor diamond to the British in 1849, also parallels Singh's: both lost their fathers at a young age and had to assume power early in life. Although Singh succeeded his father at the age of nine, he did not take office until he turned eighteen, in 1909, which he held until his early death in 1938. He was educated at Aitchison College in Lahore, served in World War I, and was awarded numerous honorary titles. As a wealthy and extravagant ruler, also known as a sportsman and cricketer, he introduced modernity and architectural developments to his town of Patiala, became famous for owning twenty Rolls-Royces, and was the first Indian to possess an airplane, for which he built a landing strip. He was married ten times and fathered eighty-eight children, not unlike some other notable rulers of the powerful Indian Mughal Empire.

And like generations of Indian elites, Singh was passionate about his collection of gems and jewelry.[44] For the 1911 coronation celebration of George V at the Delhi Durbar, Jacques Cartier and Maurice Richard of the Cartier jewelry company traveled to India, having formed relationships with several wealthy customers and eager to explore the riches of the

31

PROJECTING
A
POWERFUL
PRESENCE

subcontinent. They visited Singh, were shown his collection, and negotiated several trades. But it took fourteen more years for Singh to appear in Paris with his entourage and a wooden box filled with gems of extraordinary quality—diamonds, some of them colored, rubies, emeralds—and wonderful pieces of jewelry, all wrapped in humble newspaper. He desired a necklace worthy of a king to be manufactured by Cartier.

The production lasted about three years, and after its completion in 1928, the Patiala necklace stunned visitors when it was exhibited in Paris. It featured 2,930 diamonds and Burmese rubies, of altogether more than 1,000 carats, set into platinum, forming a five-stranded collier.[45] At the center of the lower pendant is a massive yellow diamond, the so-called De Beers diamond—found in the De Beers mine in South Africa in 1888 and weighing 234.65 carats after being cut—framed by white diamond drops. The platinum links were created in the contemporary art deco style, which favored bold geometric patterns, platinum, and densely set diamonds (and other stones), but the collier also featured the distinctively Indian aspect of a tasseled tie closure.

The celebration of luxury did not end well; the necklace disappeared in 1948 from the Patiala treasury. Even though the De Beers diamond was recovered in 1982 in London, and other parts appeared in 1998 and were purchased by Cartier, the largest stones of the necklace had disappeared. Cartier reconstructed the necklace using substitution synthetic stones. Nonetheless, for a short period of time, the opulence of this extraordinary necklace imbued its owner with an aura of importance and a royal identity.

A LEADER UNADORNED: CHAIRMAN MAO

1967

THE FIRST-CENTURY EPIC POEM *ACHILLEID*, composed by the Roman poet Statius, tells the story of Thetis trying to protect her son Achilles from death in the Trojan war by sending him to the island of Skyros, where he lived in disguise as one of King Lycomedes's daughters. Yet, when challenged by a choice between jewels and weaponry, Achilles exposed his true nature by reaching for the sword (fig. 20). The power of jewelry was lost on the heart of a warrior.

Secular leaders of democracies in the last two centuries have likewise resisted noticeable emblems other than the occasional badge. Such is also the case of Mao Zedong (1893–1976), or Chairman Mao, leader of the People's Republic of China (1946–76) and of the Chinese Communist Party. In a 1967 oil painting by Liu Chunhua, artist and member of the Red Guard, Mao exudes supreme confidence as he stands tall, youthful, and heroic, his long hair windblown. He wears plain workman's clothes, in stark contrast to prior generations of Qing dynasty emperors and opulence in traditional portraiture. With an umbrella tucked under his arm, he is ready for his

FIGURE 20 · Pietro Paolini (Italian, 1603–1681), *Achilles among the Daughters of Lycomedes*, ca. 1625–16. Oil on canvas, 127 × 203.2 cm (50 × 80 in.). Los Angeles, J. Paul Getty Museum, 78.PA.363

FIGURE 21 • Liu Chunhua (Chinese, b. 1944), *Chairman Mao Goes to Anyuan*, 1968. Lithograph on paper. London, Victoria and Albert Museum, FE.7-2008. Given by Lady Heseltine

FIGURE 22 • Mao Zedong badges displaying a variety of shapes and motives at the antique market in Hong Kong, SAR China

march to Anyuan in southern China's Jiangxi Province. Mao was, in fact, seventy-four years old when the painting was made. The historical moment memorialized by *Chairman Mao en Route to Anyuan* is a miners' strike of forty-five years earlier, a pivotal event when thirteen thousand Chinese workers enlisted in the Red Army after a nonviolent strike that Mao had helped organize. Set against a landscape recalling traditional Chinese paintings, the iconic image is nonetheless an expression of social realism. It served as a powerful tool following political setbacks; it was the onset of the Cultural Revolution (1966–76), during which Mao tried ever harder to consolidate his power following famine and other disasters. The painting was reproduced hundreds of millions of times as a poster (fig. 21), part of a larger body of ubiquitous propaganda promoting the ideals of the revolution, while tight regulations impacted behaviors, lifestyle, and dress as well as the use of jewelry. For instance, a "body without the burden of jewelry" was promoted for women to "signify liberation and dignity."[46]

The personal cult of Mao, however, did not shy away from creating tokens and pin badges with his image, as pictured in figure 22.[47] Minted from cheap materials such as aluminum or plastic but also sometimes painted on porcelain, they were distributed in the billions, with slightly varying images and inscriptions on the reverse. Their use was largely abandoned following Mao's death in 1976, as was Mao's carefully crafted persona in public images aimed at projecting his unfaltering leadership.

35

PROJECTING
A
POWERFUL
PRESENCE

NOTES

1. See Melanie Holcomb, Kim Benzel, Soyoung Lee, Diana Craig Patch, Joanne Pillsbury, and Beth Carver Wees, *Jewelry: The Body Transformed* (New York: Metropolitan Museum of Art, 2018), 97–128.

2. During World War I, the Russian crown jewels were safeguarded in the Kremlin Armory. Following the Russian Revolution, in 1922, they were catalogued and documented by a committee of specialists, and in the following years mostly sold to an international clientele. See William Clarke, *The Lost Fortune of the Tsars* (London: Weidenfeld and Nicolson, 1994); and Stefano Papi, *Jewels of the Romanovs: Family and Court* (New York: Thames and Hudson, 2013).

3. Nicholas Reeves, *The Complete Tutankhamun: The King, the Tomb, the Royal Treasure* (London and New York: Thames and Hudson, 1990), 106–11. For excavation notes, see "Carter no.: 255," Griffith Institute, http://www.griffith.ox.ac.uk/gri/carter/255-c254-4.html.

4. See René Brus, *Crown Jewellery and Regalia of the World* (Amsterdam: Pepin, 2011).

5. See David Kertai, "Libbali-sharrat in the Garden: An Assyrian Queen Holding Court," *Source Notes in the History of Art* 39, no. 4 (2020): 209–18; and Amy Rebecca Gansell, "Dressing the Neo-Assyrian Queen in Identity and Ideology: Elements and Ensembles from the Royal Tombs at Nimrud," *American Journal of Archaeology* 122, no. 1 (2018): 65–100.

6. Kertai, "Libbali-sharrat in the Garden," 211–12.

7. Muzahim Mahmoud Hussein, *Nimrud: The Queens' Tombs*, ed. and trans. Mark Altaweel, ed. McGuire Gibson (Baghdad: Iraqi State Board of Antiquities and Heritage; Chicago: Oriental Institute, 2016).

8. Jamie Novotny and Jennifer Singletary, "Family Ties: Assurbanipal's Family Revisited," *Studia Orientalia Electronica* 106 (2021): 167–78.

9. Rubina Raja and Annette Højen Sørensen, "The 'Beauty of Palmyra' and Qasr Abjad (Palmyra): New Discoveries in the Archive of Harald Ingholt," *Journal of Roman Archaeology* 28 (2015): 439–50.

10. Little actual jewelry has survived from Palmyra, in contrast to finds from Egyptian burials. See Dorothy Mackay, "The Jewellery of Palmyra and Its Significance," *Iraq* 11, no. 2 (1949): 160–87.

11. Mackay, "The Jewellery of Palmyra and Its Significance," 176–77.

12. Cecilie Brøns, Jens Stenger, Jørn Bredal-Jørgensen, Fabiana Di Gianvincenzo, and Luise Ørsted Brandt, "Palmyrene Polychromy: Investigations of Funerary Portraits from Palmyra in the Collections of the Ny Carlsberg Glyptotek, Copenhagen," *Heritage* 5, no. 2 (2022): 1199–239.

13. See Paola Rapelli, *Symbols of Power in Art: A Guide to Imagery* (Los Angeles: J. Paul Getty Museum, 2011).

14. At least some of these garments have been identified as imperial vestments from the fourteenth century. See "Charlemagne, by Albrecht Dürer," Textile Research Center, Leiden, the Netherlands, https://trc-leiden.nl/trc-needles/visual-archive/16th-century/charlemagne-by-albrecht-durer.

15. Lutz Nasdala, Teresa Lamers, H. Albert Gilg, et al., "The Imperial Crown of the Holy Roman Empire, Part I: Photoluminescence and Raman Spectroscopic Study of the Gemstones," *Journal of Gemmology* 38 (2023): 448–73.

16. Jack Ogden, *Diamonds: An Early History of the King of Gems* (New Haven, CT: Yale University Press, 2018), 54–59.

17. Barbara Plankensteiner, *Benin Kings and Rituals: Court Arts from Nigeria* (Vienna: Snoeck, Kunsthistorisches Museum with MVK and ÖTM, 2007), 369.

18. Henry Ling Roth, *Great Benin: Its Customs, Art and Horrors* (1903; repr., New York: Barnes and Noble, 1968), xiii.

19. See British Museum, Af1898,0115.31. Leopards were revered as animals with sacred power, and directly associated with the oba. They were kept domesticated at court, and their ritual sacrifice at an annual festival was the exclusive privilege of the oba.

20. David Frum, "Who Benefits When Western Museums Return Looted Art?," *The Atlantic*, October 2022, https://www.theatlantic.com/magazine/archive/2022/10/benin-bronzes-nigeria-return-stolen-art/671245/.

21. Anna Keay, *The Crown Jewels: The Official Illustrated History* (London: Thames and Hudson, 2012); and Sarah McDermott and Kirstie Brewer, "The Dazzling Crown Which Sat on the Queen's Coffin," *BBC News*, September 19, 2022, https://www.bbc.com/news/uk-england-62906194.

22. See "Your Complete Guide to the King's Coronation," *BBC News*, May 6, 2022, https://www.bbc.com/news/uk-65342840.

23. A dynasty of largely Welsh and English origin that held the English throne from 1485 to 1603.

24. See Elizabeth Cleland and Adam Eaker, with contributions by Marjorie E. Wieseman and Sarah Bochicchio, *The Tudors: Art and Majesty in Renaissance England* (New York: Metropolitan Museum of Art, 2022).

25. Susan Vincent, "Queen Elizabeth: Studded with Costly Jewels," in *Sartorial Politics in Early Modern Europe: Fashioning Women*, ed. Erin Griffey (Amsterdam: Amsterdam University Press, 2019), 117.

26. Clare Phillips, *Jewels and Jewellery* (London: V&A Publications, 2000), 38–41.

27. Heneage Jewel, Victoria and Albert Museum, https://collections.vam.ac.uk/item/O33883/the-heneage-jewel-locket-hilliard-nicholas/.

28. Susan V. Webster, "Of Signatures and Status: Andrés Sánchez Gallque and Contemporary Painters in Early Colonial Quito," *The Americas* 70, no. 4 (2014): 603–44.

29. Tom Cummins, "Three Gentlemen from Esmeraldas: A Portrait Fit for a King," in *Slave Portraiture in the Atlantic World*, ed. Agnes Lugo-Ortiz and Angela Rosenthal (Cambridge: Cambridge University Press, 2013), 119–46.

30. For an overview of this period and its jewelry, see Michael Spink, "Jewellery in the Safavid, Zand and Qajar Periods," in *The Art of Adornment: Jewellery of the Islamic Lands*, ed. Michael Spink (London: Nour Foundation in association with Azimuth Editions, 2013), 562–81, 594–95.

31 Julian Raby, *Qajar Portraits* (London and New York: Azimuth Editions in association with the Iran Heritage Foundation, 1999).

32 The frontal full-length portraits may well have been inspired by Napoleon's imperial portrayals. See Raby, *Qajar Portraits*, 11–13.

33 Raby, *Qajar Portraits*, 11.

34 See Smithsonian, with foreword by Aja Raden, *Gem: The Definitive Visual Guide*, 2nd ed. (London: Dorling Kindersley, 2023), 182–83; and V. B. Meen and A. D. Tushingham, *Crown Jewels of Iran* (Toronto: University of Toronto Press, 1968), 72–73.

35 Charlotte Gere and Judy Rudoe, *Jewellery in the Age of Queen Victoria: A Mirror to the World* (London: British Museum, 2010), 14–79.

36 Hugh Roberts, *The Queen's Diamonds* (London: Royal Collection Trust, 2012), 22–27.

37 Today this crown continues to be worn by queens during ceremonies; it has also been widely depicted, including on millions of stamps of Queen Elizabeth II.

38 Roberts, *The Queen's Diamonds*, 28–33.

39 Danielle C. Kinsey, "Koh-i-Noor: Empire, Diamonds, and the Performance of British Material Culture," *Journal of British Studies* 48, no. 2 (2009): 391–419; and William Dalrymple, *Kohinoor: The Story of the World's Most Infamous Diamond* (New Delhi: Juggernaut Books, 2016).

40 Dalrymple, *Kohinoor*, 19–61.

41 See "The Koh-i-nûr armlet c. 1830," Royal Collection Trust, https://www.rct.uk/collection/31734/the-koh-i-nucircr-armtle, for how the Indian bracelet looked upon arrival in England. After the removal of the original diamonds, rock crystals were used to restore its original appearance.

42 Kinsey, "Koh-i-Noor," 416. The two drop-shaped diamonds from the bracelet were first set into the Timur Ruby Necklace (Royal Collection Trust, RCIN 100017), and in 1858 into the coronation earrings (Royal Collection Trust, RCIN 100004). See Roberts, *The Queen's Diamonds*, 58–59.

43 Mark Landler, "Jewels in Camilla's Crown Will Not Include Famed Diamond Claimed by India," *New York Times*, February 14, 2023, https://www.nytimes.com/2023/02/14/world/europe/camilla-crown-koh-i-noor-diamond.html.

44 Jack Ogden, "Gems and the Gem Trade in India," in *Beyond Extravagance: A Royal Collection of Gems and Jewels*, ed. Amin Jaffer (New York: Assouline, 2013), 348–83.

45 Francesca Brickell-Cartier, *The Cartiers: The Untold Story of the Family Behind the Jewelry Empire* (New York: Ballentine Books, 2019), 305.

46 Hung-Yok Ip, "Fashioning Appearances: Feminine Beauty in Chinese Communist Revolutionary Culture," *Modern China* 29, no. 3 (2003): 334. Women nonetheless devised ways to emphasize their femininity, for example by slight alterations to their dress.

47 See Helen Wang, *Chairman Mao Badges: Symbols and Slogans of the Cultural Revolution*, British Museum Research Publication 169 (London: The British Museum, 2008).

CHAPTER 2

IN SEARCH OF THE SPIRITUAL

Susanne Gänsicke

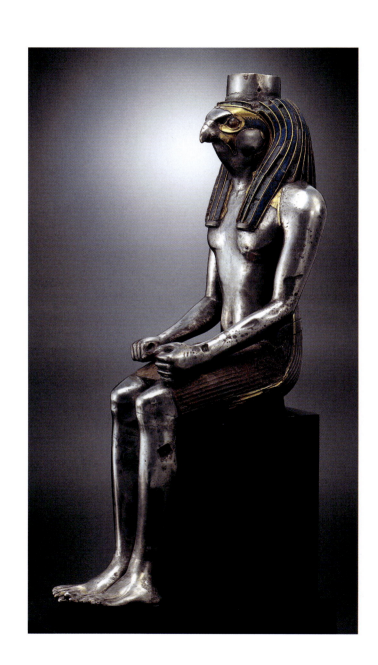

FIGURE 23 • Cult figure of a falcon-headed deity, Egypt, probably early 19th Dynasty, ca. 1295–1213 BCE. Silver, gold, lapis lazuli, and rock crystal, 41.9 cm (16½ in.) in height. Shigaraki-cho, Koka City, Shiga Prefecture, Japan, Miho Museum

JEWELRY IN THE CONTEXT OF SPIRITUALITY, and as an expression of it, is as multifaceted as the search for manifestations of the divine is fundamental to human nature.[1] Sacred settings, arenas where the natural and supernatural worlds connect and where spirits might dwell, were sought out early in human history for devotional rituals. And adornments surely played an important role, as applied to blessed shapes or animals, and perhaps as worn by individuals. Many of the great ancient civilizations shaped their gods' images after humans in anthropomorphic representations, and erected temples and shrines as the gods' homes, dedicated to ritual services. Deities and divine icons were visualized wearing crowns and other jewelry, and often seated on thrones. Religious icons might receive offerings of food or be anointed, dressed, and embellished with jewelry, and ancient temples would receive devotional offerings of jewelry and donations, thereby accumulating riches and power.

IN SEARCH OF THE SPIRITUAL

Consider for instance the statue of the falcon-headed god Horus (fig. 23, ca. 1295–1213 BCE), a rare and precious surviving temple icon from the polytheistic pantheon of ancient Egypt.[2] It was cast solidly in silver, its surface was once clad in gold, and the wig was inlaid with lapis lazuli and the eyes with rock crystal; a likely exquisite golden headdress has been lost. Or the elaborately textured and gilded painting made circa 1420 by Gentile da Fabriano depicting Mary and Christ seated on brocade-covered thrones, a dove representing the Holy Spirit above their heads and two groups of angels gathered nearby (fig. 24).[3] The gesso surface is tooled to provide almost realistic detail along the hems of the garments, and the golden jewelry—the belt of Christ, the brooch of Mary, and the crown—is three-dimensionally modeled in *pastiglia* (gesso) and gilded. These elements may once have held applied inlays of stone to make the sumptuous embellishment even more elaborate. In Christian iconography of the Virgin Mary and saints, crowns feature abundantly based on discussions in historical texts and scripture. The concept of the five heavenly crowns, to be obtained by believers in heaven after the final judgment, is anchored in the New Testament, where different crowns are assigned to different virtues.[4]

Some symbolism as manifested in religious jewelry has become almost universal over time and distance in diverse contexts, while other signs and symbols developed in specific regions and remained isolated. Some ancient religious symbols remain popular today, and have crossed into pop culture and fashion, as for example the bejeweled crosses worn prominently by musicians, influencers, and royalty, or certain

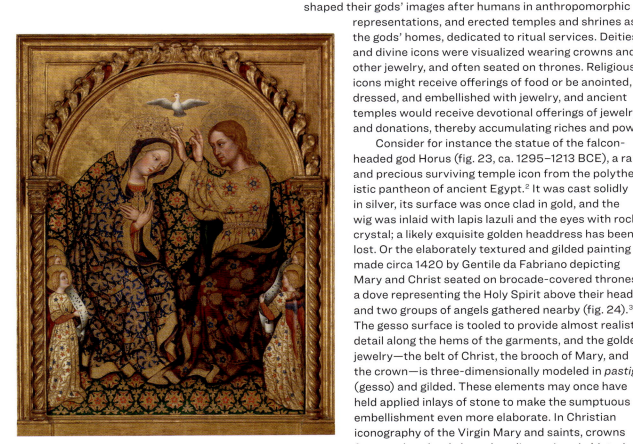

FIGURE 24 · Gentile da Fabriano (Italian, 1370–1427), *Coronation of the Virgin*, ca. 1420. Tempera and gold leaf on panel, 93 × 64.1 cm (36⅝ × 25¼ in.). Los Angeles, J. Paul Getty Museum, 77.PB.92

FIGURE 25 • Jean Paul Gaultier (French, b. 1952), *Ex-Voto* evening ensemble, 2007. Silk mousseline, silk-metal lace, crocheted gold, silver silk, iridescent crystals, appliqued holograms, and aluminum ex-votos

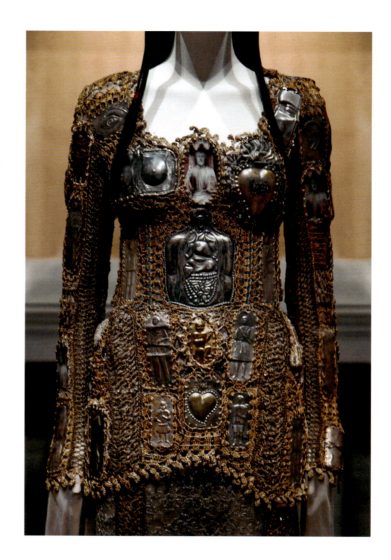

Catholic emblems that have found their way into haute couture gowns (fig. 25).⁵

The following case studies are drawn from diverse world religions to illuminate how jewelry is featured and utilized in dialogue with the divine, and how it provides unique signifiers recognizable to those of a specific community or faith, and sometimes beyond.

A QUEEN DEIFIED

CA. 1350 BCE

ANCIENT SCULPTURES OFTEN EXPERIENCED complex or even multiple lives in different contexts. Rarely does an extant sculpture relay deep insights into the past of a particular individual, but a sculpted head of the Egyptian queen Tiye (1398–1338 BCE) is an exception (fig. 26). Despite being of non-royal background—

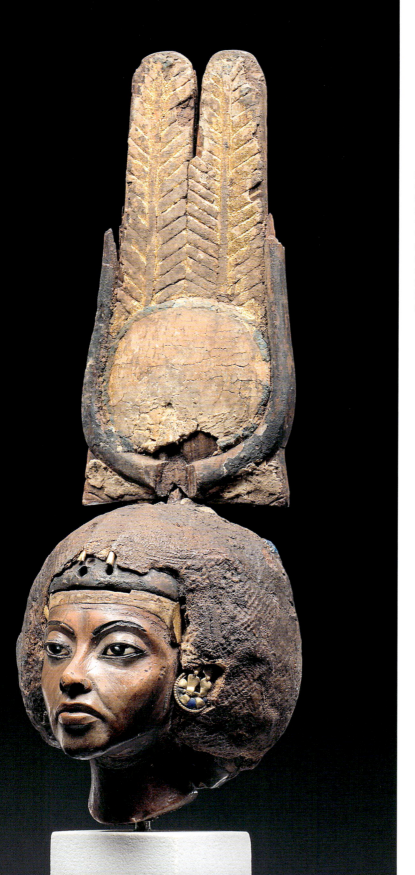

FIGURE 26 • Portrait of Queen Tiye with a crown of two feathers, Medinet el Gurob, Egypt, New Kingdom, 18th Dynasty, ca. 1350 BCE. Yew wood, silver, gold, and faience inlays, head 9.5 cm (3¾ in.) in height, head with crown 22.5 cm (8⅞ in.) in height. Berlin, Neues Museum, inv. ÄM 21834, ÄM 17852

IN SEARCH OF THE SPIRITUAL

Tiye was the daughter of Yuya, a charioteer, and Tuya, priestess of Min—she became the chief wife of Amenophis III. The small head, made circa 1350 BCE and carved from Cypriot yew wood, features the queen as a woman of vivid expression and remarkable beauty. It would have originally been set into a larger figure. Today the top of the head bears a cap of built-up layers of linen and resin, once covered with small blue beads, of which only traces remain. For decades, this item remained puzzling. The plain brown cap appeared to hide luxurious jewelry, as suggested by a golden earring peeking out from under the left ear.

Only in 1990 did scientific examination by computed radiography (CT scanning) in Berlin provide insights by allowing the digital visualization of an earlier version of the sculpture. The tomography, similar to techniques used to examine human bodies, supplies sectional images that can be combined into a 3D model of what is hidden to the naked eye. Tiye was found to be wearing a silver sheet-metal headdress (*khat*) of a soft, rounded shape typically worn by goddesses. It is lined with a golden band above her forehead bearing golden rearing cobras, symbols of kingship.[6] A second earring, shaped from gold and beset with lapis lazuli inlays and also with images of small golden cobras, is still secured to her right ear, hidden by the linen cap.

Why were these precious items with important symbolism covered? A discovery in storage at the Egyptian Museum, Berlin, provided some answers. A tall double-feather crown with cow horns and a sun disk, previously not associated with the head, was found to connect perfectly to wooden prongs at the top of Tiye's head. At some point in antiquity, Tiye was revised so as to be wearing an emblem of a goddess or a deified queen, a more standardized crown than the silver *khat* in the earlier version.

Egyptological interpretation suggests that the first rendering, with Tiye wearing the *khat* cap, depicted her as of divine status during her life, in a manner perhaps related to her function during funerary rituals for her deceased husband.[7] Her transformation into a goddess wearing a more common double-feathered crown may have occurred during a period of restoration of older traditions in the post-Amarna time, in Egypt's Eighteenth Dynasty.[8] The exquisite and unusual head not only provides an exceedingly rare example of an ancient Egyptian bejeweled sculpture, but its reuse and adaptation preserves chapters of one queen's life story, thus informing us of transitions in her identity over time. That the original jewelry was not removed during this transformation but carefully hidden adds questions we cannot fully answer, and attests to the power the emblems must have possessed.

THE WARRIOR PRIEST OF SIPÁN
640–680 CE

FAITH AND HOPE ARE INTERCONNECTED, and particularly relevant at moments of life transition: birth, marriage, death. Such occasions in many societies have been marked not only by sacred rites but also by specific items of jewelry, which through symbolism or mere accumulation provide assurances to both the living and the dead, as in the example of funerary jewelry ensuring a safe transition to the afterlife.

A sizable golden earspool, one of a pair made circa 640–80 CE and measuring almost 10 centimeters across, depicts an elite Moche warrior priest from the coastal region of northern Peru (fig. 27).[9] He wears a full set of regalia in miniature.

The ear ornament was brought to light in 1987 during archaeological rescue excavations at Huaca Regada, after looters had stumbled upon a set of complex tombs in a pyramid-shaped, mud-brick structure containing some of the finest objects ever recovered in this region.[10] The central figure on the ear ornament has since become known as the Lord of Sipán, after the individual in whose tomb it was found, who died at around forty years of age.

Crafted from individually formed golden sections and inlaid with turquoise, the jewel is exemplary of Moche metalworking skills: it is substantial in size for an ear ornament, and its features and minute details are exquisite. The miniature warrior standing in the center, flanked by smaller figures, wears a tall golden headdress, a large nose ornament, a necklace with tiny, separately connected owls' heads, and bell ornaments suspended from his belt. He is holding a scepter, and his small ears are beset with, yes, miniature earspools. The tiny emblems identify him as being of high status, as does the matching collection of life-size ornaments and insignia recovered from his funeral chamber, which mirror their miniscule counterparts. The large compound contained other burials with human remains, luxury goods, and ritual sacrifices. As many ancient tombs in northern Peru were looted entirely, the at least partially scientifically excavated royal tombs of Sipán provide critical information on the lives and rituals of a distant culture, even if the specific role of the warrior priest remains elusive and requires further research and interpretation.[11]

IN SEARCH OF THE SPIRITUAL

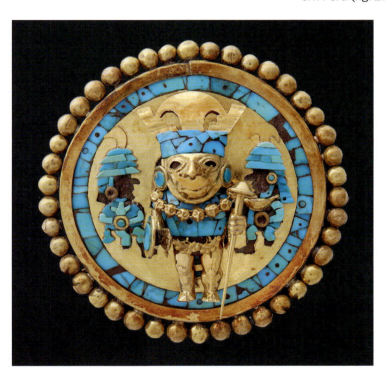

FIGURE 27 • Ear ornament depicting a warrior, Moche, Peru, 640–80 CE. Gold, turquoise, and wood, 9.5 × 9.5 cm (3¾ × 3¾ in.). Lambayeque, Peru, Museo Tumbas Reales de Sipán, Ministerio de Cultura del Perú, MNTRS-77-INC-02; S/T1-0:2

MAITREYA AS
THE BUDDHA OF
THE NEXT AGE
3RD CENTURY CE

THE USE OF AMULETS BELIEVED TO POSSESS magical or ritual powers is a universal practice. Often the items are made of natural materials such as shells, or animal parts like claws, teeth, ivory, or horn. Elsewhere certain metals, minerals, and gemstones are believed to harbor protective or spiritual attributes. In India, a land rich in gems, the Vedas (ancient Hindu Sanskrit scriptures) describe minerals and gemstones as being formed from body parts and fluids of demons.[12] *Navaratna*, a Sanskrit term for "nine gems," connected to Indian astrological bodies, may take the form of rings, pendants, or bracelets to lend protection and support to the wearer.[13] In ancient Egypt, gold and silver were associated with the flesh and bones of the gods. The red color of carnelian represented blood and life force, and the green of malachite and amazonite stood for fertility and resurrection. An amulet from the tomb of Tutankhamun (ca. 1323 BCE, fig. 28) combines complex ritual imagery with potent materials—gold, silver, carnelian, lapis lazuli, turquoise, glass—and a scarab made from rare desert glass in the center.[14] Specific sacred symbols, for example crosses, eyes, certain hieroglyphs, and magical formulas, have offered protection on many levels. The hand of Fatima, *hamsa* (Arabic for "five"), is worn as an amulet against the evil eye in the Arab world and in Jewish culture (fig. 29).[15] Amulets of magical texts and prayers

FIGURE 28 • Moon pectoral, Tomb of Tutankhamun, KV 62, Valley of the Kings, Egypt, ca. 1323 BCE. Gold, silver, carnelian, lapis lazuli, turquoise, and glass, 14.9 × 14.5 cm (5⅞ × 5¾ in.). Cairo, Egyptian Museum, JE 61884

FIGURE 29 • Three pendants in the form of *hamsa*, or the hand of Fatima. Morocco, twentieth century. Silver; left: 6.4 × 10.1 × 0.57 cm (2½ × 4 × ¼ in.); middle: 5 × 8.5 × 0.5 cm (2 × 3⅜ × 3/16 in.); right: 4.94 × 6.95 × 0.55 cm (1 15/16 × 2 ¾ × ¼ in.). Paris, Musée du quai Branly - Jacques Chirac, 74.1999.27.24, 74.1999.27.27, 74.1999.27.28

FIGURE 30 • Necklace with amulet cases, Sudan, likely late 19th or early 20th century. Koranic texts, leather, brass, glass, cowrie shells, and cloth, 25 × 26.5 × 2 cm (9⅞ × 10 ⅜ × ¾ in.). London, British Museum, Af1949,46.686

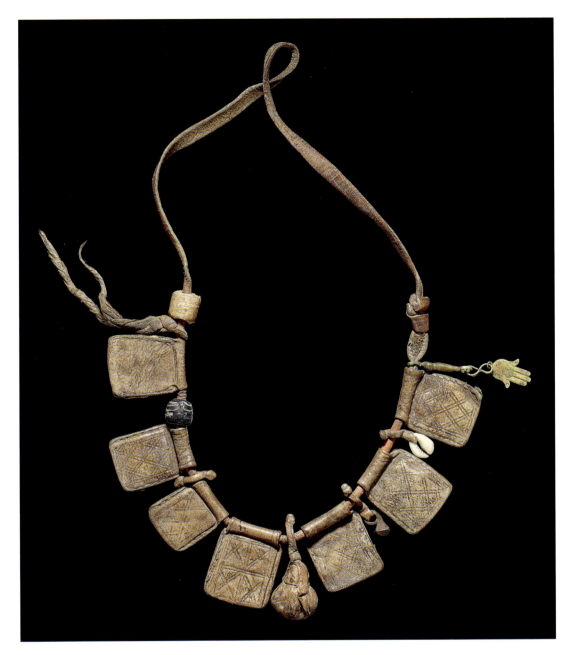

IN SEARCH
OF THE
SPIRITUAL

encased in metal or leather boxes and pouches are referred to as *kitab* in the Islamic sphere (fig. 30), and in Islam, calligraphy engraved into gems provides blessings.

In the Christian context, a prototypical example occurs in a 1460 painting of Madonna and the Christ child, where the boy wears a beaded necklace with a red coral branch pendant (fig. 31). Coral, ranging in shade from light pink to dark red,

46

CHAPTER 2

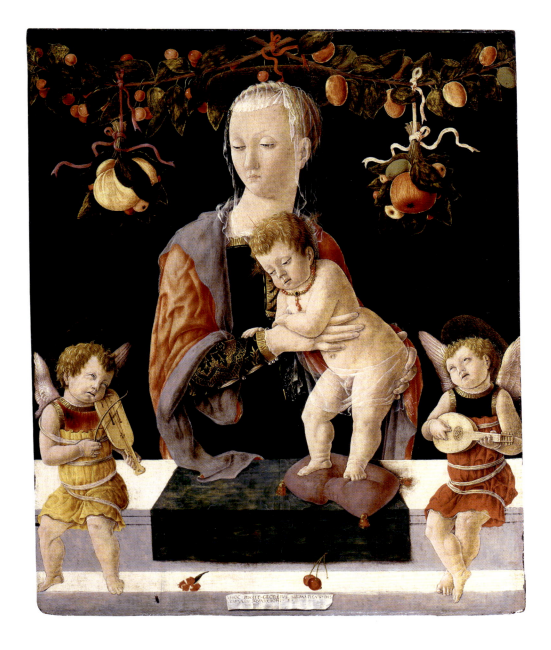

FIGURE 31 · Giorgio di Tomaso Schiavone (Croatian, 1433/1436–1504), *Madonna and Child with Angels*, 1460. Oil on panel, 70 × 56.7 × 2.5 cm (27½ × 22⅜ × 1 in.). Baltimore, Walters Art Museum, 37.1026

FIGURE 32 • Bodhisattva Maitreya, Gandhara, northwestern Pakistan, Kushan period, 3rd century CE. Gray schist, 109.5 × 38.1 × 22.9 cm (43⅛ × 15 × 9 in.). Museum of Fine Arts, Boston, Helen and Alice Colburn Fund, 37.99

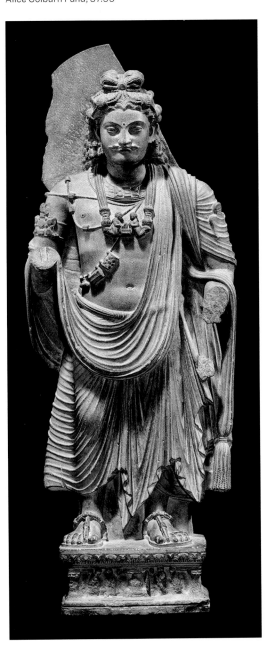

has been thought to be a potent protective substance across England and Europe, North Africa, India, the Himalayas, and the early Americas. The material, valued since ancient times, served as a popular device to protect children from evil and alleviate teething pain, among other guarding properties.[16] Myth surrounds its origin. In ancient Greece, coral branches were thought to have formed when blood streaming from Medusa's severed head reached the sea. The Roman author Pliny the Elder described coral in his *Natural History* (77 CE) as a type of shrub that turned red when lifted from the ocean; he lists as sources for it the Red Sea, the Persian Gulf, and the Sea of Sicily, with the last providing the highest quality.[17] Coral has even been valued as a medicinal powder that, when consumed, serves as a remedy. Coral good-luck charms in the shape of small horns (*cornicellos*) are still worn in Italy today. When worn by the Christ child, however, coral is as much about foreboding as it is amuletic: its red color alludes to the blood of his final sacrifice.

One of the best-known and frequently sumptuously decorated—including with abundant amulets—images from the Buddhist Gandharan period (ca. first century BCE–seventh century CE) is Maitreya as the Buddha of the Next Age, of which many fine examples exist.[18] One exquisite sculpture in Boston (fig. 32) represents a princely Bodhisattva, one of the earlier life stages of the Buddha, who assists believers on their path to attain liberation. The halo, now partially broken off, identifies him as a deity, and in some other examples of the subject, his left hand holds a flask of holy water. Created in the region of what is now Pakistan, an area of central Asia interconnected with different countries and civilizations along the Silk Road, the style reflects Eastern and Western influences.

The dense, dark gray type of stone (schist) that was favored for these sculptures allowed the makers to carve flowing robes, hair, and adornments in delicate, intricate detail.[19] Rich layers of jewelry include earrings, a torque (metal collar or neck chain) covered by a necklace, and heavy armlets that were likely set with gemstones. Even the hair, in a topknot, is adorned with strings of beads. Multiple amulet boxes are shown suspended from the sacred thread that is worn diagonally across the body. A small golden box, which may be similar to the aforementioned ones carved in stone, exists in the collection of the British Museum.[20] Its contents were described in the nineteenth century as two golden coins and an unidentified substance, but it remains doubtful that this material is original, as written mantras or charms would be expected in a Buddhist context. Sadly, not much actual jewelry has survived from the Gandharan period such that we might form a deeper understanding of its nature.

CHAPTER 2

THE GLORIOUS BUDDHA

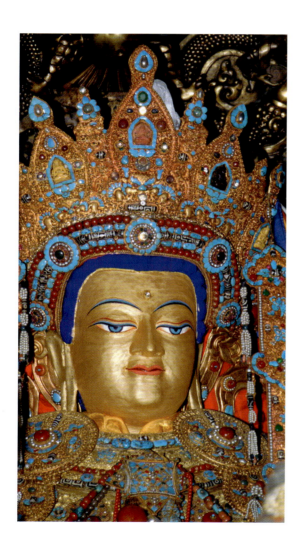

ACROSS MANY RELIGIONS, PILGRIMAGE—whether to holy places such as mountains and rivers or to particular cities, cathedrals, temples, or mausoleums—provides an ultimate encounter with the divine. Santiago de Compostela, Varanasi, Lhasa, Rome, Jerusalem, and Mecca are only a few of the many world destinations that harbor major spiritual importance. Emblems, mementos, and pilgrim badges, even if simple and mass produced, may return home with the traveler to provide lasting memories and support. Or conversely, the traveler may leave offerings, including luxury goods such as jewelry, at the pilgrimage site.

In the transformation experienced by Prince Siddhartha Gautama during his enlightenment in the sixth century BCE, he removed his princely jewelry as a renunciation of earthly possessions. Henceforth, archetypal images would show him cross-legged, in a yogic lotus position, and recognizable by symbols of Buddhahood: the topknot, the auspicious mark on his forehead, and his elongated, hollow earlobes that attest to previously worn heavy jewelry. Yet ancient sacred texts convey a vision of the godly bodies of the Buddha, Bodhisattvas, and other deities across Eastern religions such as Jainism and Hinduism as luminous or golden, and their abodes as bejeweled palaces.[21] Painted and sculpted images of the Buddha and Bodhisattvas are often surfaced with gilding and heavily adorned. Allusions to precious gems, metals, and jewelry in mythological texts serve as metaphors for the search for enlightenment, wisdom, disciples, or even the Buddha himself. Jewelry in the realm of the divine signifies magical power beyond wealth. Actual wealth acquired by believers in real life reflects good karma and piety in previous lives.

In Tibet, the most important image of the historical Buddha Shakyamuni, founder of Buddhism, is arguably the seventh-century sculpture known as Jowo Shakyamuni or Jowo Rinpoche ("precious one" in Tibetan) at Jokhang Temple in Lhasa, the country's principal pilgrimage center, to which devotees travel from afar, often on foot under arduous conditions (fig. 33). The larger-than-life-size Buddha, allegedly pictured at age twelve and dressed in fine robes, is seated in the lotus position on a magnificent throne.[22] According to legend, the statue was brought to Tibet as dowry by Princess Wencheng of the Chinese Tang court on the occasion of her marriage in 641 CE to Songsten Gampo, creator of the Tibetan Empire. Its original appearance remains unknown, as over time the sculpture has undergone repeated repairs, alterations, and regildings. The Buddha's five-petal crown, whose five leaves stand for five celestial Buddhas, and luxurious jewelry of earrings, necklaces, bracelets, and anklets were added in the fifteenth century, against the criticism of some who judged the embellishments as inappropriate for an image

FIGURE 33 • Jowo Shakyamuni, Jokhang Temple, Lhasa, Tibet, Yarlung dynasty (630–850 CE), brought to Tibet ca. 641. Gilt metals, gemstones, pearl, paint, and various offerings

FIGURE 34 • The Birth of Buddha, Nepal, 18th–19th century. Mosaic set in a gilt-silver framework with diamond, ruby, emerald, sapphire, garnet, quartz, pearl, amber, coral, lapis lazuli, turquoise, and other gemstones, 36.8 × 31.1 cm (14½ × 12¼ in.). New York, Metropolitan Museum of Art, John Stewart Kennedy Fund, 15.95.163

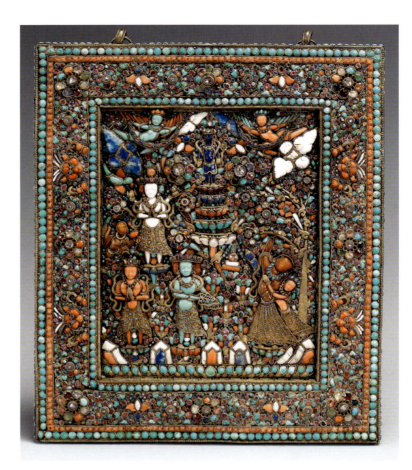

of the earthly Buddha. Jowo has since received repeated offerings in the form of a new crown and earrings, and gold continues to be offered to the image on a monthly basis.[23]

In the same craft tradition that produced jewelry for Buddhist sculptures such as the image of Jowo in Lhasa are the panels encrusted with gemstones and holy images that were produced in Nepal in past centuries and exported throughout the Himalayas to be worshipped in house shrines and temples or offered as donations. The birth of the Buddha from his mother Maya's side, with Indra and Brahma in attendance, is recounted by the bejeweled panel in figure 34. Diamonds, rubies, emeralds, sapphires, garnets, quartz, pearls, amber, coral, lapis lazuli, turquoise, and other gems form the images in a mosaic-like arrangement. The narration includes multiple layers of time; a Buddha with a body of lapis lazuli, in a later part of his life, is standing atop a lotus flower in the upper center. He has taken the very shape of a jewel, perhaps in reference to ancient texts, and embodies the essence of Buddhahood.[24]

CHAPTER 2

BEJEWELED HINDU DEITIES

RULERS IN SOUTHEAST ASIA HAVE DRAWN on divine symbols for their insignia for more than a thousand years. King Sisowath of Cambodia was crowned in 1904, while the country was under French colonial rule, and was photographed seated in ceremonial attire representing himself as the ancient Hindu god Vishnu (fig. 35).[25] The tall, multitiered crown symbolizes Mount Meru in northern India, sacred to Buddhists, Hindus, and Jains as the center of the cosmos. Although not regarded as in the lineage of Khmer divine kingship today, the Cambodian coronation ceremony includes ancient rituals and regalia, such as a bejeweled crown and sacred sword. In fact, the crowning of Norodom Prohmbarirak was delayed from 1860 until 1864 because the essential royal regalia were in Siam, which dominated Cambodia at the time, and unavailable.[26] Today the whereabouts of the regalia remain unknown, not surprisingly given Cambodia's tumultuous and violent recent history.

Hindu temples, deities' homes used as places of worship, are plentiful in South Asia and provide glimpses into ancient rituals and imagery. Some of the largest active complexes are located in the South Indian state of Tamil Nadu, such as the Meenakshi Temple in Madurai, first built in the twelfth century, then later expanded and rebuilt. They are accessed by avenues used for chariot processions during festivals, with monumental tower gates that guard the entrances to courtyards with multiple halls, sanctuaries, and often large water tanks or pools, all serving important roles during rituals. The inner sanctuary houses an image of the main deity, while numerous subsidiary niches and shrines contain icons of its other manifestations and of related gods of the polytheistic Hindu faith. Devotional activities include offerings from devotees, prayers, and *darshan*, a practice of making eye contact with the godly images.

An example of such a temple icon is a bronze sculpture of the four-armed Vishnu (fig. 36) holding sacred symbols in his roles as preserver: chakra, a war discus (to restore dharma, or divine law), and a trumpet formed by a large conch shell (emitting the sacred sound of Om). His arm rests on a *gada*, or mace (for power and knowledge), and he raises his fourth hand in a gesture of protective *abhayamudra*, while the sacred thread used in Hinduism and Buddhism is draped diagonally across his body. He is heavily bejeweled, wearing a tall crown, earrings, multiple necklaces, and layers of bracelets and armlets.

Such bronze icons are important parts of processions and festivals and are counterparts to the consecrated stone sculptures that reside permanently in Hindu sanctuaries.[27] They were produced in great quantities during the Chola dynasty (lasting from the ninth to the thirteenth century CE) by lost-wax casting using copper alloys. After the fourteenth

FIGURE 35 • King Sisowath of Cambodia (1840–1927) in his coronation attire linking him to Vishnu, 1904. The king also embodies Mount Meru, represented by his crown.

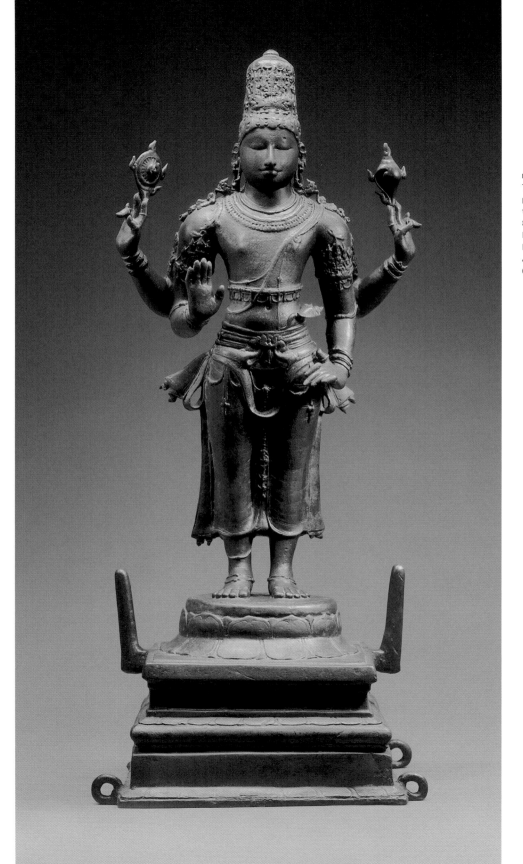

FIGURE 36 · Standing Vishnu, Tamil Nadu, India, Chola period, ca. 3rd quarter of the 10th century. Copper alloy, 85.7 cm (33¾ in.) in height. New York, Metropolitan Museum of Art, purchase, John D. Rockefeller 3rd gift, 62.265

FIGURE 37 • Jewelry, Ranganathaswamy Temple, Srirangam, Tamil Nadu, India, 1895. Archaeological Survey of India Collections, 1896–98

century, *pancha loha*, an alloy of five metals—gold, silver, and copper, with varying amounts of tin, zinc, or iron—was used. Small amounts of precious metal offerings, sometimes jewelry provided by devotees, were (and still sometimes are) incorporated into alloys for sculptures, such that the jewelry literally joins the matter of the divine body. Detailed descriptions of donated Hindu bronzes were often recorded on temple walls and include names of patrons and the size and type of castings offered. Daily rituals entail nourishing the sculptures: they are anointed and richly decorated with textiles and fine gold jewelry (fig. 37). A sculpture without embellishments would be considered in a state of nudity.[28] Temple jewelry, received by donations, is safeguarded in the treasuries and accounts for the enormous wealth of the temples.[29]

THE UNEMBELLISHED ASCETIC JINA

JAINISM, ONE OF THE OLDEST RELIGIONS of South Asia, emerged in the first millennium BCE in the broad plain of the river Ganges that curves from Pakistan along the region of northern India south of the Himalayas, and is still practiced today, predominantly in India. Nonviolence and meditation form the core of Jain philosophy, helping the practitioner overcome restrictions based on karma on the path to obtain *moksha*, spiritual liberation from suffering and the cycle of rebirth. Plain, austere, nude, and unadorned Jain icons typically express the deep-seated concentration required on the long path to acquire eternal bliss. The deities are depicted seated in the lotus pose or standing tall and straight with arms hanging next to the body. This yoga posture is experienced in practice over extended periods of time—in deep concentration, relaxation, and "abandonment of the body."

This posture is held by a monumental sculpture of Gomateshwara, or Bahubali, at Shravanabelagola in Karnataka, India, which was carved from a single block of granite. His body is strong, smooth, and unadorned except for winding twines growing upward around his limbs. Every twelve years, during an important Jain festival, Mahamastakabhisheka, the sculpture is anointed with floods of libations—water, sandalwood paste, milk, and powders—in a succession of colorful veils.

Even the mere silhouette of a Jain icon can capture the essence of Jainism. In a small altarpiece commissioned by a private family (fig. 38), a copper sheet, held in an ornate gilded bronze frame with an inscription inlaid in silver, contains the central image—formed by his absence. Virtue and austerity are thus visualized in a surprising manner: the *siddha*, or person who has been released from the cycle of endless rebirth, is represented by empty space, like a shadow, and entirely devoid of recognizable features, attributes, or, significantly for our purposes, jewelry.[30] Jain images are stark and powerful works of art. While some are made from valuable materials and as such do not shy away from a sense of luxury, their typical simplicity of form and lack of jewelry stand in contrast to Buddhist and Hindu examples from the subcontinent.

FIGURE 38 • Siddhapratima Yantra (Shrine of a Perfected Being), Delhi Sultanate period, India, 1333. Bronze, copper alloy, traces of gilding, and silver, 21.9 × 13.1 × 8.9 cm (8⅝ × 5⅛ × 3½ in.). Washington, DC, National Museum of Asian Art, Smithsonian Institution, Freer Collection, Purchase Charles Lang Freer Endowment, F1997.33a–b

IN SEARCH OF THE SPIRITUAL

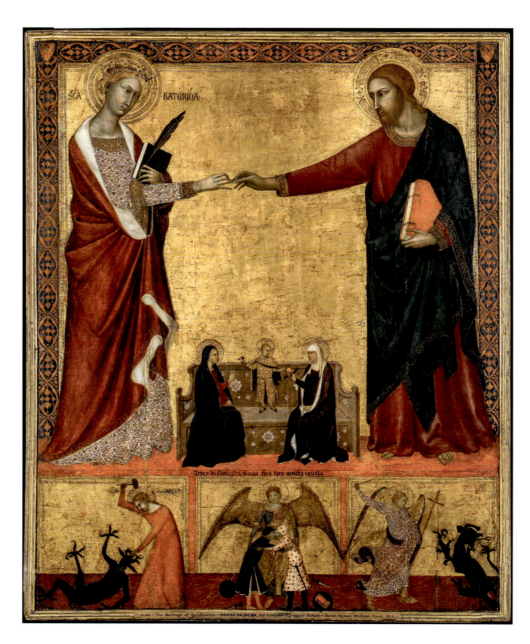

FIGURE 39 • Barna da Siena (Italian, active ca. 1330–50), *The Mystic Marriage of Saint Catherine*, 1340. Tempera on panel, 138.7 × 111.1 cm (54⅝ × 43¾ in.). Museum of Fine Arts, Boston, Sarah Wyman Whitman Fund, 15.1145

BARNA DA SIENA'S MYSTIC MARRIAGE OF SAINT CATHERINE
1340

LEGEND HAS IT THAT SAINT CATHERINE OF ALEXANDRIA woke up with a ring on her finger after a dream in which she and Christ were joined in marriage. Catherine is believed to have lived in the second or third century CE in Alexandria, Egypt, born to a noble family, perhaps even a princess. She was drawn to religion, and after a first dream of encountering Christ, who at that point rejected her, she took up studies with a hermit in the principles of the faith, and eventually she and her mother were baptized. Emboldened by her faith and religious experiences, during an encounter with the Roman emperor Maximinus, she challenged him on his cruelty toward Christians. Allegedly, after being invited to discourse with Roman scholars, which prompted a number to convert to Christianity (they were swiftly executed), she was punished and imprisoned. Yet another encounter, with none less than the emperor's wife, led to another conversion. The result was severe punishment and a death sentence. After a failed attempt at putting her to death by an executioner's wheel, a torture instrument used in early historical times to crush the bodies of felons, which miraculously broke apart, she was beheaded and her body taken to the Sinai Peninsula in Egypt, where the sacred Saint Catherine's monastery is located.

During the fourteenth century, the martyrdom of Saint Catherine received a revival, and she became popular in the religious texts that are said to have influenced Joan of Arc, among others. Barna da Siena's 1340 painting *Mystic Marriage of Saint Catherine* depicts the moment of the actual placement of the ring by Christ as a grown man, as envisioned in her dream (fig. 39). In most paintings imaging the placement of the ring, it is provided by the Christ child, often in a setting with other protagonists.[31] The exact nature of the ring, however, evades us.

Although rings have been cherished for millennia, their use as promises of marriage began in the late Roman period, and the exchange of rings in the actual wedding ceremony is based on Christian traditions. Still today, pilgrims to the Monastery of Saint Catherine receive a silver ring bearing the saint's initials and carrying her blessings.[32] They are cherished and kept as heirlooms by their devout owners, providing tangible evidence of the seeker's experience as well as symbolism understood by others who have journeyed to the monastery.

THE POPE'S CEREMONIAL RING

PAPAL INSIGNIA ARE AS OPULENT AS those of secular kings and emperors, and to this day follow centuries-old conventions. The smallest of the emblems, the papal ring, may be the most mysterious one: its large bezel is ritually kissed by devotees, and a new ring is fabricated for each new pontiff. First introduced as a sacramental ritual in 1265, every new pope thereafter received a new, made-to-order ring at his installment. Traditionally, the central image on top of the bezel featured

IN SEARCH OF THE SPIRITUAL

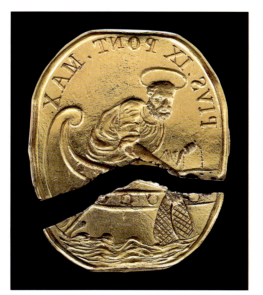
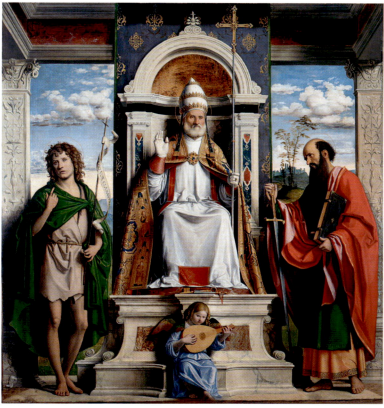

FIGURE 40 • Pope Pius IX's fisherman's ring, broken and rendered defunct after his death in 1846. Gold, 2.5 × 2.2 × 2.2 cm (1 × ⅞ × ⅞ in.). Alice and Louis Koch Collection, inv. 1523

FIGURE 41 • Cima da Conegliano (Giovanni Battista Cima) (Italian, ca. 1459–1517), *St. Peter Enthroned with St. John the Baptist and St. Paul*, 1515–16. Oil on panel, 155 × 146 cm (61 × 57½ in.). Milan, Italy, Brera Pinacoteca, inv. 292

Saint Peter casting his net from a boat, representing his role in the Gospels as a fisher of man. The outer edge bore the name of the living pope. Used as a signet ring to seal letters and papal bulls (public documents), the ring was intrinsic to the living pontiff. Upon his death, it was destroyed with a silver hammer (fig. 40) and turned into a new ring for his successor.[33] The ring's use as an actual seal was abandoned in the nineteenth century. Changes in ritual have led to a different practice today, in which the rings are not destroyed but the image they bear is scratched and thereby devalued.

The current pope, Pope Francis, chose a different type of ring made from gold-plated silver, as opposed to earlier, more opulent versions, and it bears the often-used image of Saint Peter holding the two keys as painted by the Venetian artist Giovanni Battista Cima (fig. 41). The 1515–16 portrait of Saint Peter, however, is an image not of any living leader of the Roman Catholic Church but of the biblical apostle Peter, fisherman of Lake Galilee, who according to Catholic tradition was chosen as first pope by Jesus.[34] Flanked by Saint John the Baptist and Saint Paul, he is seated on a throne, wearing the papal costume and regalia of the early sixteenth century. The papal insignia

marking his office include the luxurious embroidered cape, the three-tiered tiara, or triple crown, the papal staff or ferula topped by a cross, and two keys at his feet signifying his power in Heaven and in papal office on Earth. On his gloved hand, he wears another papal emblem: the *Anulus piscatoris*, ring of the fisherman.

AYUBA SULEIMAN DIALLO, DISPLACED WEST AFRICAN PRINCE AND RELIGIOUS SCHOLAR

1733

THE PORTRAIT OF AYUBA SULEIMAN DIALLO (1701–1773) in figure 42 was painted in 1733 in London, after the sitter had completed a life-altering journey that began two years earlier. In the portrait by William Hoare, Diallo wears traditional clothes, white robes, and a turban, dressed as he would have been in his native country of Senegal. Around his neck, a red-colored leather-bound Quran is suspended by a cord. While not traditional jewelry, the tome can be viewed in lieu of a pectoral or a large pendant.

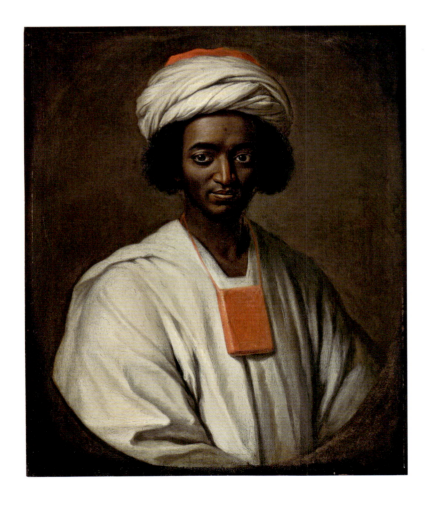

FIGURE 42 • William Hoare (British, 1707–1792), *Portrait of Diallo*, 1733. Oil on canvas, 76.2 × 63.5 cm (30 × 25 in.). Doha, Qatar Museums Authority, L245

IN SEARCH OF THE SPIRITUAL

Diallo, a member of the Fulbe ethnic group, came from a family of Muslim religious and political leaders and wrote and spoke Arabic. He was captured and sold into slavery while traveling on business in West Africa, his region of origin, and was taken to Maryland. He was tasked to work on a plantation but escaped and found himself in jail, and eventually was recognized as a pious and learned man.[35] A letter written in Arabic by him to his homeland ended up in England, where it was deciphered, and led unexpectedly to his freedom. James Oglethorpe, director of the Royal African Company, bought Diallo out of slavery, and he was brought to England in 1733.

On his voyage from the United States to England, Diallo learned English, and while in London, he translated Arabic texts into English. The display of the Quran as an emblem of faith is also a statement of his scholarly abilities. At the same time, the Quran, as displayed by Diallo, is reminiscent of protective amulets in the Muslim world, which have traditionally been in the shape of small leather pouches of varying shapes (called *kitab*, or "book" in Arabic; see fig. 30). Containing religious texts and formulas, they are believed to protect the faithful when worn. The painting of Diallo is as unique as his story: it is a rare egalitarian portrait of an African in England, a representation of a devout scholar of Islam, identified by the Quran worn in lieu of ornament, and as such, an uncommon depiction in the sphere of Islam, where images of humans are restricted.[36]

NOTES

1 Neil MacGregor, *Living with the Gods: On Beliefs and Peoples* (New York: Knopf, 2018).

2 Catherine C. Roehrig, "Cult Figure of a Falcon Headed Deity," in *Ancient Art from the Shumei Collection*, ed. Dorothea Arnold (New York: Metropolitan Museum of Art, 1996), 4–7, cat. 2.

3 Keith Christiansen, "The *Coronation of the Virgin*, by Gentile da Fabriano," *J. Paul Getty Museum Journal* 6/7 (1978): 1–12.

4 Edwin Hall and Horst Uhr, "Aureola Super Auream: Crowns and Related Symbols of Special Distinction for Saints in Late Gothic and Renaissance Iconography," *Art Bulletin* 67, no. 4 (1985): 567–603.

5 Andrew Bolton, Barbara Drake Boehm, Marzia Cataldi Gallo, C. Griffith Mann, David Morgan, Gianfranco Ravasi, David Tracy, and Katerina Jebb, *Heavenly Bodies: Fashion and the Catholic Imagination* (New York: Metropolitan Museum of Art, 2018), 2:108–9; and Tanya Dukes, "The Cross Returns as a Style Choice in Jewelry," *New York Times*, March 12, 2023, https://www.nytimes.com/2023/03/12/fashion/jewelry-cross-diana-madonna-1980s.html.

6 Dietrich Wildung, "Metamorphosen einer Königin: Neue Ergebnisse zur Ikonographie des Berliner Kopfes der Teje mit Hilfe der Computertomographie Author," *Antike Welt* 26, no. 4 (1995): 245–49.

7 Marianne Eaton-Krauss, "The 'Khat' Headdress to the End of the Amarna Period," *Studien zur altägyptischen Kultur* 5 (1977): 21–39.

8 Dorothea Arnold, *The Royal Women of Amarna* (New York: Metropolitan Museum of Art, 1996), 27–35; and Eaton-Krauss, "The 'Khat' Headdress to the End of the Amarna Period," 21–39.

9 Joanne Pillsbury, Timothy Potts, and Kim N. Richter, *Golden Kingdoms: Luxury Arts in the Ancient Americas* (Los Angeles: J. Paul Getty Museum, 2017), 151, cat. 32.

10 Walter Alva and Christopher B. Donnan, *Royal Tombs of Sipán* (Los Angeles: Fowler Museum of Cultural History, University of California, 1993).

11 Jeffrey Quilter, "Moche Politics, Religion, and Warfare," *Journal of World Prehistory* 16, no. 2 (2002): 145–95.

12 Phyllis Granoff, "Relics, Rubies and Ritual: Some Comments on the Distinctiveness of the Buddhist Relic Cult," *Rivista degli studi orientali* 81, fasc. 1/4 (2008): 59–72.

13. Oppi Untracht, *Traditional Jewelry of India* (New York: Harry N. Abrams, 1997), 304–11.

14. "Carter no.: 267d," Griffith Institute, http://www.griffith.ox.ac.uk/gri/carter/267d.html.

15. Eva-Maria von Kemnitz, *The Hand of Fatima: The Khamsa in the Arab-Islamic World* (Leiden: Brill, 2023); and Sheila Paine, *Amulets: A World of Secret Powers, Charms and Magic* (London: Thames and Hudson, 2004).

16. Maya Corry, Deborah Howard, and Mary Laven, *Madonnas and Miracles* (London: Philip Wilson, 2017), 134–35.

17. Pliny the Elder, *Natural History*, trans. H. Rackham, vol. IX, book XXXII.XI (London: Loeb Classical Library, 1938), available at https://www.loebclassics.com/view/pliny_elder-natural_history/1938/pb_LCL418.477.xml?readMode=recto.

18. Kurt A. Behrendt, *The Art of Gandhara in the Metropolitan Museum of Art* (New York: Metropolitan Museum of Art, 2007).

19. Pratapaditya Pal has raised questions, such as whether Maitreya, a divine being, appears to be expressing human vulnerability by wearing shoes and amulet cases. Pratapaditya Pal, "Reflections on the Gandhāra Bodhisattva Images," *Bulletin of the Asia Institute* 20 (2010): 101–15.

20. Susan Stronge, Nima Smith, and J. C. Harle, *A Golden Treasury* (Ahmedabad, India: Victoria and Albert Museum and Mapin, 1988), 13, fig. 17.

21. Phyllis Granoff, "Maitreya's Jewelled World: Some Remarks on Gems and Visions in Buddhist Texts," *Journal of Indian Philosophy* 26, no. 4 (1998): 347–71.

22. Tashi Tsering. "Jowo Śākyamuni," in *Jokhang: Tibet's Most Sacred Buddhist Temple*, ed. Gyurme Dorje, Tashi Tsering, Heather Stoddard, Andre Alexander, Ulrich van Schroeder, and His Holiness the Dalai Lama (New York: Thames and Hudson, 2010), 123–58.

23. Cameron David Warner, "Re/Crowning the Jowo Sakyamuni: Texts, Photographs, and Memories," *History of Religions* 51, no. 1 (2011): 1–30.

24. Granoff, "Maitreya's Jewelled World," 347.

25. Anne Richter, *The Jewelry of Southeast Asia* (New York: Harry N. Abrams, 2000), 54–57, fig. 35; and Robert Heine-Geldern, "Conceptions of State and Kingship in Southeast Asia," *Far Eastern Quarterly* 2, no. 1 (1942): 15–30.

26. In the nineteenth century, Cambodia was subjugated by Vietnam and Thailand, at times controlled by both; the two countries also took control of the sacred regalia. David P. Chandler, "Cambodia's Relations with Siam in the Early Bangkok Period: The Politics of a Tributary State," *Journal of the Siam Society (Bangkok)* 60, no. 1 (1972): 153–69. The crown is referred to as the Great Crown of Victory of Cambodia, *Preah Maha Mokot Reach*. See also Cristina Maza, "Trailing the King's Forgotten Crown Jewels," *Phnom Penh Post*, December 9, 2016, https://www.phnompenhpost.com/arts-culture/trailing-kings-forgotten-crown-jewels.

27. For a full discussion on ritual use of South Indian temple bronzes see Vidya Dehejia, Richard H. Davis, Irā Nākacāmi, and Karen Pechilis, *The Sensuous and the Sacred: Chola Bronzes from South India* (New York: American Federation of Arts, New York, 2002).

28. Dehejia et al., *The Sensuous and the Sacred*, 26–27.

29. For Indian temple jewelry, see Oppi Untracht, "Unique Vernacular Ornaments," in *Icons in Gold: Jewelry of India from the Collection of the Musée Barbier-Mueller*, ed. Laurence Mattet (Paris and Geneva: Somogy Art Publishers, 2005), 40–61; and Dehejia et al., *The Sensuous and the Sacred*, 223–39.

30. Christopher Key Chapple, "Jain Yoga: Nonviolence for Karmic Purification," in *Yoga: The Art of Transformation*, ed. Debra Diamond and Molly Emma Aitken (Washington, DC: Smithsonian Institution, 2013), 131–37.

31. Carolyn Diskant Muir, "St. Catherine of Alexandria," in *Saintly Brides and Bridegrooms: The Mystic Marriage in Northern Renaissance Art* (London: Harvey Miller, 2012), 17–47.

32. https://www.mountsinaimonastery.org/news-blog/2015/11/21/bride-of-christ-st-catherine-of-alexandria-november-25.

33. Anna Beatriz Chadour, *Ringe–Rings: The Alice and Louis Koch Collection*, vol. 2 (Leeds, UK: Routledge, 1994), no. 1523, 472.

34. Papal portraits flourished in the Renaissance and Baroque periods, providing rich information on the sitters, and are often laden with symbols and allegories comparable to representations of secular rulers. Jan L. De Jong, *The Power and the Glorification: Papal Pretensions and the Art of Propaganda in the Fifteenth and Sixteenth Centuries* (University Park: Pennsylvania State University Press, 2013).

35. Marcia Pointon, "Slavery and the Possibilities of Portraiture," in *Slave Portraiture in the Atlantic World*, ed. Agnes Lugo-Ortiz and Angela Rosenthal (Cambridge: Cambridge University Press, 2013), 41–69.

36. In 1734, Diallo's memoir was published and he returned to West Africa. Thomas Bluett, *Some Memoirs of the Life of Job, the Son of Solomon, the High Priest of Boonda in Africa, who was a slave about two years in Maryland, and afterwards being brought to England, was set free, and sent to his native land in the year 1734* (London: printed for Richard Ford, 1734).

CHAPTER 3

FOR THOSE WE LOVE AND MOURN

Yvonne J. Markowitz

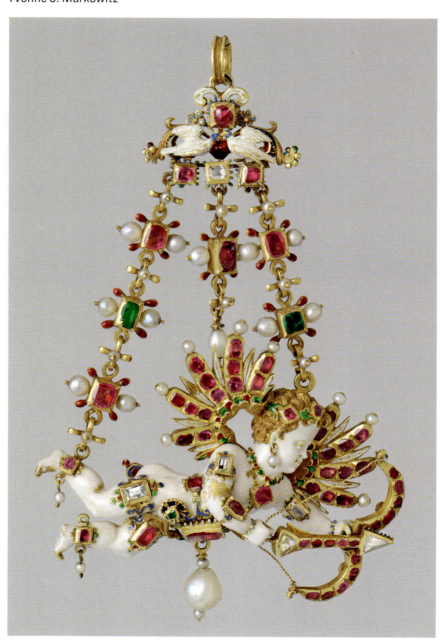

FIGURE 43 • Pendant with Cupid and billing doves, German, about 1600. Gold, enamel, pearl, emerald, and ruby, 10 × 6.8 cm (3¹⁵⁄₁₆ × 2¹¹⁄₁₆ in.). Rijksmuseum, Amsterdam, BK-17052

JEWELRY CAN BE A MANIFESTATION OF LOVE, friendship, personal grief, or collective loss. Although not equally represented among world cultures, adornments evocative of these sentiments were common in Europe and North America from the sixteenth through the nineteenth century. In the case of amorous yearnings, precursors of these expressions can be found in the literature of the ancient world, including the love poetry of Egypt's New Kingdom (1539–1077 BCE). In one impassioned poem preserved in the Papyrus Chester Beatty I, the author refers to his beloved as "Shining bright, fair of skin / Lovely the look of her eyes / Sweet the speech of her lips / She has not a word too much. / Upright neck, shining breast / Hair true lapis lazuli / Arms surpassing gold / Fingers like lotus buds."[1] Sexual longing and eroticism are also expressed in the biblical Song of Songs[2] and the sybaritic shenanigans of classical Erotes, which likely involved jewelry, as ancient literature refers to it. In turn, gods like Eros become embodiments of love, referenced symbolically by jewelers. Fertility deities such as the Egyptian frog goddess Heket, the Egyptian feline goddess Bastet, the Greek goddess Aphrodite, and their associated objects[3] were also commonly referenced by jewelers well into the twentieth century. Cupid with his arrow (fig. 43), the doves of Venus, and flaming hearts are but a few of the emblems and attributes incorporated into adornments readily identified as tokens of affection.

Jewelry can likewise serve as a commemoration of personal grief or collective loss. Although mourning adornments, whose roots go back to fifteenth-century England, were typically commissioned by individuals in memory of close friends and relatives,[4] the death of a beloved public figure has sometimes been memorialized with the issuing of a quantity of memorial jewelry and ephemera.[5] In this case, the jewelry was part of a larger, communal experience of mourning, and identified the wearer as among the bereaved.

FOR THOSE WE LOVE AND MOURN

"LET NO MAN PUT ASUNDER": THE LUTHER MARRIAGE RING 1525

ALTHOUGH ROMANCE, LOVE, AND PHYSICAL YEARNINGS between the sexes are well documented in the arts and literature of the ancient world, the topics of betrothal and conjugal union are less frequently addressed.[6] An exception is the "sacred marriage" between the Sumerian deities Inanna and Dumuzi (later known as Ishtar and Tammuz).[7] Their ardent proclamations of love and fulfillment predated what would later evolve into a contractual relationship based on practical concerns, including the transfer of property, familial stability, and a guarantee that a man's children are his biological heirs.

The contractual nature of marriage in modern Western culture was established in Roman times and addressed both the ethical and the legal principles governing the institution.[8]

Among these were the age of lawful consent, monogamy, the sharing or allocation of property, and the legal standing of women. Symbolizing this arrangement is the betrothal or marriage ring with clasped right hands (*dextrarum iunctio*). A typical example features an oval cameo bezel-set in a gold mount (fig. 44). The raised, joined hands in the center of the carved stone represent not only friendship but also a legally binding agreement.[9] Below the hands, the inscribed word "OMONOIA" (harmony) alludes to the Greek Harmonia (Roman Concordia), goddess of concord and peace, who sometimes appeared on coins and medallions commemorating the marriages of imperial couples.[10]

Betrothal or wedding rings with clasped hands, here known as *fede* rings (from the Italian meaning "trust"), were also popular in Europe from the late medieval period and the Renaissance through the nineteenth century. During the fifteenth century, the clasped hands were sometimes a design element placed along the back of the ring shank (hoop) and the front of the ornament was set with a gemstone. Also popular were rings inscribed with "posies"—short poetic texts of an affectionate or religious nature often written in Latin or French, the languages preferred by the educated classes. Many of these latter rings were simple bands, including a fourteenth-century ornament with an engraved inscription on the surface derived from a motto woven into a ribbon attached to the seal of the twelfth-century king Richard I (fig. 45). The Lombardic inscription reads: "IOSVI : DE : DRVERIE : NE : ME : DVNE : MIE" (I am a love gift, do not give me away).

FIGURE 44 • Ring with cameo of clasped hands, Roman, Imperial period, 3rd century CE. Gold and sardonyx, 1 × 2.3 × 1.9 cm (⅜ × ⅞ × ¾ in.). Museum of Fine Arts, Boston, gift of Robert E. Hecht, Jr., in memory of Robert E. Hecht, Sr., and Julia K. Hecht, 63.1555

FIGURE 45 • Posey ring, English, about 1300–1350. Gold, 1.9 × 1.9 × 0.3 cm (¾ × ¾ × ⅛ in.). London, Victoria and Albert Museum, M.60-1960. Given by Dame Joan Evans

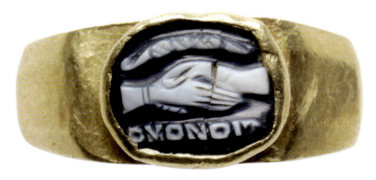

FIGURE 46 • Gimmel ring, German, 16th century. Gold, enamel, ruby, and emerald, 2.8 cm (1⅛ in.) in diameter. London, British Museum, AF.1096

This gimmel ring bears a Latin inscription that references the biblical admonition "What God has joined together, let no man put asunder" (Matthew 19:6).

A different betrothal and/or wedding ring popular in parts of Europe from the fifteenth through the seventeenth century was the gimmel ring (from the Latin *gemellus*, meaning "twin"), a finger ornament composed of two or three separate hoops forming a single shaft, linked together at the base so as to be capable of fanning open.[11] Bezel designs were either clasped hands or precious gems, especially rubies and diamonds—stones traditionally associated with love and permanence. The most elaborate examples also bore inscriptions engraved on the flattened facing sides of the hoops (fig. 46).[12]

Possibly the most famous gimmel ring is the one associated with the German reformer and seminal figure of the Protestant Reformation, Martin Luther (1483–1546), and his future wife, Katharina von Bora (1499–1552).[13] It has been purported that the ring, whose design is credited to Luther's close friend the artist Lucas Cranach the Elder (1472–1553), was made of gold recycled from an earlier ring, as Luther had no ready funds to cover the cost.[14] The marriage took place

FOR THOSE WE LOVE AND MOURN

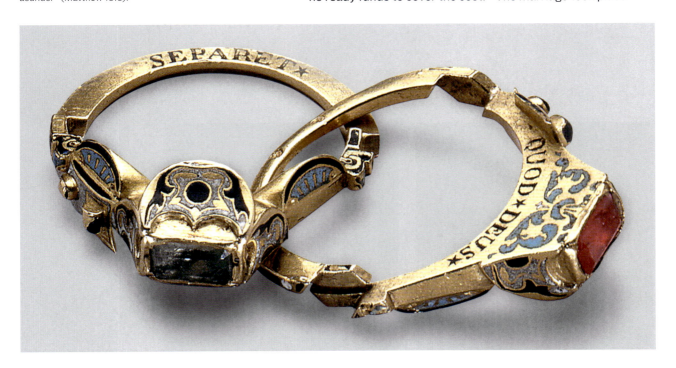

in Wittenberg, Germany, on June 13, 1525, and was vociferously criticized by the Roman Catholic Church, as Luther, a former monk, and Katharina, a former nun, had previously taken vows of celibacy.

Much has been written about the fate of the Luther marriage ring. In fact, two forms of the ring have been described by several scholars, including George F. Kunz, a US gemologist who reports on both. The first was described as a gold ring set with a small ruby and engraved with the text "D. Martinus Lutherus Catharina v Boren / 13 Jun 1525." It is purported to feature "a high relief representation of the crucifixion and the instruments of the Passion: the pillar, scourge, spear, etc."[15] According to jewelry historian Beatriz Chadour-Sampson, this description matches a ring in the Stadtgeschichtliches Museum Leipzig, Germany.[16]

Kunz also describes a second ring that may have been the Luther marriage ring:

> This is of the type of gimmel rings, divisible but not separable. On one loop the setting is a diamond, on the other is a ruby. The bezel separates into two halves when the ring is opened, and reveals on the two hidden sides the initials *CVD* and *MLD* for Katharina von Bora and Martin Luther, Doctor. On the inner side of the conjoined hoops is the inscription *Was Got zusamen*

FIGURE 47 • Lucas Cranach the Elder (German, 1472–1553), *Portrait of Katharina von Bora*, ca. 1526. Oil on panel, 22.6 × 16 cm (8⅞ × 6¼ in.). Eisenach, Germany, Wartburg-Stiftung, M0064

FIGURE 48 • Lucas Cranach the Elder (German, 1472–1553), *Portrait of Martin Luther*, ca. 1526. Oil on panel, 22.5 × 16.5 cm (8⅞ × 6½ in.). Eisenach, Germany, Wartburg-Stiftung, M0065

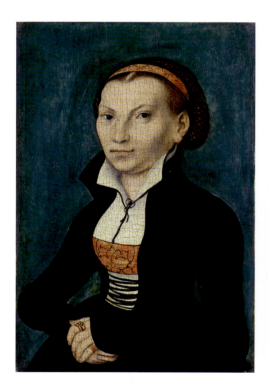
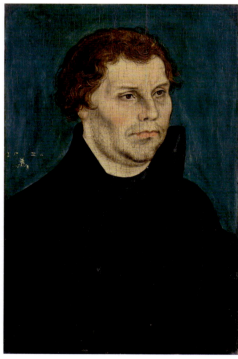

fiegt sol kein mensch scheiden (Those whom God hath joined, shall no man put asunder). The diamond is on the Luther side of the divided bezel, and signifies power, durability, and fidelity; the ruby on the side marked with the wife's initials is taken to mean exalted love.[17]

The German inscription is of special significance, in that it is written in the vernacular, a reference to one of the reformer's most important undertakings: the translation of the Greek New Testament into German, a feat that made the Bible more accessible to the laity.

Although the whereabouts of the original Luther gimmel ring are unknown,[18] several early nineteenth-century reproductions attest to the design described by Kunz. A portrait of Katharina, one of several painted by Cranach around the time of her marriage, shows her wearing several rings on her left hand (fig. 47). None appears to be the ruby-set ring or the gimmel, so it is possible that the painting was executed before the bespoke commission was completed. A painting of her husband made at the same time (fig. 48) depicts the middle-aged theologian wearing a high-necked garment devoid of ornamentation, a fitting presentation for one highly critical of what he believed were the ostentatious trappings of the Catholic Church.

AN EXCHANGE OF HAIR BETWEEN FRIENDS

1812

OBJECTS THAT MEMORIALIZE A LOVED ONE or a cherished leader form an important part of European and North American material culture. Although historians view memorializing keepsakes and adornments as relative newcomers in the decorative arts, there are several antecedents. One of the most intriguing is a lock of hair (a traditional symbol of remembrance) recovered from the tomb of Tutankhamun (ca. 1341–ca. 1323 BCE), the ancient Egyptian boy king. The brown lock of hair, found in a miniature coffin inscribed for his grandmother the influential Queen Tiye, has been described by Egyptologists as "an affectionate memento."[19] Centuries later, it would be the height of mourning fashion to wear ornaments with compartments designed to encapsulate strands of hair of the recently departed.[20] As time passed, it also became fashionable for close friends to exchange such ornaments for sentimental reasons.

The fellowships and tensions between the United States' founding families are rarely addressed in written accounts of the times. Considering the complexities and compromises involved in forging a new government and the forceful, independent personalities involved, it is remarkable that despite differences of opinion, there was general agreement, or at least compromise, on major issues. But one personal feud we do know about—that between John (1735–1826) and Abigail Adams

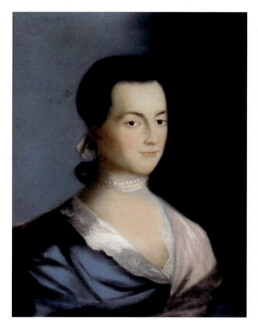
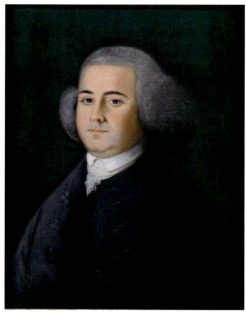

FIGURE 49 • Benjamin Blyth (American, 1746–1811), *Abigail Adams (Mrs. John Adams)*, ca. 1766. Pastel on paper, 57 × 44.3 cm (22 3/8 × 17 1/2 in.). Boston, Collection of the Massachusetts Historical Society, 01.026

FIGURE 50 • Benjamin Blyth (American, 1746–1811), *John Adams*, ca. 1766. Pastel on paper, 57 × 44.5 cm (22 3/8 × 17 1/2 in.). Boston, Collection of the Massachusetts Historical Society, 01.027

(1744–1818) and Mercy Otis Warren (1728–1815)—offers insight into how jewelry can bridge the gap between fractious parties, and even symbolize the bond between close friends.

Abigail Adams (fig. 49) was the quintessential revolutionary woman of her age. Born into a New England family with deep colonial roots, the future wife of the second US president, John Adams (fig. 50), read extensively and maintained a lively literary correspondence with friends and relatives.[21] In their first eight years of marriage, as tensions between England and the colonies escalated, Abigail bore five children and John built his law practice, participated in local politics, and wrote newspaper articles on constitutional matters. He made headline news with his successful defense of British soldiers arrested on murder charges resulting from the Boston Massacre. He later served as a Massachusetts delegate to the First Continental Congress in Philadelphia, helped draft the Declaration of Independence, and was the chief author of the Massachusetts State Constitution, the last document that served as the model for the US Constitution. He was a member of the Federalist Party, whose supporters called for a strong centrist government, friendly relations with Britain (rather than revolutionary France), a national bank, and fiscal conservatism.

Another luminary of the colonial and revolutionary periods was Mercy Otis Warren (fig. 51), a Massachusetts poet, playwright, and historian who used her considerable talents to inform and arouse the colonists as they endured a litany of injustices under British rule. Her husband, James Warren

FIGURE 51 • John Singleton Copley (American, 1738–1815), *Mrs. James Warren (Mercy Otis)*, ca. 1763. Oil on canvas, 126.1 × 100. 3 cm (49⅝ × 39½ in.). Museum of Fine Arts, Boston, Bequest of Wilson Warren, 31.212

FIGURE 52 • Mercy Otis Warren brooch, ca. 1812. Gold, seed pearl, hair, and crystal, 1.3 × 2.5 × 1.1 cm (½ × 1 × ½ in.). Boston, Collection of the Massachusetts Historical Society, 01.041

FIGURE 53 • John and Abigail Adams ring, ca. 1812. Gold, seed pearl, hair, and crystal, 1.6 × 2.4 × 2.4 cm (⅝ × 1 × 1 in.). Boston, Collection of the Massachusetts Historical Society, 01.040

(1726–1808), a Massachusetts lawyer and merchant who served as speaker of the Massachusetts Provisional Congress and paymaster general of the Continental Army during the Revolutionary War, was also committed to the cause.[22] Both were early advocates of the move toward independence; later they would strongly endorse an anti-Federalist position. Together, they eloquently expressed their fear that the formation of a powerful presidency would lead to a return to monarchy as well as the creation of an unmanageable judiciary.

Despite their geographic proximity and shared interests, it was not until 1772 that the Adamses and Warrens met as couples.[23] Over the next decade, as resistance segued into rebellion and revolution, these patriots came together often and maintained a steady stream of correspondence. As the ratification of the Constitution was debated, Mercy Warren came to believe that John Adams had been unduly influenced by the trappings of monarchy during his stay in England. In her three-volume publication *History of the Rise, Progress, and Termination of the American Revolution* (1806), she voiced her criticism of certain aspects of his presidency. John saw it as a personal attack and did not hesitate to respond in a series of letters aimed at addressing her "inaccuracies."[24]

After several years of silence, a friend engineered a reconciliation. Two ornaments containing hair commissioned by Abigail Adams are testimony to their renewed friendship.[25] Both are representative examples of Federalist-style jewelry (American jewelry dating to the early days of the New Republic, roughly 1790 to 1820),[26] but they are unique in that the story behind them is steeped in early US history and the identities of some of the era's major players. The first, a gold rectangular brooch in the Georgian style, contains a lock of hair that Mercy sent to Abigail (fig. 52). Surmounting the plaited hair in the central compartment are the initials "MW." Both the hair and gold-foil monogram are protected by a cabochon crystal

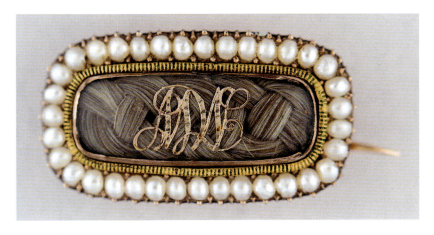
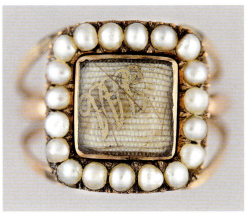

bordered by thirty-five seed pearls. The reverse, composed of an unadorned, gold-sheet backing, a hinged pin, and a C hook, is also convex. The second ornament (fig. 53), a gold finger ring, contains the combined hair of John and Abigail Adams and their initials, "JAA," in gold foil. Given to Mercy Warren circa 1812, the square bezel with pearl surround and tripartite band represents a ring style popular during the first quarter of the nineteenth century. A letter from Mercy to Abigail upon receipt of the ring illustrates the depth of feeling associated with this exchange of "true friendship":

Plymouth Ms Janry 26th 1813

My dear Madam
Your every friendly Letter under date Decr 30th came safe to hand with its inclosure [sic], within a few days after date, and would have been earlier acknowledged, but for intervening circumstances needless to relate.—

I shall with pleasure wear the ring, as a valuable expression of your regard; —nor, will it be the less valued for combining with yours, a lock of hair from the venerable and patriotic head of the late President of the United States.—This, being at his own request, enhances its worth in my estimation. —For this I thank him.

While I view this testimonial of their regard, I shall be daily reminded from whose heads the locks were shorn—friends who have been entwined to my heart by years of endearment, which, if in any degree interrupted by incalculable circumstances, the age of us all now reminds us, we have more to think of, than the partial interruptions of sublunary friendships. —

My name has ever been engraves [sic] on the heart of Mrs. Adams, and when she informs me, she has placed the initials of my name on the faded lock I gave her, and means to wear it on her bosom as an external mark of her regard, it cannot but be pleasing to the mind who considers true friendship, as one of the best cordials of human life, and wishes a re-union of those hereafter, which have been formed, continued, and still exist in sincerity and truth. —May ours be prepared and sublimated for an existence in endless peace! —

I shall bear in my recollection, the very agreeable promise you made in the close of your last, that if the "Spring should find you well and your friend also," you would again visit Plymouth, and as in former days, hold sweet converse together. —A visit from two such aged friends would be gratifying indeed. —

Mr Adams with yourself will accept the respect & regard / of Your Friend,

M Warren[27]

MOURNING LINCOLN
1865

FIGURE 54 • "A Nation's Loss" Abraham Lincoln mourning ribbon, 1865. Silk, 14 × 7 cm (5½ × 2¾ in.). Harrogate, TN, Abraham Lincoln Library and Museum, Lincoln Memorial University

ABRAHAM LINCOLN REMAINS ONE OF THE MOST admired and idealized US presidents. His death on April 15, 1865, was a momentous national event whose impact has often been compared to the assassination of John F. Kennedy nearly a century later. In both cases, the outpouring of grief was immediate, and many would remember for the rest of their lives where and when they received the shattering report.[28]

The news that the body was to pass through seven states and dozens of cities on its way from Washington, DC, to Springfield, Illinois, for interment sent entrepreneurs scurrying to sell mourning ribbons, badges, and wreaths to grief-stricken Americans (fig. 54). The badges that first appeared on the market adapted ambrotypes, tintypes, and ferrotypes of Lincoln used during the 1864 presidential campaign and fastened them to black crepe rosettes, silk ribbons, and base-metal (non-precious) findings (pins, backings, suspension hoops, etc.). The May 6 issue of Harper's Weekly, which contained several advertisements offering Lincoln ephemera, was probably one of the earliest to carry ads for such decorations. Over time, the most prized among the items available to mourners were official medals bearing an image of the fallen president. These medals, commissioned by the US government, had their origin in the Revolutionary War era; by the time of Lincoln's death, the striking of commemorative presidential medals by the US Mint had become an established tradition. On April 25, Congress commissioned one hundred small silver medals designed by the German-born artist Anthony C. Paquet (1814–1882), who served as an assistant engraver at the US Mint in Philadelphia from 1857 to 1865. Each featured a profile bust of Lincoln in high relief on the front, and on the reverse the inscription "BORN / FEB. 12, 1809 / ASSASSINATED / APRIL 14, / 1865" within a wreath of oak leaves (fig. 55). The item proved popular, and several hundred more were produced that fall and winter. The reverse of these later medalets differed in that a broken column with a scroll, symbolizing the Emancipation Proclamation, replaced the inscription.[29]

The day after Lincoln's death, Easter Sunday, came to be known as Black Easter. In churches, holy day vestments were replaced with black fabrics and analogies were made between the sacrificial Christ and the fallen president. During Mary Lincoln's protracted period of bereavement, she frequently wore two items of jewelry: a pendant watch made of black onyx in bold, geometric segments (figs. 56, 57) and an onyx and diamond ring.[30] For her, they had profound personal associations with departed loved ones; for those in her orbit, they were poignant reminders of the passing of a beloved president and the thousands of Americans lost to war and war-related maladies (infected wounds, typhoid, malaria). In these tragedies, the United States was united in grief.

FIGURE 55 • Anthony C. Paquet (American, b. Germany, 1814–1882), Abraham Lincoln commemorative medalet, 1865. Gold, silver, enamel, and crystal, 3.2 × 2.5 × 0.63 cm (1¼ × 1 × ¼ in.). Quirk Family Collection

FIGURE 56 • Mary Lincoln's mourning watch, 1860s. Gold, onyx, enamel, and crystal, 11.4 × 3.8 cm (4½ × 1½ in.). Washington, DC, National Museum of American History, Smithsonian Institution, gift of Lincoln Isham, great-grandson of Abraham Lincoln, 1958, 22575

Lapel watches were popular timepiece adornments worn by women in the nineteenth century.

FIGURE 57 • Mathew Brady Studio (American, active 1844–83), *Mary Todd Lincoln*, ca. 1863. Albumen silver print, 8.6 × 5.3 cm (3⅜ × 2 in.). Washington, DC, National Portrait Gallery, Smithsonian Institution

Mary Lincoln experienced major losses during her lifetime. Here she is shown in mourning attire after the death of her eleven-year-old son, Willie, in 1862. Three years later, Abraham Lincoln was assassinated, and Mary remained in mourning for the rest of her life.

FIGURE 58 • One of several charm bracelets owned by Queen Victoria, 19th century. Gold, enamel, diamond, and pearl, 10.3 × 2.2 cm (4 × 7/8 in.). London, Royal Collection Trust, RCIN 65290

FOR THOSE WE LOVE AND MOURN

THE DUCHESS OF WINDSOR'S CHARM BRACELET

1934–1944

ALTHOUGH CHARM BRACELETS ARE OFTEN considered a mid-twentieth-century phenomenon, their rise in popularity traces back to the nineteenth century. Britain's Queen Victoria (1819–1901), known for her love of jewelry, was no doubt instrumental in their widespread appeal, as she was especially fond of bejeweled keepsakes, wearable mementos, and ornaments with sentimental messaging.[31] For her, the charm bracelet served as a tangible reminder of loved ones (living and departed) and events associated with poignant memories. She owned several of these ornaments, including a favorite that was displayed in the Albert Room at Windsor Castle after her death (fig. 58).

The 1920s and 1930s witnessed a renewed interest in the charm bracelet. The finest examples, designed and sold

internationally by Cartier and Oscar Heyman & Brothers in the United States, were made of platinum with gem highlights (fig. 59). Many were sold with a complete set of theme-related charms featuring popular sporting activities or transportation symbols—images that reflected the era's preoccupation with movement, speed, and progress. By the beginning of the 1950s, the trend was for women to "create" their own bracelets with a personal selection of charms added to over time, making each bracelet a unique personal record, a sort of portable autobiography with a distinct narrative quality. They were also a rich source of cultural information, making visible certain aspects of a woman's life as expressed through a shared set of meanings and symbols.[32]

An exceptional example was owned by First Lady Mamie Eisenhower (1896–1979), a woman who avoided high-style couture but whose favorite charm bracelet was bespoke (fig. 60). Composed of thirty-five gold charms, it documented important events in the career of her illustrious husband, Dwight D. Eisenhower (1890–1969). Included are several military emblems, the former general's five stars, a miniature jeep with "IKE" on the hood, an openwork NATO commemo-

FIGURE 59 • Oscar Heyman & Brothers, designer (American, founded 1912), charm bracelet, 1920s or 1930s. Platinum, diamond, sapphire, ruby, and emerald, 16.5 cm (6½ in.) in length. New York, Vartanian & Sons

FIGURE 60 • Mamie Eisenhower's charm bracelet, 1940s–1950s. Gold and enamel, approx. 17.8 cm (7 in.) in length. Abilene, Kansas, Dwight D. Eisenhower Museum

Marcel Jewelers in New York was one of the largest retailers of gold charms during the 1950s, the golden age of the charm bracelet.

rative,[33] an Ike campaign charm, and a miniature White House with the inaugural date of "1-20-53." The paperclip-link bracelet dates to the 1930s, while the charms were assembled over several decades. It is not lost on us today that these charms were essentially identifying and defining a woman's role in society through the accomplishments of her spouse. But on another level, the achievements of one's significant others were, and still are, often regarded as one's personal successes.

The charm bracelet worn by the fashion icon and future Duchess of Windsor Wallis Simpson (1896–1986) on her wedding day, June 3, 1937, was a compilation of a series of gifts from the heir to the British throne, the Prince of Wales, who reigned briefly as King Edward VIII in 1936 (figs. 61, 62).[34] Having met at a friend's weekend gathering outside London, the twice-divorced American and the dashing prince would soon embark on a semi-clandestine, tumultuous romance that began in the early 1930s, endured through a constitutional crisis that culminated in the king's abdication, and segued into decades of married life outside England as the Duke and Duchess of Windsor.

FOR THOSE
WE LOVE
AND MOURN

FIGURE 61 • Cecil Beaton (British, 1904–1980), Wallis Simpson wearing her Cartier cross bracelet, 1937. Photograph. London, National Portrait Gallery

FIGURE 62 • Cartier, designer (French, founded 1847), Duchess of Windsor pendant-cross charm bracelet, 1934–44. Platinum, diamond, emerald, sapphire, ruby, aquamarine, and amethyst, 19 cm (7½ in.) in length. Private collection

The wedding-day bracelet, one of the most recognizable pieces of jewelry of the twentieth century, is composed of seven Latin crosses (known as the *crux Immissa*, one of the oldest Christian symbols) suspended from a metal chain encircling the wrist (the chain was later replaced by a diamond-set platinum wristlet, and two more crosses were added in 1944). All were custom made by the international high-style jeweler Cartier.[35] Each pendant is set with gems except for the earliest, which is made of undecorated platinum. What distinguishes the bracelet from others in the genre are the inscriptions engraved on the underside of each cross. These notations, all of them dated, denote intimate events in the lives of the lovers. The inscriptions themselves are facsimiles of handwritten text and include:

- A platinum cross inscribed *WE are too 24-XI-34* (a pun referring to Wallis and Edward and possibly the upcoming wedding of the prince's brother George, Duke of Kent)
- A cross set with calibré-cut[36] sapphires and inscribed *Wallis—David 23.6.35* (Edward's forty-first birthday)
- A cross set with calibré-cut rubies and inscribed *Wallis—David St Wolfgang 22.9.3(5)* (referencing a trip the couple made to the Austrian town of St. Wolfgang im Salzkammergut)
- A cross set with baguette diamonds and inscribed *The Kings [sic] Cross and God bless WE 1-3-36* (possibly referring to Wallis's departure from London for Paris on March 1, 1936, about six weeks after Edward began his short reign)
- A cross set with calibré-cut emeralds and inscribed *X Ray Cross Wallis—David 10.7.36* (referring to an X-ray that revealed Wallis's healed ulcer)
- A cross set with calibré-cut aquamarines and inscribed *God save the King for Wallis 16.VII.36* (perhaps a reminder of an Irish journalist's attempt to assassinate Edward on July 16, 1936)[37]
- A cross set with calibré-cut sapphires, emeralds, a calibré-cut ruby, and a baguette diamond and inscribed *Our marriage Cross Wallis 3.VII.37 David* (the couple was married at the Château de Candé, Monts, France, on July 3, 1937)
- A cross set with calibré-cut amethysts and inscribed *Appendectomy Cross Wallis 31-VIII-44 David* (referencing the surgery Wallis underwent at Roosevelt Hospital in New York on August 31, 1944)
- A cross set with calibré-cut yellow sapphires and inscribed *"Get Well" Cross Wallis Sept. 1944 David* (referring to Wallis's recovery from her appendectomy)

Wallis Simpson's charm bracelet was created when such things were on the cutting edge of fashion in Britain, continental Europe, and the Americas. While this particular bracelet has come to symbolize the excitement, devotion, and personal

sacrifices associated with enduring love, the reality of the marriage, as disclosed in recently revealed documents, suggests otherwise.[38] The romance, it appears, was more ephemeral than the jewelry.

AMERICAN REQUIEM: 3047.9.11.2001

DANIEL JOCZ (1943–2023), A BOSTON-BASED SCULPTOR, jeweler, and educator,[39] revived the concept of mourning jewelry in response to the devastating destruction and human loss caused by the terrorist attack on New York's World Trade Center on September 11, 2001 (fig. 63). His unique reaction to the event—the creation of a series of six brooches designed to be mounted together in a shadow-box frame—bears the title *American Requiem: 3047.9.11.2001* (figs. 64–69), with the numerical subtitle referencing the date of the attack and what was then the reported casualty figure (more recent accounts cite 2,977 deaths). Unlike traditional mourning adornments that incorporate widely held symbols of loss and grief, Jocz's opus transformed a communal experience into a powerful expression of his private turmoil and sorrow; each brooch in the series is an abstracted representation of his subjective response to a collective loss rather than the memorialization of a specific individual, and instead of deploying a shared vocabulary of symbols or traditional mourning materials, invented imagery is conveyed using a range of materials and techniques.

In creating this evocative work, Jocz was inspired by the musical structure of the requiem, a hymn used in the Roman

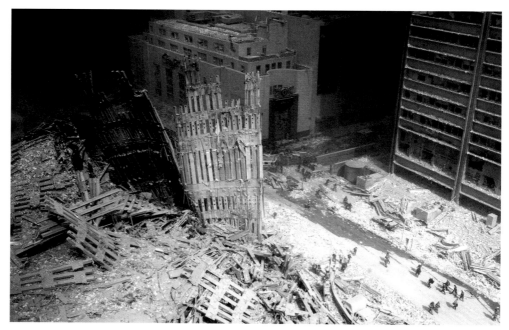

FIGURE 63 · Firefighters walk amid rubble near the base of the destroyed South Tower of the World Trade Center, New York, September 11, 2001.

FIGURE 64 • Daniel Jocz, (American, 1943–2023), *Requiem Aeternum* (American Requiem 3047.9.11.2001), 2002. Silver and 23-karat gold leaf, 7.6 cm (3 in.) in width. Museum of Fine Arts, Boston, The Daphne Farago Collection, 2013.1697

Inspired by Hector Berlioz (French, 1803–1869), *Requiem (Grande Messe des Morts)*, opus 5 (1837):

Eternal rest give unto the dead, O Lord
And let perpetual light shine upon them
Eternal rest give unto them, O Lord
And let perpetual light shine upon them

FOR THOSE WE LOVE AND MOURN

FIGURE 65 • Daniel Jocz, (American, 1943–2023), *Dies Irae and Tuba Mirum* (American Requiem 3047.9.11.2001), 2002. Silver, 14-karat gold, and sapphire, 7.6 cm (3 in.) in width. Museum of Fine Arts, Boston, The Daphne Farago Collection, 2013.1698

Inspired by Hector Berlioz (French, 1803–1869), *Requiem (Grande Messe des Morts)*, opus 5 (1837):

This day, this day of wrath
Shall consume the world in ashes
A trumpet, spreading a wondrous sound
Through the graves of all lands,
Will drive mankind before the throne.
Death and Nature shall be astonished
When all creation rises again
To answer to the judge.

FIGURE 66 • Daniel Jocz, (American, 1943–2023), *Libera Me* (American Requiem 3047.9.11.2001), 2002. Silver and glass beads, 8.2 cm (3¼ in.) in width. Museum of Fine Arts, Boston, The Daphne Farago Collection, 2013.1699

Inspired by Giuseppe Verdi (Italian, 1813–1901), *Messe da Requiem* (1874):

Deliver me, O Lord, from death eternal in that awful day
When the heavens and the earth shall be moved,
When Thou shalt come to judge the world by fire…
Eternal rest grant unto them, O Lord,
And let perpetual light shine upon them.

FIGURE 67 • Daniel Jocz, (American, 1943–2023), *Hostias* (American Requiem 3047.9.11.2001), 2002. Fine and sterling silver and 22-karat gold granulation, 6.4 cm (2½ in.) in width. Museum of Fine Arts, Boston, The Daphne Farago Collection, 2013.1700

Inspired by Wolfgang Amadeus Mozart (Austrian, 1756–1791), *Requiem* (unfinished):

We offer unto Thee this sacrifice of prayer and praise
Receive it for those souls whom we today commemorate
Allow them, O Lord, to cross from death into the life which once
Thou didst promise to Abraham and his seed.

FIGURE 68 • Daniel Jocz, (American, 1943–2023), *Offertorium Domine* (American Requiem 3047.9.11.2001), 2002. Silver, 18-karat gold, and paint, 8.2 cm (3¼ in.) in width. Museum of Fine Arts, Boston, The Daphne Farago Collection, 2013.1701

Inspired by Wolfgang Amadeus Mozart (Austrian, 1756–1791), *Requiem* (unfinished):

O Lord, deliver the souls of all the departed faithful
From the torments of hell and the bottomless pit;
Deliver them from the mouth of the lion.

Catholic Mass to commemorate the dead, and he planned the series as a composition made up of successive "movements." The title of each brooch makes reference to a verse from either Hector Berlioz's *Requiem (Grande Messe des Morts)*, opus 5, Giuseppe Verdi's *Messe da Requiem*, or Wolfgang Amadeus Mozart's *Requiem*. When mounted in its custom frame, the brooches form two rows of three pins that can be read from left to right, as one would a hieroglyphic text.

FIGURE 69 • Daniel Jocz, (American, 1943–2023), *Agnes Dei* (American Requiem 3047.9.11.2001), 2002. Silver and 18-karat gold, 6.8 cm (2¾ in.) in width. Museum of Fine Arts, Boston, The Daphne Farago Collection, 2013.1702

Inspired by Hector Berlioz (French, 1803–1869), *Requiem (Grande Messe des Morts)*, opus 5 (1837):

Lamb of God, who takest away the sins of the World, grant them everlasting rest.
Thou, O God, praised in Sion and unto
Thee shall the vow be performed in Jerusalem.
Hear my prayer, unto Thee shall all flesh come.
Grant them eternal rest, O Lord, and may perpetual Light shine upon them, with Thy saints forever,
Lord, because Thou are merciful. Amen.

To make this complex work more accessible to a potential wearer or viewer, Jocz wrote a brochure explaining his intentions. The text describes how distraught he was after the 9/11 attacks and how his "emotions finally manifested themselves in a creative way. What I saw in my mind's eye was a small piece of paper bleeding. This notion, of a sheet of paper emitting a singular emotion, eventually became a series of silver tablets on which I could interpret my feelings."[40] The first of his "tablets" is a sheet of burned metal with tattered edges designed to depict toppling girders, two of which suggest a Christian cross, an allusion to death and sacrifice. The second, a distorted city-like grid of burned silver with gold flecks, recalls the immediate impact of the attacking planes on the buildings. The third consists of a dull silver rectangle with crimson glass droplets that appear to ooze out of the metal, a representation of pain and loss. The fourth, which features darkened fragments of silver highlighted by granulated gold X's, symbolizes the souls of the deceased rising from a damaged earth. The fifth pin, a shimmering sheet of blackened silver with applied wires of gold, signifies hope. And the final brooch, a restored grid with multiple five-pointed gold stars representing rising souls, completes the cycle.[41]

For those who lived through 9/11 and its aftermath, seeing the brooches may arouse vivid memories and feelings. Some may sense an immediate, unspoken connection with the artist. Others may view the work more as a compelling public memorial based on a shared human experience. The brooches, installed in their shadow-box mount, are in the permanent collection of the Museum of Fine Arts, Boston, and thus function similarly in some respects to the artist Maya Lin's Vietnam Veterans Memorial in Washington, DC.

NOTES

1. "A Cycle of the Seven Stanzas," Papyrus Chester Beatty I, reproduced in Miriam Lichtheim, *Ancient Egyptian Literature: The New Kingdom II* (Los Angeles: University of California Press, 1976), 182. The papyrus is located in the Chester Beatty library and gallery, Dublin.

2. Attributed to Israel's third monarch, King Solomon, the sensual and lyrical text known as the Song of Songs most likely dates to around the third century BCE. See Patrick Hunt, *Poetry in the Song of Songs: A Literary Analysis* (New York, Washington, DC, and Baltimore: Peter Lang, 2008), 5.

3. For example Aphrodite, the ancient Greek goddess of love, is often shown with a scallop shell, doves, an apple, or myrtle leaves.

4. Mourning jewelry, especially rings, was sometimes paid for by the person commemorated or by heirs specified in the deceased's will. The rings tended to be distributed either at the funeral or within the mourning period. See Anita Mason and Diane Packer, *An Illustrated Dictionary of Jewellery* (New York: Harper and Row, 1974), 251–52.

5. In the United States, the death of George Washington occasioned a wide market for commemorative ornaments. Such items were worn as a public display of the wearer's admiration and patriotism. See Robin Jaffee Frank, *Love and Loss: American Portrait and Mourning Miniatures* (New Haven, CT: Yale University Press, 2000), 110–17.

6. Gonzalo Rubio, "Inanna and Dumuzi: A Sumerian Love Story," *Journal of the American Oriental Society* 121, no. 2 (April–June 2001): 268–74.

7. Knowledge of the Inanna-Dumuzi cult is largely based on the cuneiform tablets excavated at Nippur (in what is now Iraq) by the University of Pennsylvania Expedition in the 1880s.

8. For more information on the institution of marriage in ancient Rome, see Beatriz Chadour-Sampson, *The Power of Love: Jewels, Romance and Eternity* (London: Unicorn, 2019), 15.

9. The ring was given after the marriage contract had been agreed upon by both families. See Chadour-Sampson, *The Power of Love*, 15.

10. Martin Henig and Michael Vickers, eds., *Cameos in Context: The Benjamin Zucker Lectures, 1990* (Oxford and Houlton, ME: Ashmolean Museum, 1993), 28–29.

11. According to Diana Scarisbrick, the gimmel ring represents two lovers side by side. Diana Scarisbrick and Martin Henig, *Finger Rings* (Oxford: Ashmolean Museum, 2003), 28.

12. Diana Scarisbrick, *Rings: Symbols of Wealth, Power, and Affection* (New York: Harry Abrams, 1993), 51.

13. There is some question as to whether the original ring was a gimmel. It may be that descriptions of the ornament by several jewelry specialists are based on copies made around the 1817 Reformation Jubilee. Personal communication from Beatriz Chadour-Sampson, September 2023.

14. Jeanette C. Smith, "Katharina von Bora through Five Centuries: A Historiography," *Sixteenth Century Journal* 30, no. 3 (Fall 1999): 748.

15. George Frederick Kunz, *Rings for the Finger* (Philadelphia and London: Lippincott, 1917), 217.

16. Anna Beatriz Chadour, *Rings: The Alice and Louis Koch Collection II* (Leeds, UK: Maney, 1994), 465. It also matches several "revivalist" rings made around 1817.

17. Kunz, *Rings for the Finger*, 217. The biblical reference is Mark 10:9; Matthew 19:6.

18. It has been suggested that the original wedding ring is in Leipzig, Germany. Ursula Röhrs, *Mythos Lutherring: Der Ring der Katharina von Bora* (Schwäbisch Gmünd, Germany: Museum und Galerie im Prediger, 2021). This one is not a gimmel but a ring that features a single ruby as well as devotional iconography. The inscription is also different. Thanks to jewelry historian and ring specialist Beatriz Chadour-Sampson for her insights on this ornament.

19. The hair was scientifically analyzed and determined to match the hair of a mummy identified as Queen Tiye. "Queen Tiye Found!," *Oriental Institute, University of Chicago News and Notes*, no. 30 (October 1976): 1–4.

20. Unlike soft tissue, hair survives time and decomposition. Its durability makes it an ideal symbol of everlasting love and affection. Frank, *Love and Loss*, 10.

21. Abigail's father hired a tutor for his three daughters, who had access to the family's extensive library. Among its many volumes were the works of classical writers (in translation), including Shakespeare, Pope, and Milton, as well as books on history and political theory. Lynne Withey, *Dearest Friend: A Life of Abigail Adams* (New York: Touchstone, 1981), 8–12.

22. James Warren was also a member of the Sons of Liberty, an underground resistance movement opposed to the British Crown, and fought in the 1775 Battle of Bunker Hill in the Charlestown neighborhood of Boston.

23. John Adams and James Warren knew each other earlier through the courts, while wives Abigail and Mercy met in the spring of 1773 through mutual friends. See Nancy Rubin Stuart, *The Muse of the Revolution* (Boston: Beacon Press, 2008), 27, 52.

24. David McCullough, *John Adams* (New York: Simon & Schuster, 2001), 594–96.

25. Sarah Nehama, *In Death Lamented: The Tradition of Anglo-American Mourning Jewelry* (Boston: Massachusetts Historical Society, 2012), 96–97.

26. For a survey of Federalist-style jewelry, see Martha Gandy Fales, *Jewelry in America, 1600–1900* (Woodbridge, UK: Antique Collectors' Club, 1995), 79–160.

27. "From Mercy Otis Warren to Abigail Adams, 26 January 1813," Founders Online, National Archives, https://founders.archives.gov/documents/Adams/99-03-02-2242.

28. But see Harold Holzer, "Afterlife: America's First Assassinated President Wasn't Universally Mourned," *Smithsonian Magazine*, March 2015, 50–55.

29. R. W. Julian, *Medals of the U.S. Mint: The First Century, 1792–1892* (El Cajon, CA: Token and Medal Society, 1977), 104, 105. The broken column may represent the division of the country, although in Freemasonry it represents the passing of a fellow traveler; Lincoln was not a Mason but was honored in many lodges.

30. Fales, *Jewelry in America, 1600–1900*, 249–50.

31 Queen Victoria's reign is also associated with many innovative jewelry forms and the use of exotic, nontraditional materials such as taxidermied hummingbirds and tiger claws. See Charlotte Gere and Judy Rudoe, *Jewellery in the Age of Queen Victoria: A Mirror to the World* (London: British Museum Press, 2010), 190–213, 244–47.

32 For a discussion of the meaning and development of the charm bracelet, see Yvonne J. Markowitz, "Jewelry as Biography: The Charm Bracelet in Mid-20th Century America," *Adornment: The Newsletter of Jewelry and Related Arts* 3, no. 3 (Fall 2001): 1–8.

33 Eisenhower was NATO's first supreme commander, serving from 1950 to 1952.

34 The bracelet, along with other jewels from the Duchess of Windsor's collection, was auctioned at Sotheby's London in 1987 and then again in 2010, when it sold for $935,786.

35 Cartier had been founded in Paris in 1847, and at this time had showrooms in Paris, London, and New York. According to a recent biographer, Cartier was the Duke of Windsor's jeweler of choice for his gifts to Mrs. Simpson; Boucheron, another leading high-style retailer, was the source of presents for his previous mistress, Freda Dudley Ward. Francesca Cartier Brickell, *The Cartiers: The Untold Story of the Family behind the Jewelry Empire* (New York: Ballantine Books, 2019), 342–43. Other wedding gifts from the duke, including an extraordinary *jarretière* (a flat, strap bracelet made from broad links with a buckle-like fastener) of platinum, diamond, and sapphire, were made by the Paris firm Van Cleef & Arpels. Chadour-Sampson, *The Power of Love*, 114–15.

36 Faceted and cut into squares, rectangles, or oblongs, and set close together.

37 Stefano Papi and Alexandra Rhodes, *Famous Jewelry Collectors* (New York: Harry N. Abrams, 1999), 118.

38 This was especially evident during the later years of the marriage, when several visitors to the couple's home noted the duchess's cruel and demeaning treatment of the duke. See Andrew Morton, *Wallis in Love: The Untold Life of the Duchess of Windsor, the Woman Who Changed the Monarchy* (New York and Boston: Grand Central, 2018), 314–21.

39 Jocz holds a BFA in sculpture from the Philadelphia College of Art and an MFA from the University of Massachusetts. He began his career as a sculptor, and for many years he taught at the Massachusetts College of Art and Design. See Cindi Strauss, ed., *Ornament as Art: Avant-Garde Jewelry from the Helen Williams Drutt Collection* (Stuttgart, Germany: Arnoldsche Art Publishers; Houston: Museum of Fine Arts), 480–81. For a recent biography, see Sarah Davies, ed., *The Art and Times of Daniel Jocz* (Stuttgart, Germany: Arnoldsche Art Publishers, 2023).

40 Daniel Jocz, *American Requiem: 3047.9.11.2001* (Boston: Daniel Jocz, 2002), n.p. See also Paul Massari, "Daniel Jocz: Eternal Rest, Perpetual Light," *Ornament* 26, no. 3 (Spring 2003): 40–45.

41 Yvonne J. Markowitz, *Artful Adornments: Jewelry from the Museum of Fine Arts, Boston* (Boston: MFA Publications, 2011), 118–19.

CHAPTER 4

AN ILLUSTRIOUS PAST SERVING THE PRESENT

Susanne Gänsicke

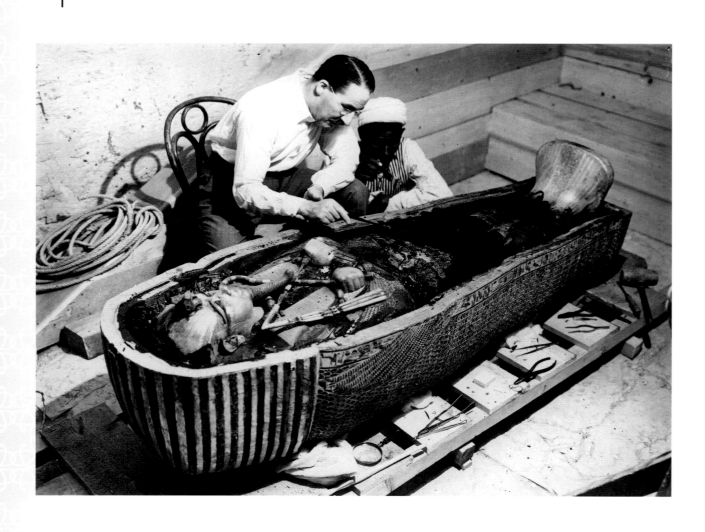

FIGURE 70 • Harry Burton, photographer (British, 1879–1940), Howard Carter and an unidentified Egyptian archaeologist with the innermost coffin of Tutankhamun, 1922. Oxford, Tutankhamun Archive, Griffith Institute, University of Oxford, P0770

ON NOVEMBER 26, 1922, FAMOUS WORDS were uttered in Egypt's Valley of the Kings. To Lord Carnarvon's question "Can you see anything?," the British Egyptologist and archaeologist Howard Carter reportedly replied, "Yes, wonderful things," as he peered through a small opening into the interior of the tomb of Tutankhamun (fig. 70).[1] In years to come, one of the greatest ancient treasures ever recovered from the Old World would have a pervasive impact on the imagination, design, and production of jewelry in the West.

Around the world and through the centuries, cultures have drawn on forms and symbolism from a (sometimes perceived or imagined) glorious past or golden age in their jewelry production. The motivations are legion. The interest may be purely aesthetic, or it may be an acknowledgment of recent remarkable discoveries or military victories by one's own nationals, as with the Assyrian style in Britain after Sir Austen Henry Layard's excavations in Mesopotamia (1845–51), or the Egyptian revival in France following Napoleon's campaign in Egypt and Syria (1798–1801).[2] Sometimes it is a deliberate effort to legitimize current power structures and politics. For example, when Egypt was ruled by the Kushite Twenty-Fifth Dynasty (774–656 BCE), whose kings originated from Nubia in northern Sudan, aspects of Egyptian customs and iconography, funerary equipment and rituals, and sculptural conventions were adapted to announce a new era of supremacy and legitimacy. But, the kings wore new crowns specific to Nubia, or necklaces featuring rams' heads, in reference to Amun, one of the principal deities of Nubia. In some countries, newly discovered ancient symbols native to one's own land have spurred the creation of new nationalistic styles, such as the Old Norse style in Scandinavia and the Anglo-Saxon style in Britain.

It is hard to overstate the innovations in jewelry design and manufacture that occurred in the nineteenth century, from neoclassical styles through numerous manifestations of archaeological styles and revivals. The following examples investigate the phenomenon of revival jewelry in its numerous and varied nineteenth-century manifestations.

83

AN ILLUSTRIOUS PAST SERVING THE PRESENT

EMPEROR NAPOLEON I'S CORONATION REGALIA

1804

THROUGHOUT HIS TUMULTUOUS YEARS in power, Napoleon Bonaparte, the French Revolutionary army general turned emperor Napoleon I, made considerable use of the arts to establish and promote his persona, vision, and authority. Jean-Auguste-Dominique Ingres's enormous 1806 painting showing him in full imperial regalia, seated as emperor on an imposing throne in neoclassical style, is a quintessential example of such propaganda (fig. 71). It is one of several grand scenes by leading artists of the day commemorating Napoleon I's coronation on December 2, 1804, at Notre-Dame in Paris. Some of the pictured

FIGURE 71 • Jean-Auguste-Dominique Ingres (French, 1780–1867), *Napoleon I on His Imperial Throne*, 1806. Oil on canvas, 259 × 162 cm (102 × 63¾ in.). Paris, Musée de l'Armée des Invalides, inv. 5420

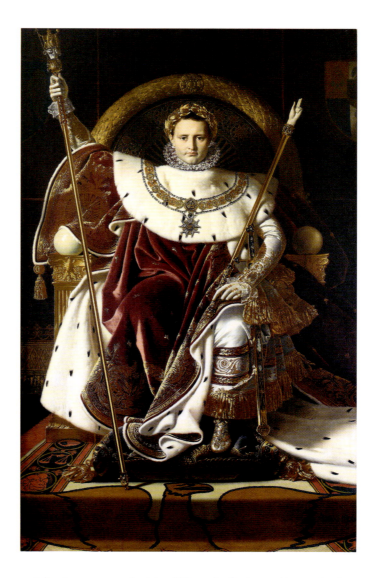

regalia draws on ancient traditions, for instance the opulent golden laurel wreath, consisting of one hundred individual golden leaves and seeds reminiscent of Greek and Roman culture; the crimson velvet coat trimmed and lined with ermine, evoking the Roman emperors; and the sacred golden scepter of Charles V (1338–1380), also known as the Scepter of Charlemagne, which was created around 1379 and is surmounted by a small figure of Charlemagne, now part of the French crown jewels (Charlemagne's original regalia remain unknown).[3] Contemporary elements of Napoleon's regalia, for example the rod of justice and the heavy golden collar of the Grand Master of the Legion of Honor, were created for the occasion by Martin-Guillaume Biennais, a celebrated

goldsmith of the time.⁴ Nonetheless, despite its grandeur and luxurious materials, the image did not meet with public approval and was deemed inappropriate to be given to Bonaparte by Jean-François Léonor Mérimée, a prominent art connoisseur and chemist, who called it "gothic and barbarous," and a poor likeness besides.⁵ It was given to the collection of the Corps Législatif, and then in 1822 to the Hôtel des Invalides in Paris, a museum and monument to French history that also houses the tomb of Napoleon I.

The crown worn by Napoleon during his coronation, also by Biennais, was based on medieval models. Wrought from gilded silver with a simple, unembellished shape, it is beset with prized ancient cameos from the royal treasury (fig. 72). In keeping with Bonaparte's imperial aspirations, he referred to it as the Crown of Charlemagne, although, like the far older scepter,

FIGURE 72 • Martin-Guillaume Biennais, designer (French, 1764–1843), crown for Napoleon I, called the "Crown of Charlemagne," ca. 1804. Gilded silver, ancient cameos, velvet, and textile, 25 × 18.5 × 18.5 cm (9⅞ × 7¼ × 7¼ in.). Paris, Musée du Louvre, MS 91

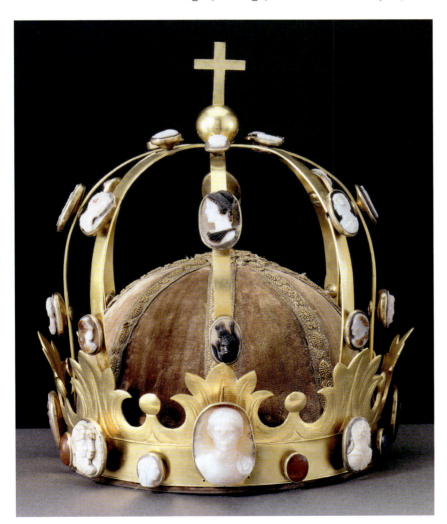

it lacked any direct relation to an actual relic of Charlemagne.[6] The French Revolution had caused a disruption in the production of luxury jewels and regalia and the loss of many of the French crown jewels, so Napoleon drew on Greek and Roman symbols as well as medieval forms to develop a new visual language. Imagining and viewing himself in succession of the medieval Carolingian dynasty under Charlemagne, he created a firm connection between himself and past powerful rulers.

Napoleon led France through turbulent years after the Revolution, and despite repeated setbacks he was able to reclaim command repeatedly, culminating in his coronation in 1804. A decade or so later, however, he suffered devastating military defeat during the Russian War (1812) and again at Waterloo (1815), resulting in his dismissal and exile. His regalia were removed from display at Notre-Dame in 1815, and not long into the ensuing period of Bourbon Restoration (1814–30), the wreath was melted into a golden ingot.

On one occasion in 1805, while the emperor was wearing his regalia, a leaf detached, and he gifted it to the painter Jean-Baptiste Isabey, who enshrined it in a snuff box in 1852 (fig. 73).[7] The leaf became a kind of relic—tangible evidence of spectacular but misguided and delusional grandeur.

PAULINE BORGHESE'S CAMEOS

1804–1815

DURING HIS REIGN, NAPOLEON I PROMOTED extravagance, contrary to the previously exhibited values of the French Revolution, which opposed the monarchy, its opulence, and inequality in general. Luxurious new creations were commissioned by him; his wife, the empress Josephine; and his younger, favorite sister, Pauline Borghese, while gems from the crown jewels of the ancien régime (pre-revolutionary France) were reset into contemporary designs by Napoleon's chosen jeweler, Marie-Étienne Nitot, who years earlier served an apprenticeship under a court jeweler of Queen Marie Antoinette.[8] Beyond jewelry, neoclassical style elements, for instance motifs based on Greek and Roman architecture such as pillars and geometric patterns, permeated fashion, furniture, and the decorative arts in what came to be called the Empire style, which was adopted beyond France in Europe and Russia.

Pauline Borghese dazzled her contemporaries with her beauty, fashion sensibility, jewelry, and extravagant and free-spirited lifestyle. The neoclassical marble sculpture *Venus Victrix* (1805–8) by Antonio Canova, depicting her seminude, scandalized her husband, Camillo Borghese, who kept it in a secluded setting.[9] Trendsetter Pauline was well documented by artists. She often adapted jewels already in her possession, resetting and re-creating pieces to serve (or create) the latest style, matching her brother's redefinition and revival of luxury goods.[10]

Cameos in particular were highly valued and much cherished, since for Napoleon they provided a direct link to ancient sculpture and architecture, and thus to the authority of past emperors. In Roman times, a few exceptionally large cameos, carved from layered agate, such as the Cameo of Tiberius (Great Cameo of France) (fig. 74) or the Gemma Constantiniana, a fourth-century CE gem created under Constantine to celebrate the defeat of an opponent, memorialized and promoted the status of emperors.[11] Cameos were an overwhelming trend among women as well. In 1805, the *Journal des Dames et des Modes* went as far as to advise the reader: "A woman of fashion wears cameos on her belt, cameos on her necklace, a cameo on each of her bracelets, a cameo on her diadem."[12]

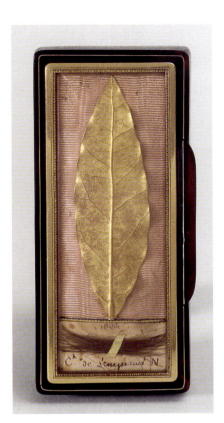

FIGURE 73 · Gold leaf from Napoleon's wreath inserted into a box by Jean-Baptiste Isabey, 1852. Thuya wood, tortoiseshell, and gold, 10.2 × 4.5 × 2 cm (4 × 1¾ × ¾ in.). France, Musée national du château de Fontainebleau – Musée Napoléon Ier

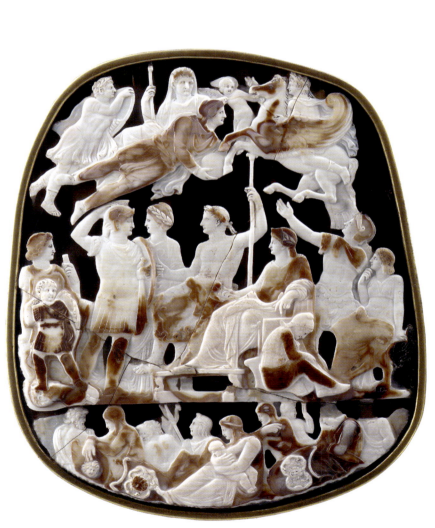

FIGURE 74 · Cameo of Tiberius (Great Cameo of France), Roman, ca. 25–50 CE. Onyx, 31 × 26.5 cm (12¼ × 10½ in.). Paris, Bibliothèque nationale de France, Cabinet des Médailles, inv. Camée, 264

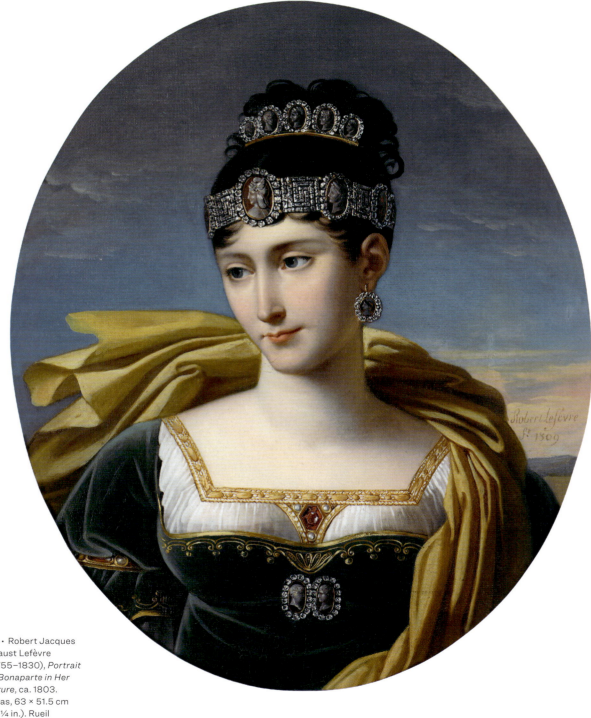

FIGURE 75 • Robert Jacques François Faust Lefèvre (French, 1755–1830), *Portrait of Pauline Bonaparte in Her Cameo Parure*, ca. 1803. Oil on canvas, 63 × 51.5 cm (24¾ × 20¼ in.). Rueil Château-Malmaison, France, Château de Malmaison

Pauline heeded the advice and encouraged the trend by flaunting her own diamond-studded cameo parure (matching jewelry set). In a beguiling portrait made circa 1803 by Robert Jacques François Faust Lefèvre, a prominent portraitist of the French Empire, she sparkles with a diadem, bandeau, earrings, and brooches created by the jeweler and his son François (fig. 75). Numerous paintings and engravings with different costumes and settings provide variations on the theme, including a large 1806 painting of her in a floor-length gown, wearing her parure, next to a marble bust of her brother.[13]

ELIZABETH BARRETT BROWNING'S DOVE BROOCH

CA. 1850

NINETEENTH-CENTURY ARCHAEOLOGICAL DISCOVERIES across the Mediterranean, North Africa, and the Middle East brought to light sites, artifacts, and precious jewelry of quality and in quantities never seen before. Sometimes items were found accidentally, sometimes they were sought by treasure hunters, and increasingly they were unearthed during excavations conducted using new, scientific approaches. These finds stirred a longing for connection with distant pasts and the integration of their visual vocabularies into contemporary life. For instance, an exquisite and unusual jewelry treasure of the Nubian queen Amanishakheto, who died around 10 BCE, discovered at Meroë in northern Sudan by Giuseppe Ferlini in the 1830s (fig. 76), inspired the French designer Henri Cameré (1830–1894) many decades later (fig. 77).[14]

In Italy, excavations of Etruscan necropolises such as the Regolini-Galassi tomb near Cerveteri (roughly 9th–1st century BCE), discovered in 1836, yielded particularly interesting precious-metal finds, including ample amounts of gold jewelry of technical finesse and delicacy previously unknown. In the following years, the goldsmith Fortunato Pio Castellani and his sons Alessandro and Augusto, who had already been creating jewelry in ancient styles, were tasked by papal authorities, on whose lands the necropolis was located, with the study and restoration of the newly found Etruscan objects, leading to far-reaching consequences for the world of jewelry.[15] The Castellanis began investigating ancient metalworking techniques of delicate execution, such as filigree and granulation, and imitating and re-creating these approaches with unparalleled technical finesse. They also collected and sold ancient jewelry and displayed it prominently alongside their own creations in their store in Rome (fig. 78), which became enormously successful and influential. Castellani shops opened in Naples, Paris, and London in the 1860s, serving a wealthy international clientele with exquisite products housed in equally exquisite jewelry boxes.[16]

FIGURE 76 • Hinged bracelet from the pyramid (Beg. N. 6) of Queen Amanishakheto, Meroë, Sudan, ca. 10 BCE. Gold and enamel, 4.6 cm (1¾ in.) in height. Munich, Germany, Staatliches Museum Ägyptischer Kunst, inv. 2455

FIGURE 77 • A rare revival bracelet based on the Nubian queen Amanishakheto's treasure, although embellished with added turquoise elements set into bezels and a different overall color scheme, attributed to Henri Cameré (French, 1830–1894), ca. 1880–1920. Pictured here as a hand-colored albumen print. Amsterdam, Rijksmuseum, RP-F-2014-48-1

FIGURE 78 • The Castellani showroom, Rome, after 1870

Although travelers had long been coming to Italy to study and collect art, the early nineteenth century experienced a boom of US and northern European voyagers and wanderers. Mostly well educated and well heeled, they flocked to France, Switzerland, and foremost Italy on the so-called Grand Tour. Art and travel mementos collected along the way became the new status symbols, and these included archaeologically inspired jewelry. Particular materials and techniques dominated different regions of Italy: lava and coral in Naples, micro-mosaic in Rome, *pietra dure* inlays of colorful stones in Florence, and finer gold-chain compositions in Venice. A visit to the Castellani shop in Rome was considered essential.

In 1846, the poets Elizabeth Barrett Browning and Robert Browning moved from England to Italy following their secret marriage (Elizabeth's father had disapproved). They would remain there until Elizabeth's death in 1861 in Florence after a lifelong battle with health problems and pain. The Brownings lived in a milieu of expatriates, surrounded by artists, writers, musicians, archaeologists, art dealers, travelers, and other seekers. They enjoyed these circles and their salons, and like everyone else, they visited Castellani's shop. The setting inspired the opening lines of Robert Browning's verse poem "The Ring and the Book" (1860): "Do you see this Ring? 'Tis Rome-work, made to match (By Castellani's imitative craft)."[17]

Elizabeth was portrayed three years prior to her death in a painting, which formed one of a pair, the second featuring her husband, commissioned by their friend Sophia May Eckley (fig. 79). The overall tone is somber, with the dark-haired sitter in dark clothes against a dark, paneled background. Yet white lace and her brooch, seemingly attached to a dark blue velvet

FIGURE 79 • Michele Gordigiani (Italian, 1835–1909), *Elizabeth Barrett Browning*, 1858. Oil on canvas, 73.7 × 58.4 cm (29 × 23 in.). London, National Portrait Gallery, NPG 3165

FIGURE 80 • Maker unknown, brooch, Italian, ca. 1850. Gold and micro-mosaic, 3.8 × 3.8 cm (1½ × 1½ in.). Philadelphia Museum of Art, 1899-923

ribbon, stand out. The round dove of peace pin features the bird carrying an olive branch against a blue background and the letters "PAX," set into a structured golden frame (fig. 80). The design is formed by minute tesserae of glass rods, known as micro-mosaic, a Roman specialty in which ancient floor designs were translated into a new technique perfectly suited for archaeological-style jewelry.[18] The date and circumstances of its purchase remain unknown, although it has been referred to as the Florentine brooch, perhaps because it was purchased in Florence while the Brownings lived there, yet it carries a stamp on the reverse pointing to fabrication in Rome.[19] The Brownings were friendly with the US sculptor William Wetmore Story and his wife, who were going to buy a dove brooch for Elizabeth around 1854, but she declined, noting that she already owned one.[20] She treasured the object dearly, and unlike others of her time, she never owned further pieces of archaeological revival jewelry.

Robert safeguarded several mementos after Elizabeth's death. He kept one of her rings on his chatelaine (ornamental

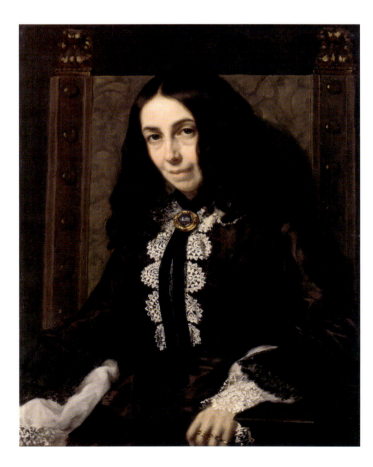

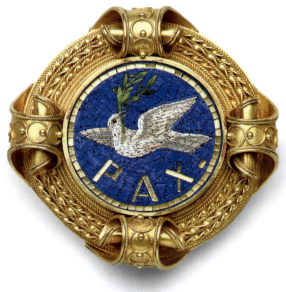

WILLIAM
WETMORE
STORY'S
CLEOPATRA

1860

belt hook) and retained the brooch for decades. In 1880, he finally parted with it, giving it to his close friend Clara Bloomfield, who left it to the Philadelphia Museum of Art in 1899.[21]

THE OPENING OF THE FRENCH-BUILT SUEZ CANAL in 1869 provided faster and more direct trade routes with the Arabian Peninsula, the Horn of Africa, the Persian Gulf, and Asia, and the global reach of Europe via commerce, culture, and colonialism accelerated. Major international exhibitions had already begun to be staged in London, Paris, Vienna, Chicago, Philadelphia, and other locations, with the first Great Exhibition opening in London in 1851. Jewelers featured prominently at the fair, with fifteen countries represented and thirty-eight exhibitors from Britain alone.[22] *The Grammar of Ornament*, published in 1856 by Owen Jones, an architect who served as an interior designer for the 1851 Great Exhibition, popularized designs and patterns drawn from international architecture and textiles, some of which were featured at the fair. At the 1867 International Exhibition in Paris, archaeological jewelry displayed an enthusiastic focus on Egypt, as featured for example in the display created by the goldsmith Gustave Baugrand. Giuseppe Verdi's opera *Aida* (1871), supposedly set in the Old Kingdom of Egypt and commissioned by Isma'il Pasha, khedive of Egypt and Sudan, for the Khedivial Opera House in Cairo, was widely performed in Europe and the United States, instigating yet another resurgence of Egyptian-inspired costumes and jewelry.

Given that everything Egyptian was on people's minds at this time in Europe and the United States, Cleopatra was an overwhelmingly popular subject among US sculptors working in Italy.[23] The aforementioned William Wetmore Story had already been in Rome for many years when he set up his studio there in 1856. Like many of his contemporaries working in the neoclassical style, he was inspired by all the new archaeological discoveries and reveled in the abundant availability of quality marble and skilled craftspeople. A pair of monumental sculptures of African queens—the Libyan Sibyl and the Egyptian Cleopatra—stand out among his large-scale sculptures of female figures, some historical and some mythological.[24] He first modeled Cleopatra in clay in 1858, and the marble was finished in 1860 (several later versions exist with alterations, including the one in fig. 81) and displayed at the 1862 International Exhibition in London.

Story's version of Cleopatra appears stern and angular—at least in her facial features—in comparison to comparable works by the sculptors Thomas Ridgeway Gould or Edmonia Lewis.[25] Certain attributes are true to actual ancient Egyptian pharaonic statues, for instance the *nemes* (striped) headcloth surmounted by a cobra (both royal symbols), while her pose, dress, and

chair are neoclassical in style. Cleopatra's neck is graced by a two-tiered beaded necklace with a pendant, perhaps a winged element, that suspends three rounded scarabs, with two smaller scarabs flanking the center. The jewelry provides a sense of solidity and weight. She wears a plain bracelet on her right arm and a snake bracelet, a typical style of ancient Greek and Roman armlets, on her left, likely in an allusion to her impending suicide.

Even though no direct example of the necklace exists, and certainly none from ancient Egypt, Castellani designed a few items with rounded scarab pendants inspired by Egyptian motifs.[26] It may well be that Story saw such items during his calls to their store, which are documented in the visitor book and by his purchase of a dove brooch similar to Elizabeth Barrett Browning's.[27] Story's *Cleopatra* was honored in Robert Browning's novel *The Marble Faun* (1860), this being just one example of the innumerable cross-fertilizations that flourished in the immersive artistic environment of that place and time.[28]

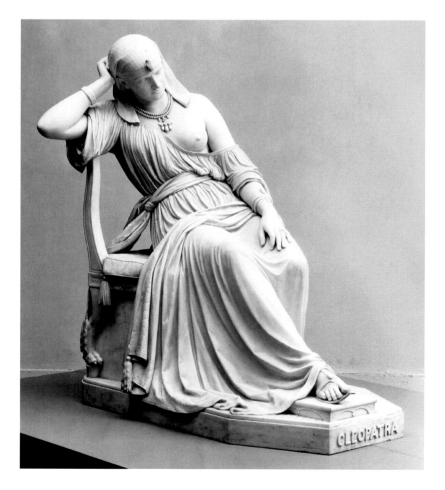

FIGURE 81 • William Wetmore Story (American, 1819–1895), *Cleopatra*, designed 1858, carved 1869. Marble, 141 × 84.5 × 130.8 cm (55½ × 33¼ × 51½ in.). New York, Metropolitan Museum of Art, gift of John Taylor Johnston, 1888, 88.5a–d

FIGURE 82 · Vicente Palmaroli y González (Spanish, 1834–1896), *Portrait of Lady Layard*, 1870. Oil on canvas, 101.5 × 78.5 cm (40 × 30⅞ in.). London, British Museum, 1980,1216.1

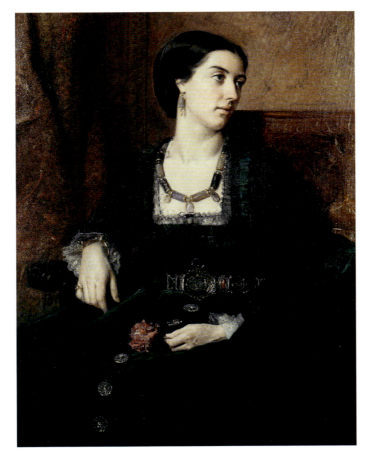

Ancient jewelry and different forms of revival jewelry served as artistic inspiration for poets, sculptors, and painters. Adornments based on antiquity were not only fashionable but also a direct manifestation of the creative milieu.

LADY LAYARD'S ASSYRIAN-REVIVAL NECKLACE

1869

THE WEDDING PORTRAIT OF ENID GUEST, who on the occasion of her marriage became Lady Layard, was painted in 1870 in Madrid by the Spanish court artist Vicente Palmaroli y Gonzáles (fig. 82). Lady Layard was twenty-seven years of age and had prepared carefully for the sitting, wearing a ruffled dress of green velvet from Turin studded with large antique paste buttons, a detail she recorded in her diaries.[29] Her extravagantly wide Renaissance-style belt, fabricated from partially enameled silver by Antonio Cortelazzo in Vincenza, Italy, was a gift from her much older husband (and cousin), Sir Austen Henry Layard, who at the time was ambassador to Spain. The mélange of costume and accessories speaks to the prosperous and international lifestyle enjoyed by the Layards.

FIGURE 83 • Phillips Brothers and Sons (British, active 1839–1902), Lady Layard's necklace, 1869. Gold and stone (including chalcedony, agate, hematite, and marble), necklace 49.7 cm (19½ in.) in length, earring 6.6 cm (2⅝ in.) in length (left), earring 6.7 cm (2⅝ in.) in length (right); bracelet 6.9 × 7.4 cm (2¾ × 2⅞ in.). London, British Museum, 115656

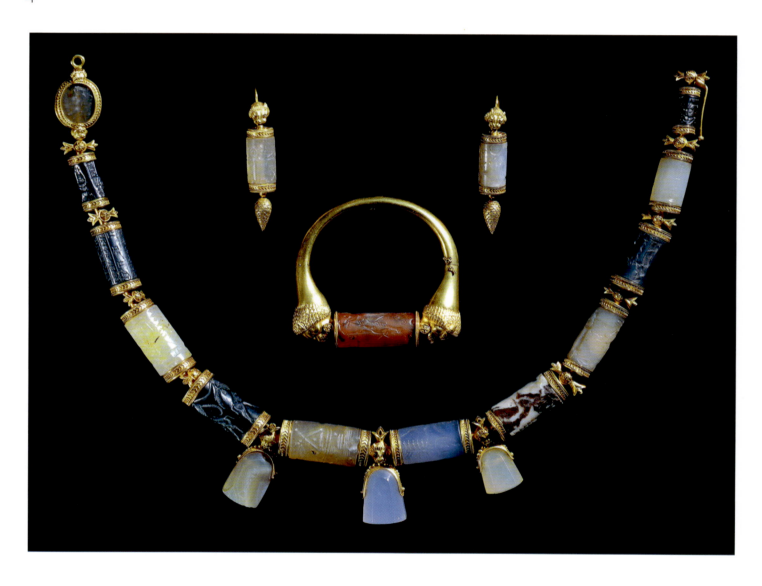

What makes this image exceptional, however, is an unusual ensemble of jewelry that set Lady Layard apart from all of her contemporaries (fig. 83). Presented to her as a wedding gift by her husband, the necklace, earrings, and bracelet are made from numerous ancient cylinder seals and stamp seals, which bear incised designs and text and were originally used to create stamped impressions in clay. Ranging in date from the third to the first millennium BCE, the ancient stones share no common history; they are a historical mélange.[30]

Sir Layard had gained fame from his research and excavations in Nimrud and Nineveh in today's Iraq, a role he appears to have relished, as can be gleaned from a portrait of him in Oriental costume at the British Museum. Undoubtedly he brought the ancient gems to England from his travels; possibly they were even his personal discoveries. In London, he worked with the Phillips Brothers jewelers to set the stones into golden frames decorated with chevron patterns. The seals are deployed as beads, and suspended as drops at the front of the necklace. The contemporary goldwork by Phillips Brothers picked up other motifs from ancient Assyrian palace reliefs. Pine cones (protective symbols) form the bottom drops of the earrings, while on the bracelet two golden lion heads frame a royal seal bearing the name of King Esarhaddon, whose sources of inspiration were the weighty armlets worn by muscular kings as shown on reliefs such as the one discussed in chapter 1 (see page 11). In the painting, however, the uniqueness of this bracelet is somewhat hidden under the ruff of the dress.

Archaeological exploration of ancient Mesopotamia did not begin until the mid-nineteenth century, first by French groups, followed by Layard's work. And Assyrian revival style, inspired by Layard's excavations, remained a mostly British phenomenon. It did not rely on exact replicas of ancient jewelry, as was the case with archaeological jewelry in Italy, but freely incorporated style elements of sculpture and architecture. In this context, the set of Lady Layard is truly singular. We know from her diary that the jewels were greatly admired and served as an important conversation piece at an 1873 royal dinner with Queen Victoria.[31] Perhaps the set's purpose was as much to declare her husband's accomplishments as to adorn the wearer.

SOPHIA SCHLIEMANN AND THE GOLD OF PRIAM
CA. 1873

AMONG THE MANY ARCHAEOLOGISTS WITH diverse "qualifications" active in the nineteenth century, Heinrich Schliemann stands out even among those brazen treasure hunters as one whose legacy lies as much in what he misrepresented as in what he discovered. Research and interpretation of his diaries, notes, letters, and other archival evidence continues today. After an already colorful life involving multiple international business ventures, by his forties he had amassed a fortune that allowed

FIGURE 84 • The "Treasure of Priam" after its discovery, displaying vessels and blades in bronze and silver, and the golden jewelry at the top. From Heinrich Schliemann, *Atlas trojanischer Alterthümer: Photographische Berichte über die Ausgrabungen in Troja* (Leipzig, Germany: F. A. Brockhaus, 1874), plate 204

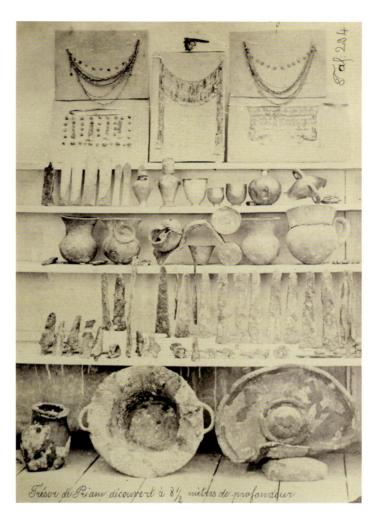

him to follow his lifelong obsession with the epics of the Greek poet Homer. In 1868, he traveled in the eastern Mediterranean to seek the whereabouts of Homer's ancient city of Troy, the setting for the Greek myth of the Trojan War. In 1869, he married Sophia Engastromenos, then aged seventeen, daughter of an affluent Athenian family.

His excavations over the years in a multilayered settlement near the town of Hisarlik in Turkey yielded nineteen impressive caches of antiquities. The most famous group, identified by Schliemann as Treasure A in 1873, has become known variably as "Priam's treasure," the "Gold of Priam," or simply the "Gold of Troy," after the mythological Priam, last king of Troy. It has also since become known that Schliemann did not in fact uncover the fabled ancient Troy, whose date would fall into the late second millennium BCE. The objects found by him are actually much older, Bronze Age materials dating to around

2450 BCE, and comprise items of silver and gold, including vessels, jewelry, and ornaments, bronze blades, and other metal artifacts (fig. 84). But although his attributions were not correct, and even the alleged idea of "Treasure A" as a single treasure may not be accurate, the terms live on.[32]

Sophia famously posed with some of the gold jewelry around 1873, shortly after its discovery (fig. 85).[33] In the photograph, we can see a large diadem with pendants around the forehead, basket-shaped earrings, an earring in the right ear, and layers of gold bead necklaces.[34] The goldwork is exquisite: the diadem is formed by a golden band from which ninety vertical strands stream curtain-like over the forehead. They are made from loop-in-loop chains, created by mechanically interlinking small rings of wire to form flexible and strong chains, the foremost type used in antiquity. On the diadem, they are further embellished with tightly set, tiny golden leaves.

FIGURE 85 · Photographer unknown, Sophia Schliemann wearing the Gold of Troy, ca. 1873

FIGURE 86 • Théodore Chassériau (French, 1819–1856), *The Toilette of Esther*, 1841. Oil on canvas, 45.5 × 35.5 cm (17⅞ × 14 in.). Paris, Musée du Louvre, R.F.3900

Schliemann elevated his wife to the status of archaeologist in his writings and reports, although these claims, like countless others he made throughout his life, have proven to be largely fraudulent. We should more readily regard Sophia's now-iconic image, using the ancient artifacts simply as decor—some even misplaced, like the earrings on her neck ruffle, perhaps due to a lack of understanding of their intended function—as like that of a hunter posing with their trophy.

Schliemann did not report his discoveries to the state authorities who oversaw archaeological objects in Turkey. Instead he took a portion of the treasure, including the gold, to Athens, and announced its finding there. At this time, excavated finds often left the country from whose soil they were extracted, and he was eyeing the British Museum as the final repository for his treasures. That museum did not purchase the cache, but the objects were still displayed in London, at the Victoria and Albert Museum, until 1880. Next, they were transferred to Germany, and exhibited after 1885 at the new Völkerkunde Museum in Berlin, while other parts of his finds remain in Turkey or reside in other collections.

World War II added a new chapter of displacement as, like many other museum collections, Schliemann's discoveries were hidden at its onset in a bunker. Then in 1945, in the chaotic aftermath of the war, the artifacts were packed and relocated to Moscow. To date, the treasures reside in the collection of the Pushkin Museum, have been declared Russian state property, and have by now been published and exhibited repeatedly.[35] In times of war, art objects and jewelry, like their owners, suffer displacement, disassociation, and damage. In the nineteenth century in Germany, the Gold of Priam never incited a new visual vocabulary or the production of archaeological revival jewelry.[36] Nonetheless, the power of ownership over the ancient treasure endures, as it does with countless other displaced antiquities. As does the quest for its ownership, notwithstanding it being of neither German nor Russian origin.[37] Meanwhile, in the Turkish village of Hisarlik, today also called Troy, archaeologists and historians tirelessly continue the quest for Homer's Troy.

JEWELRY IN ORIENTALIST PAINTINGS
CA. 1800S

AS WE HAVE SEEN, ARTISTS OF THE NINETEENTH CENTURY drew from a wide range of sources to visualize scenes from antiquity, fueled by recent archaeological discoveries as well as mythology, ancient texts, the Bible, and their own imaginations. Conspicuous depictions of jewelry enriched visualizations of mysterious pasts and distant lands.

Théodore Chassériau, who studied with both Ingres and Eugène Delacroix, chose an unusual scene for his romantic painting of *The Toilette of Esther* (1841, fig. 86). Drawing

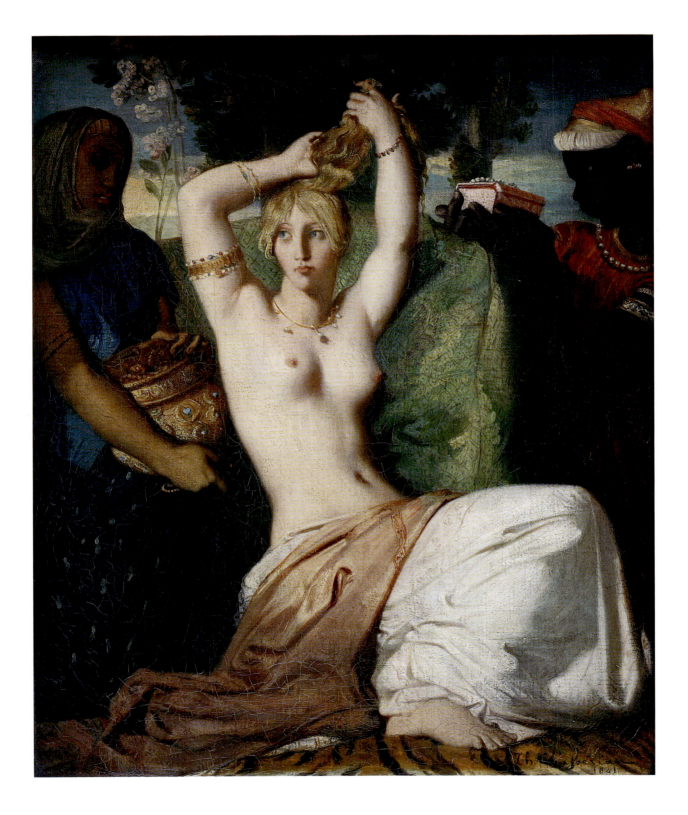

101

AN ILLUSTRIOUS PAST SERVING THE PRESENT

FIGURE 87 • Jeweled bracelet (one of a pair), Byzantine, probably made in Constantinople, ca. 500–700 CE. Gold, silver, pearls, amethyst, sapphire, glass, and quartz, 3.8 × 8.2 × 8.2 cm (1½ × 3¼ × 3¼ in.). New York, Metropolitan Museum of Art, gift of J. Pierpont Morgan, 1917, 17.190.1671

FIGURE 88 • Sir Edward John Poynter (British, 1836–1919), *Helen*, 1887. Watercolor and bodycolor, 28.8 × 21.3 cm (11⅜ × 8⅜ in.). England, Royal Collection Trust, RCIN 913534

from the biblical Book of Esther, he imagined his subject in an intimate setting while preparing for her presentation to the Achaemenid king Ahasuerus as his bride.[38] The beautiful, blond, blue-eyed Esther has two attendants. Both are painted imprecisely, as dark skinned and in exotic costume, one presenting her with a heavy bejeweled urn or casket, the other with a smaller jewelry box. Esther is unclothed from the waist up except for gold jewelry on her arms and neck. The ornaments are as fanciful as the setting; they convey a sense of richness but remain too vague to be clearly identified. The larger armlet on her right arm may be loosely based on Byzantine examples (fig. 87), and the necklace resonates with Hellenistic goldwork or possibly revival jewelry of the time, but historical accuracy was clearly not important to Chassériau here.

Compare this, then, with a watercolor made four decades later: Sir Edward John Poynter's 1887 depiction of another legendary beauty and queen, Helen of Troy, bedecked with an abundant amount of gold (fig. 88).[39] The mélange of gold ornaments, from different periods and geographic regions, include a tiara, large drop earrings, a gold and red beaded necklace, and another necklace with heavy golden pendants. Interestingly, Poynter had the latter created expressly for the painting: he commissioned a jeweler to take contemporary Indian silver pendants from Gujarat and gild them to make pseudohistoric items of jewelry that would complement

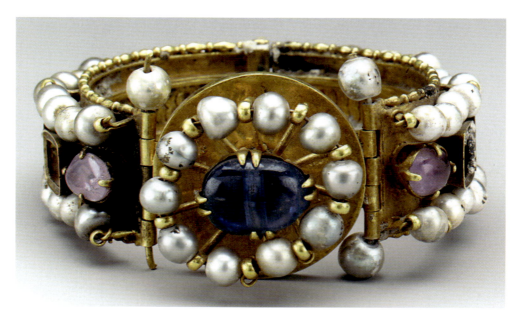

FIGURE 89 • Edwin Longsden Long (British, 1829–1891), *Love's Labour Lost*, 1885. Oil on canvas, 127 × 191.1 cm (50 × 75¼ in.). New York, Dahesh Museum of Art, 1995.10

a correspondingly Indian-looking textile wrapped around the sitter.[40] Yet, even here, realism was more something to gesture to than something to aspire to, as despite the subject's ostensible relation to Troy, none of the pieces had any relation to the recently discovered and much-publicized Gold of Troy.

Edwin Longsden Long also took a more detail-oriented approach in his romantic, mytho-historic scenes such as *Love's Labour Lost* (1885, fig. 89). Here a seated Egyptian princess is surrounded by attendants and musicians, monkeys, and a gazelle. Small artifacts such as toys, furniture, and wall paintings are based on Long's study of Egyptological publications and (rug excluded) do create an environment studded with items of daily life from the Egyptian New Kingdom. Yet the jewelry worn by the princess is not based on ancient examples available for study at that time. Rather, she is wearing a stunning contemporary Egyptian revival necklace created by Émile-Désiré Philippe using a combination of delicate Egyptian symbols and charms, made from enameled and gilded silver in combination with colorful gemstone scarabs, which Long is said to have had in his studio at the time.[41]

What unites these paintings is a haphazard use of generalized Eastern attributes to embellish European-generated narratives. Imaginings of the ancient and contemporary East among Western artists served romantic notions, played to popular fashions, and supported power structures in a time of rampant colonialism and looting of ancient tombs. Jewelry also served to enhance and erotize female figures. The three paintings discussed here include fantasy ornaments with some actual jewelry drawn from ancient examples but unrelated to the ostensible subject; and revival jewelry that did exist and was inspired by examples pertinent to the painting's subject. The identities of the subjects were ultimately not as relevant as men's interpretations of them in art. In each case, the jewelry serves as a focal point that tells us more about the vision of the creator than the life of the woman depicted.

NOTES

1. "Excavation Journals and Diaries Made by Howard Carter and Arthur Mace," Griffith Institute, http://www.griffith.ox.ac.uk/discoveringTut/journals-and-diaries/season-1/journal.html.

2. Charlotte Gere and Judy Rudoe, *Jewellery in the Age of Queen Victoria: A Mirror to the World* (London: British Museum Press, 2010), 374–461.

3. "Sceptre de Charles V," Louvre Collection, Paris, MS 83, https://collections.louvre.fr/en/ark:/53355/cl010113393; and Danielle Gaborit-Chopin, *Regalia: Les Instruments du sacre des rois de France, les "Honneurs de Charlemagne"* (Paris: Ministère de la culture et de la communication, Editions de la Réunion des musées nationaux, 1987).

4. The National Order of the Legion of Honor was created by Napoleon I in 1802, after similar orders had been abolished during the French Revolution, to bestow civilian and military orders of merit.

5. "Napoleon I on His Imperial Throne," History Website of the Fondation Napoleon: https://www.napoleon.org/en/history-of-the-two-empires/paintings/napoleon-i-on-his-imperial-throne/.

6. "Couronne aux camées, dite 'couronne de Charlemagne,'" Département des Objets d'art du Moyen Age, de la Renaissance et des temps modernes, Louvre collection, Paris, https://collections.louvre.fr/en/ark:/53355/cl010097017.

7. "Snuff box containing a golden leaf from the coronation crown," History Website of the Fondation Napoleon, https://www.napoleon.org/en/history-of-the-two-empires/objects/snuff-box-containing-a-golden-leaf-from-the-coronation-crown/.

8. Clare Phillips, *Jewels and Jewellery* (London: V&A Publications, 2000), 68–71.

9. "*Venus Victrix* by Canova," Galleria Borghese, Rome, https://borghese.gallery/collection/sculpture/venus-victrix-by-canova.html.

10. Susan Weber and Stefanie Walker, *Castellani and Italian Archaeological Jewelry* (New Haven, CT: Yale University Press for Bard Graduate Center for Studies in the Decorative Arts, Design, and Culture, 2004), 93, 96.

11. The Gemma Constantiniana is in the Rijksmuseum van Oudheden (National Museum of Antiquities), Leiden, the Netherlands.

12. *Journal des Dames et des Modes* 35 (March 16, 1805) (Ventose 25, an XIII), 282.

13. Robert Jacques François Faust Lefèvre, *Pauline Bonaparte, duchesse de Guastalla, â princesse Borghese*, Château de Versailles, France, MV 7684, https://collections.chateauversailles.fr/#/query/0ef228d3-aca5-4351-80bb-b49fb072c0d9.

14. Karl-Heinz Priese, *The Gold of Meroe* (New York: Metropolitan Museum of Art; Mainz, Germany: Zabern, 1993), 36, 37; Yvonne Markowitz and Peter Lacovara, "The Ferlini Treasure in Archeological Perspective," *Journal of the American Research Center in Egypt* 33 (1996): 1–9; Marjan Unger and Suzanne Van Leeuwen, *Jewellery Matters* (Amsterdam: Rijksmuseum, 2017), 467, fig. 488; and "Armband in Egyptische stijl, anonym, 1880–1920," Rijksmuseum, Amsterdam, https://www.rijksmuseum.nl/nl/collectie/RP-F-2014-48-1.

15. Gere and Rudoe, *Jewellery in the Age of Queen Victoria*, 399.

16. Maria José Oliveira, Teresa Maranhas, Ana Isabel Seruya, Francisco A. Magro, Thierry Borel, and Maria Filomena Guerra, "The Jewellery from the Casket of Maria Pia of Savoy, Queen of Portugal, Produced at Castellani's Workshop," *Archaeo Sciences* 3 (2009): 265–70.

17. Robert Browning, *The Ring and the Book* (London: Smith, Elder, 1868), 1:1.

18. Judy Rudoe, "Elizabeth Barrett Browning and the Taste for Archaeological-Style Jewelry," *Philadelphia Museum of Art Bulletin* 83, no. 353 (1986): 22–32.

19. The stamped symbol is an assay mark used in Rome after 1815. Rudoe, "Elizabeth Barrett Browning and the Taste for Archaeological-Style Jewelry," 22.

20. Weber and Walker, *Castellani and Italian Archaeological Jewelry*, 172.

21. "Brooch," Philadelphia Museum of Art, https://philamuseum.org/collection/object/38398.

22. Gere and Rudoe, *Jewellery in the Age of Queen Victoria*, 254.

23. Thomas Ridgeway Gould, *Cleopatra*, Museum of Fine Arts, Boston, 18.404, https://collections.mfa.org/objects/38100; and Edmonia Lewis, *The Death of Cleopatra*, Renwick Gallery, Smithsonian American Art Museum, Washington, DC, 1994.17, https://americanart.si.edu/artwork/death-cleopatra-33878. On the topic, see Naurice Frank Woods, "An African Queen at the Philadelphia Centennial Exposition 1876: Edmonia Lewis's *The Death of Cleopatra*," *Meridians* 9, no. 1 (2009): 62–82.

24. Thayer Tolles, Lauretta Dimmick, Donna Hassler, Joan M. Marter, and Jerry L. Thompson, *American Sculpture in the Metropolitan Museum of Art* (New York: Metropolitan Museum of Art, 1999), 86–95.

25. Woods, "An African Queen at the Philadelphia Centennial Exposition 1876," 62–82; and Susanna W. Gold, "The Death of Cleopatra / The Birth of Freedom: Edmonia Lewis at the New World's Fair," *Biography (Honolulu)* 35, no. 2 (2012): 318–41.

26. For instance "Castellani Necklace and Scarab Brooch, circa 1860," *Jewellery Editor*, http://www.thejewelleryeditor.com/images/castellani-revival-necklace-scarab-brooch-1860/; and "Egyptian-Style Necklace," Walters Art Museum, Baltimore, 57.1530, https://art.thewalters.org/detail/4539/egyptian-style-necklace-with-scarabs/.

27. Weber and Walker, *Castellani and Italian Archaeological Jewelry*, 172.

28. Gere and Rudoe, *Jewellery in the Age of Queen Victoria*, 412–14, 498, 501.

29. Gere and Rudoe, *Jewellery in the Age of Queen Victoria*, 394–97.

30. John Curtis, Julian Reade, and Dominique Collon, *Art and Empire: Treasures from Assyria in the British Museum* (London: British Museum Press, 2005), 220–21.

31. "Lady Layard's Journal," Baylor University, University Libraries, https://www.browningguide.org/lady-layards-journal/#layard. Today the jewelry and its original Phillips leather case are in the collection of the British Museum.

32. Donald F. Easton, "Priam's Gold: The Full Story," *Anatolian Studies* 44 (1994): 221–43; and David A. Traill, "Schliemann's Discovery of 'Priam's Treasure': A Re-Examination of the Evidence," *Journal of Hellenic Studies* 104 (1984): 96–115.

33. David A. Traill, "The Archaeological Career of Sophia Schliemann," *Antichthon* 23 (1989): 99–107.

34. For relevant information on the "Priam treasure" excavated by Schliemann, see Karl E. Meyer, "The Hunt for Priam's Treasure," *Archaeology* 46, no. 6 (1993): 26–32; and Vladimir P. Tolstikov and Mikhail Treister, *The Gold of Troy: Searching for Homer's Fabled City* (New York: Ministry of Culture of the Russian Federation, A. S. Pushkin State Museum of Fine Arts, in association with H. N. Abrams, 1996), 27–94.

35. Mikhail Treister, "First Report on Priam's Treasure," *Archaeology* 48, no. 5 (1995): 64–66.

36. Gere and Rudoe, *Jewellery in the Age of Queen Victoria*, 376.

37. Karl E. Meyer, "Who Owns the Spoils of War?," *Archaeology* 48, no. 4 (1995): 46–52.

38. Stéphane Guégan, Vincent Pomarède, and Louis-Antoine Prat, *Théodore Chassériau, 1819–1856: The Unknown Romantic* (New York: Metropolitan Museum of Art, 2002).

39. "Helen," Royal Collection Trust, https://www.rct.uk/collection/913534/helen.

40. Gere and Rudoe, *Jewellery in the Age of Queen Victoria*, 302–3.

41. Gere and Rudoe, *Jewellery in the Age of Queen Victoria*, 384. On the necklace by Émile-Désiré Philippe, of which several versions exist, see "Parure égyptienne Musée des Arts Décoratifs," D 21.A–E, http://collections.madparis.fr/parure-1. Long also painted Esther wearing Egyptian revival jewelry: *Queen Esther*, National Gallery of Victoria, Australia, P.301-1, https://www.ngv.vic.gov.au/explore/collection/work/4147/.

CHAPTER 5 · FANTASIZING THE PRESENT

Yvonne J. Markowitz

FIGURE 90 • Mae West wearing diamond jewels, 1930s

FIGURE 91 • Art deco bracelet owned by Mae West with French assay mark, 1930s. Platinum and diamonds. Neil Lane Collection

IT WAS NOT BY HAPPENSTANCE THAT what many call the golden age of Hollywood coincided with the Great Depression and the United States' entry into World War II. They were, in fact, intimately intertwined in that the glamorous film-star lifestyles and escapism promoted on and off the silver screen served as a welcome antidote to the devastating aftereffects of the 1929 stock market crash, news of wartime horrors and casualties, and government-mandated austerity measures. This tumultuous period, characterized by a pervasive sense of hopelessness, widespread poverty, and social upheaval, wrought radical changes in daily life and a yearning for more carefree times. Current realities must have been even harder to grasp in the aftermath of the lively Roaring Twenties—a time of explosive economic growth, enticing new consumer goods, and exciting innovations in communications, travel, and entertainment.

As President Franklin Roosevelt initiated a series of financial reforms and public projects designed to stabilize the economy, a coterie of writers, movie producers, and directors in Hollywood set out to soothe the country's damaged psyche. They operated from the premise that all that was needed to allay the anxieties and deprivations of the times was a fantasy-filled, lighthearted experience at the local cinema. To help accomplish this end, a new breed of costume and jewelry designers emerged—individuals who eventually became celebrities in their own right. Travis Banton (Paramount, Twentieth Century-Fox, Universal), Edith Head (Paramount, Universal), Adrian (MGM), and William Hoeffer (cofounder of the New York jewelry firm Trabert & Hoeffer) were among the main creative talents. Often conspicuously cited in movie credits, their careers paralleled those of Hollywood's leading stars. For the first time, starlets wore authentic jewels while filming—high-style adornments designed by international firms such as Cartier, Mauboussin, and Van Cleef & Arpels. In some cases, the jewelry was rented or loaned to the studios; other times, it was owned by Hollywood elites who also wore their sumptuous ornaments about town and for publicity photos for premier fashion and lifestyle magazines (figs. 90, 91).[1] Ordinary women aspiring to emulate these flamboyant figures purchased inexpensive facsimiles mass-produced by a burgeoning costume-jewelry industry.

By the early 1940s, the collective experience of the decade-long Depression, the attack on Pearl Harbor, and the United States' entry into yet another world war had finally caught up with the contrived, lighthearted display of wealth, gaiety, and extravagant living promoted by the film industry. The age of glamour had devolved into a delayed reckoning as Hollywood prepared to take on the darker aspects of contemporary life.[2] A now widely hailed subgenre of the mid-1940s through the early 1950s, film noir, featured chiaroscuro,

FANTASIZING THE PRESENT

dizzying compositions with jagged angles, flashbacks, and sometimes on-location sets. Characters and plots were often dark and featured hard-boiled detectives, brutish underworld villains, seductive women of questionable character, and themes of alienation. The transition from glamour to darkness took hold almost overnight, although some films, such as the thriller *Sorry, Wrong Number* (1948), which features a manipulative femme fatale (Barbara Stanwyck) outfitted in exquisite designer clothes and stunning gem-set jewels, exemplified both moments.

After the war, the movies would witness technical advances—Cinemascope, Panavision, VistaVision, and 3D helped to make the 1950s a decade of expansive, spectacular, big-production filmmaking—as well as new genres, including science fiction (*The Day the Earth Stood Still* [1951]), historical epics (*The Ten Commandments* [1956]), and character-driven films (*A Streetcar Named Desire* [1951]). But never again would Hollywood be so closely associated with ostentatious glamour for its own sake. Girl-next-door aesthetics of purity, simplicity, and natural charm came to dominate the silver screen, and the glamorous lead performers of the 1930s were replaced by respectable, dependable characterizations that represented traditional values and a return to normalcy. The suburban housewife dedicated to home and children became the new female ideal, and wedding rings the most desirable of adornments.

MARLENE DIETRICH'S EMERALDS IN *DESIRE*

1936

THE GERMAN AMERICAN ACTRESS Marlene Dietrich (1901–1992) was known for her exotic looks, daring attire, seductive voice, and tantalizing androgyny.[3] Like many leading stars of the 1930s and 1940s, she was transformed by the Hollywood studio machine into a highly polished object of desire. This calculated metamorphosis was part artifice, part fantasy, and part an intensification of her undeniable magnetism. Her breakthrough role came in *The Blue Angel* (1930), directed by Josef von Sternberg (1894–1969), in which she played a licentious cabaret singer who lures a respected high school teacher into a life of debauchery and degradation. The film catapulted Dietrich to international stardom and helped her secure a lucrative contract with Paramount.

Sternberg became a regular collaborator of Dietrich's, and a major promoter of the Dietrich image. At his orchestration, on-set still photographers as well as celebrity photographers produced a steady stream of lavish images used in advertising campaigns, fan magazines, and popular publications such as *Life*. In a candid acknowledgment of the role Sternberg played in creating her look, Dietrich wrote: "I am his product, all of his making. He hollows my cheeks with shadows, widens the

look of my eyes, and I am fascinated by that face up there on the screen and look forward to the rushes each day to see what I, his creature, will look like."[4] Sternberg expressed similar sentiments. Upon completing *The Blue Angel*, he remarked that he "put her into the crucible of my conception, blended her image to correspond with mine...to externalize an idea of mine."[5]

Dietrich's costume designer in the early 1930s was Travis Banton, known for his sensuous, form-fitting designs, sumptuous fabrics, and extravagant detailing (fig. 92). Early in her career, Dietrich also decided that fine jewelry would be part of her fantasy-based appeal. She was part of a select circle of highly paid film stars, often dubbed America's aristocracy,

FIGURE 92 · Eugene Robert Richee, probable photographer (American, 1896–1972), Marlene Dietrich in an outfit designed by Travis Banton for *Shanghai Express* (Paramount), 1932

whose glamorous film roles were believed to be exciting extensions of their lives outside the studio. These actresses acquired sparkling jewels in keeping with their public personas and were seen and photographed wearing them at public events such as fashion shows, Hollywood openings, nightclubs, and transatlantic travel.

Among the earliest high-style ornaments acquired by Dietrich were four diamond bracelets given to her by Sternberg as a Christmas gift in 1931. Two were of the strap bracelet variety popular during the art deco era and often worn in multiples. Around the same time, Sternberg purchased a sapphire ring for the actress—perhaps one of the large star-sapphire jewels popular with the Hollywood set.[6] Later in her career, during the filming of Alfred Hitchcock's thriller *Stage Fright* (1950), Dietrich made Hollywood jewelry history with a stunning diamond and ruby *jarretière* bracelet—a strap bracelet made from flat, broad links with a buckle fastener and occasionally a movable slide—made by Van Cleef & Arpels in 1937 from several ornaments already in Dietrich's collection (figs. 93, 94). Dietrich's bedazzling bracelet is "rimmed with baguette-cut diamonds" that "encircle a diamond geometric motif. Attached to the diamond hexagon are twin tapering circular and baguette-cut diamond straps with a central graduated baguette-cut clasp. The extraordinary underside of the ruby disk is a flaring pavé-set diamond panel... accented by baguette-cut diamonds, mounted in platinum."[7] It is rumored that in the 1930s Dietrich had a romantic dalliance with Louis Arpels, a principal of the firm.[8]

And while Dietrich was no doubt delighted by her diamond, ruby, and sapphire baubles, she was positively enamored with emeralds. An intimate biography written by her daughter notes that her emerald obsession began around 1933 with a gift from a paramour, fellow performer Maurice Chevalier (1888–1972). It was "a magnificent square-cut emerald ring...the only perfect stone she ever received from a swain."[9] It was, however, no match for the suite of emerald jewels Dietrich purchased for herself in New York in 1934.

Retailer Trabert & Hoeffer was a relative newcomer in the exclusive gem-set jewelry trade and operated out of a sleek modernist shop on New York's Park Avenue.[10] Howard Hoeffer, one of its cofounders, saw market potential in Hollywood and pioneered the practice of renting jewelry to leading studios. In addition to introducing the latest designs from Paris to US audiences, he is credited with popularizing the multipurpose jewel, especially the long sautoir necklace, which can be taken apart and reconfigured into brooches, clips, bracelets, and/or pendants. According to Maria Riva's biography, Dietrich's suite was housed in a custom-made leather case and consisted of "three bracelets in various widths, two large clips, one large

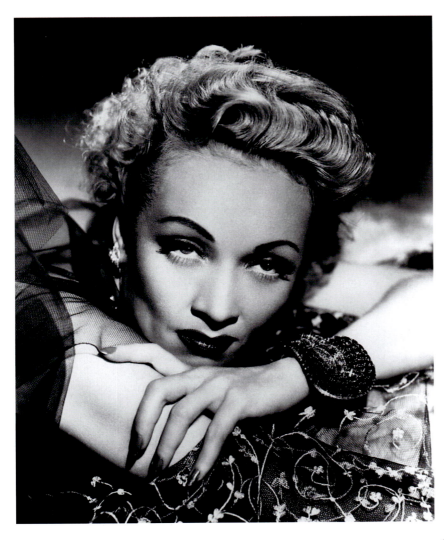

FIGURE 93 • Marlene Dietrich poses with a large *jarretière* bracelet by Van Cleef & Arpels in a publicity still for Alfred Hitchcock's thriller *Stage Fright* (Warner Brothers), 1950.

FIGURE 94 • Van Cleef & Arpels, designer (French, founded 1896), *jarretière* bracelet, 1937. Platinum, ruby, and diamond. Private collection

FANTASIZING THE PRESENT

pin, and one unbelievable ring [fig. 95]. The main diamond bracelet was as wide as a man's shirt cuff and housed the largest emerald. A perfect cabochon, the size of a Grade A egg set horizontally, spanned the entire width of my mother's wrist. Because of its size, it was the only emerald permanently anchored into its diamond setting. All the others were interchangeable!"[11]

FIGURE 95 · Trabert & Hoeffer, designers (American, 1926–36), Marlene Dietrich's emerald jewels, 1934. Platinum, diamond, and emerald

FIGURE 96 · In this publicity still for her 1936 film *Desire* (Paramount), Marlene Dietrich wears her personal diamond and emerald (the size of an egg!) bracelet by Trabert & Hoeffer.

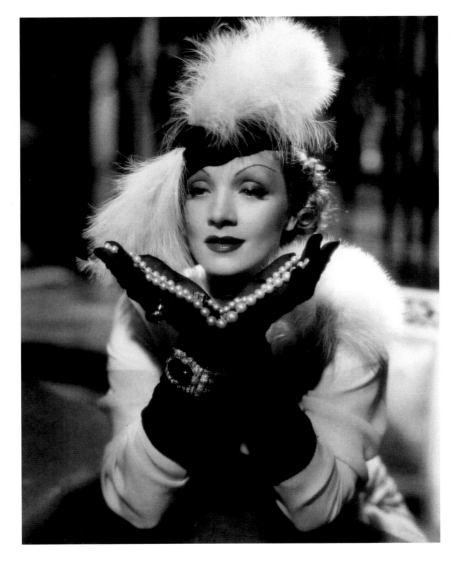

The perfect vehicle for displaying Dietrich's beloved emeralds was the romantic comedy *Desire* (1936), in which the actress plays an elegant jewel thief (fig. 96). The film begins with Dietrich posing as the wife of a wealthy neurologist, pulling off a clever con in an upscale jewelry salon in Paris. Once in possession of a two-million-dollar pearl necklace, she absconds flamboyantly to San Sebastian, Spain, where she hopes to fence it. Along the way, she encounters a charming but naive automotive engineer from Detroit, played by Gary Cooper. To avoid detection by customs agents, she hides the pearls in Cooper's coat pocket and then schemes ways of retrieving the ill-gotten goods. In the end, the pearls are returned to their rightful owner and the leading couple are united in a sentimental

wedding scene. Dietrich wore her emerald ensemble often, and when several jewels from the suite came up for sale at Sotheby's, New York, in 2014, part of the immense interest they aroused was their association with one of the most glamorous personalities of the silver screen and a movie role specifically about coveted jewels.

NORMA SHEARER VS. JOAN CRAWFORD IN *THE WOMEN*

1939

AS NOTED ABOVE, BEAUTIFUL STARLETS didn't just wear sumptuous jewelry; the jewelry was itself sometimes a thematic driver of the film plot. For example, in the romantic comedy *Vogues of 1938* (1937), modeling, the fashion industry, and fashion shows are leitmotifs that culminate in a musical extravaganza with models wearing exclusive designer clothing by Alexander "Omar" Kiam[12] and jewelry lent by Trabert & Hoeffer-Mauboussin. The movie was shot in Technicolor, making it the perfect vehicle to promote colored gems, especially the costly star sapphires and rubies that were all the rage among high-style jewelry retailers and their clients (figs. 97, 98). Trabert & Hoeffer-Mauboussin was credited at the beginning of the film as the movie's sole supplier of jewelry.

Equally suffused with themes of glamour and its trappings was the star-studded satire *The Women* (1939). This witty drama, based on a 1936 Broadway hit of the same name written by Clare Boothe, centers on duplicity, infidelity, and competition among frenemies. Its all-female cast features many of Hollywood's most successful actresses, including Norma Shearer, Joan Crawford, Rosalind Russell, Paulette Goddard, and Joan Fontaine (fig. 99). The subtitle of the film, *It's All about Men*, speaks volumes: the women characters are either seductive ingénues intent on marrying, pampered wives married to successful men, or divorcées in search of new partners. For moviegoers mired in the deprivations of the Great Depression and deeply apprehensive of US involvement in another world war, the early scenes of *The Women* must have been an enchanting distraction. The film begins with a frenzied series of vignettes set inside a palatial spa called Sydney's located on Park Avenue in Manhattan. The camera makes a broad sweep of the salon's grand exterior and its multistoried interior, where the furnishings and equipment are *moderne* in style— a later phase of art deco emphasizing horizontal design, movement, and machine-like imagery. In high-style jewelry, *moderne* refers to ornaments made of polished gold (as opposed to platinum) that are large, bold, and three-dimensional. Many of the attending employees are dressed as elegant consultants and also wear high-style clothes and jewelry.

After its tour of the salon, the camera focuses on a chatty manicurist who delightedly reveals that the husband of one of the spa's patrons, played by Norma Shearer, is romantically

FIGURE 97 · Trabert & Hoeffer, designer (American, 1926–36), Star of Burma brooch, 1934, here pictured in a *Vogue* ad from December 1935. Platinum, diamond, and ruby

FIGURE 98 · Actors Joan Bennett (center, left) and Warner Baxter in a scene from *Vogues of 1938* (Walter Wanger Productions), 1937, in which rival fashion houses compete; Bennett wears a multiuse diamond and ruby necklace by Trabert & Hoeffer-Mauboussin.

FANTASIZING THE PRESENT

CHAPTER 5

FIGURE 99 · This poster for *The Women* (MGM), 1939, features (left to right) Joan Crawford, Norma Shearer, and Rosalind Russell; the dazzling adornments are part of their elaborate costumes.

involved with a gold digger shopgirl, played by Joan Crawford. In what is now referred to as the "confrontation scene" (fig. 100), the two have it out in an elegant fitting room following a tour-de-force fashion show filmed in Technicolor. The women's attire and adornments highlight their characters' personalities.[13] Shearer wears an off-shoulder black gown that is elegant and understated, and her jewelry is limited to a diamond ring and a series of stacked gem-set bracelets, then the height of fashion (these are worn in different configurations in other scenes of the film). In contrast, Crawford wears a gaudy gold-lamé ensemble with matching turban and a truly enormous gold and citrine bracelet (figs. 101, 102).[14] This stunning ornament, part of a bespoke set that included a necklace with detachable clip, earrings, and a ring, had been purchased by the actress from Raymond C. Yard Inc., a New York jeweler whose clients also included the Rockefeller, Vanderbilt, and DuPont families. Yard was also popular among the Hollywood set, especially with Douglas Fairbanks Jr. (Crawford's first husband) and his wife, Mary Pickford, also an avid jewelry collector.

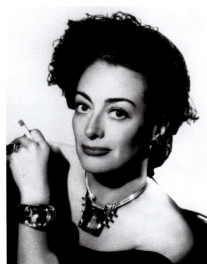

FIGURE 100 • In this scene from *The Women* (MGM), 1939, the faithful and forgiving Mary (right) wears an elegant black gown with refined, stacked bracelets on her left wrist, while home-wrecker Crystal (left) wears a gaudy gold-lamé ensemble and a large gold and citrine bracelet on her left arm.

FIGURE 101 • Publicity still of Joan Crawford wearing her gold and citrine jewelry suite, ca. 1950s. Neil Lane Collection

FIGURE 102 • Raymond C. Yard, designer (American, active 1922–present), Joan Crawford's gold and citrine jewelry suite, 1930s. Neil Lane Collection

FANTASIZING THE PRESENT

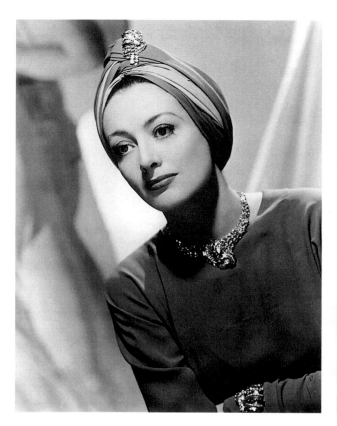 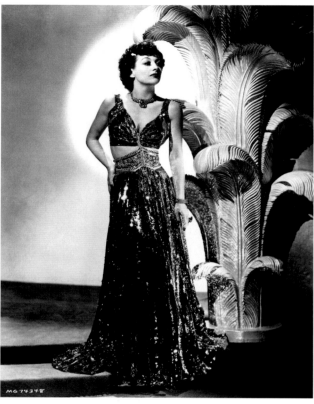

FIGURE 103 • In this publicity still for *The Women* (MGM), 1939, Joan Crawford wears her gold, diamond, and aquamarine three-piece Verger Frères jewelry suite.

FIGURE 104 • Although they did not ultimately appear in the film, Joan Crawford wore two pieces from her Verger Frères suite in publicity photos for *The Women* (MGM), 1939.

Crawford had also planned (as indicated in promotional stills) on wearing another dazzling suite from her personal collection in *The Women* (figs. 103–5). Composed of three pieces (a close-fitting necklace, a bracelet, and a dress clip), this gold, aquamarine, and diamond ensemble was made around 1937 by the French jewelry house Verger Frères. The set also bears hallmarks of the New York retailer E. M. Tompkins, a jewelry boutique Crawford frequented.[15] It was clearly a favorite of the actress, who was photographed often wearing one or more pieces of the suite during the heyday of her career.

BARBARA STANWYCK'S NECKLACE IN *SORRY, WRONG NUMBER*

1948

BARBARA STANWYCK (1907–1990) was a leading Hollywood actress who, like Dietrich, rose to stardom during the 1930s. Despite being at one point the highest-paid actress in the United States, Stanwyck never thought of herself as glamorous in the manner of Jean Harlow, Claudette Colbert, or Marilyn Monroe, but rather as a professional dedicated to her craft. She embraced a wide range of roles, including burlesque queens, wisecracking reporters, women with questionable pasts, and ruthless women bent on murder: "Some of my most interesting roles have been completely unsympathetic."[16] Stanwyck was also an atypical

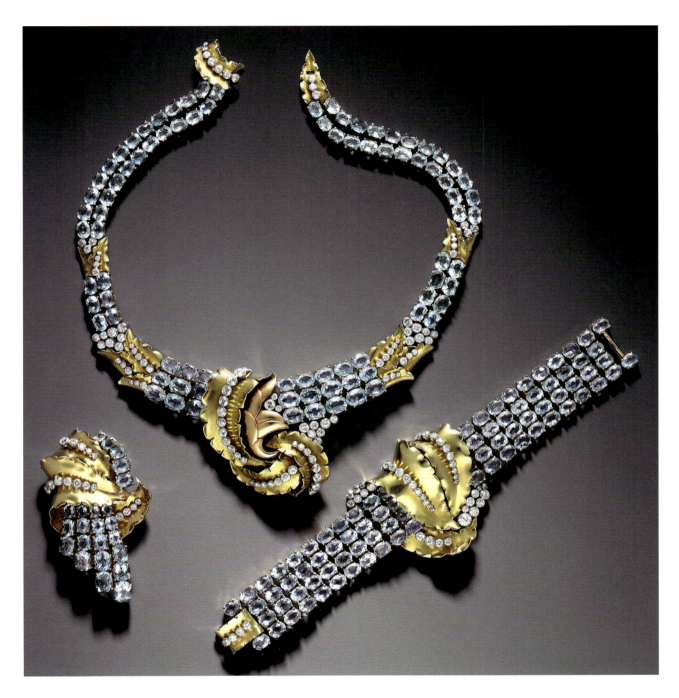

FIGURE 105 • Verger Frères, designer (French, founded 1872), Joan Crawford's three-piece jewelry suite, ca. 1937. Gold, diamond, and aquamarine; necklace 34.3 cm (13½ in.) in length, bracelet 17.5 cm (6⅞ in.) in length, brooch 6.8 cm (2¹¹⁄₁₆ in.) in length. Private collection

FIGURE 106 • Barbara Stanwyck poses wearing a blue plaid blouse and a red kerchief—and, importantly, no discernible jewelry—in a studio portrait, 1935. At the time, she owned a working ranch outside Los Angeles where she bred and rode horses.

FIGURE 107 • Newlyweds Robert Taylor and Barbara Stanwyck at a press conference at Café Victor Hugo, Beverly Hills, California, on May 14, 1939, the day of their wedding; on her left hand, Stanwyck wears a ruby and gold engagement ring and bracelet purchased from Trabert & Hoeffer-Mauboussin (active 1936–53).

Depression-era superstar in that she viewed her on-screen presentation (costuming, jewelry, makeup) as an extension of the role at hand rather than a deliberate deployment of glamour for its own sake (fig. 106). Biographer Al DiOrio noted that she seldom wore much jewelry except for various gifts from Robert Taylor (her second husband) and "a diamond horseshoe-shaped ring to which she was partial."[17] Early in her career, during the filming of *Ladies of Leisure* (1930) for Columbia Pictures, director Frank Capra noted that the aspiring actress was "naive, unsophisticated, caring nothing about makeup, clothes or hairdos.... She knew nothing about camera tricks, how to 'cheat' her looks so her face could be seen.... She just turned it on—and everything else on stage stopped."[18]

In fact, it was Taylor who loved high-style jewelry, especially adornments set with precious stones. Among his early gifts to Stanwyck was an engagement ring set with heart-shaped rubies (her birthstone), followed later that year by a matching diamond and ruby bracelet (fig. 107). Taylor enjoyed being part of the creative process when it came to jewelry, and worked closely with designers at the Beverly Hills location of Trabert & Hoeffer-Mauboussin. At the time, the shop was run by William Ruser, one of the firm's leading salespeople.[19] Taylor would bring Ruser sketches of designs for ornaments and accessories for himself and his wife. Probably the most extravagant was a platinum and diamond necklace composed

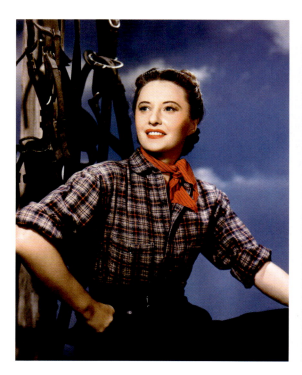
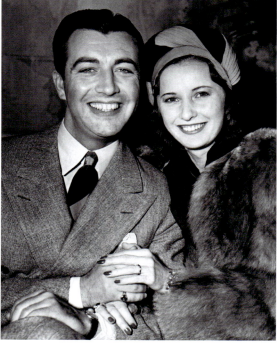

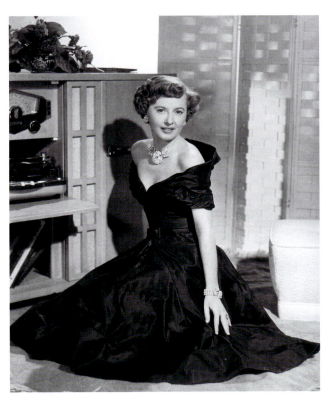

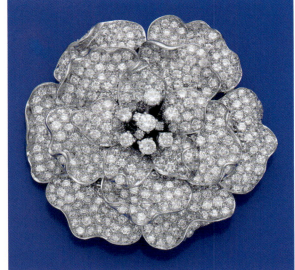

FIGURE 108 • Barbara Stanwyck in her diamond gardenia necklace designed by William Ruser

FIGURE 109 (TOP AND BOTTOM) • William Ruser (active 1947–69), one of three detachable brooches from Barbara Stanwyck's gardenia necklace (front and back), 1947. Platinum and diamond

FANTASIZING THE PRESENT

of a gem-set chain and three pendant brooches in the form of gardenia blossoms (figs. 108, 109). The dazzling jewel was a 1947 Christmas gift, and like many high-style ornaments of the 1930s and 1940s, it could be reconfigured in several ways— for example, the brooches could be worn separately, and the neckpiece could be simplified by removing two of the smaller flowers.

This necklace took center stage during a brief flashback to a wedding scene in *Sorry, Wrong Number* (1948), one of Stanwyck's best-known roles (fig. 110). The movie is based

FIGURE 110 • Barbara Stanwyck wears her own diamond gardenia necklace with matching earrings in the wedding flashback in *Sorry, Wrong Number* (Paramount), 1948.

FIGURE 111 • Barbara Stanwyck wears elaborate rental jewelry and a Chantilly lace nightgown by Edith Head in *Sorry, Wrong Number* (Paramount), 1948.

on an equally iconic radio play by Lucille Fletcher. The plot, partly conveyed in flashbacks, centers on the life of a wealthy, manipulative, high-strung heiress who is plagued by psychosomatic ailments that keep her bedridden and completely dependent upon others. Half of Stanwyck's scenes were filmed in her character's bedroom, and Edith Head, one of Hollywood's most powerful costume designers (she won eight Academy Awards from a total of thirty-five nominations during her long career), created five different nightgowns for this static set,

with the most striking appearing in the final, frantic scene. Multiple preparatory sketches were made for this important gown, an elegant, tailored pink Chantilly lace number with a bed jacket embellished by "thousands of dollars of rented jewelry [from Ruser], requiring an armed guard who had to accompany Stanwyck on the set at all times."[20] Among the diamond jewels featured were a floral brooch worn at the neck, a wide bracelet, ribbon earrings, and a stunning 10-carat diamond wedding ring (fig. 111).

BERNARD WALDMAN AND THE MODERN MERCHANDISING BUREAU
1930S

WHILE DECO-ERA FILMS WITH LUXURIOUS SETS, glamorous costuming, spectacular adornments, and lighthearted story lines offered movie fans a brief escape from their daily woes, they also stimulated an enduring desire for the tantalizing goods that were part and parcel of what was perceived as an upper-class life. Flashy automobiles, elegant homes with swimming pools, upscale entertainments, air travel, and exotic vacations at posh hotel resorts were all part of the allure. Movie moguls, fashion advertisers, manufacturers, and retailers were quick to capitalize on this desire to dress and live like the stars (fig. 112). During the late 1920s and early 1930s, they collaborated with one another to create a Hollywood-based fashion industry whose influence extended far beyond Southern California.

FIGURE 112 • Macy's in New York, pictured here in the 1930s, was the first department store to carry film-inspired fashion that included both day and evening wear at affordable prices.

An important figure who served as a corporate middleman between the film studios and the fashion designers was Bernard Waldman (1900–1981), founder of the Modern Merchandising Bureau. According to film historian Charles Eckert:

> By the mid-1930s Waldman's system generally operated as follows: sketches and/or photographs of styles to be worn by specific actresses in specific films were sent from the studios to the bureau (often a year in advance of the film's release). The staff first evaluated these styles and calculated new trends. They then contracted with manufacturers to have the styles produced in time for the film's release. They next secured adverting photos and other materials that would be sent to retail shops. This ad material mentioned the film, stars, and the studio as well as the theaters where the film would appear.... Waldman's concern also established a popular chain of fashion shops known as Cinema Fashions. Macy's contracted for the first of these in 1930 and remained a leader in the Hollywood Fashion shops.[21]

Department stores also carried the latest in costume jewelry trends, with many examples replicating high-style adornments at a fraction of the price. As a result, women had both the opportunity to identify with their favorite bejeweled cinema actors and the ability to assume an aura of high-style living as they went about their daily affairs.

NOTES

1. See Penny Proddow, Debra Healy, and Marion Fasel, *Hollywood Jewels: Movies, Jewelry, Stars* (New York: Harry N. Abrams, 1992), 81.

2. Movie mogul Samuel Goldwyn foresaw the demise of glamour, noting that "overdressing the movies is going to cease. The audiences are fed up with too luxuriant costumes and sets: they want what is simple." Edwin Schallert, "Glamour Due for Discard, Says Goldwyn," *Los Angeles Times*, May 13, 1934, A1.

3. The actress, wearing a top hat and tuxedo, created a memorable moment in film history when she dared to flaunt a same-sex kiss in *Morocco* (1930).

4. Per a letter from Dietrich to her director husband, Rudolf Sieber, during the filming of *Morocco*. Maria Riva, *Marlene Dietrich by Her Daughter Maria Riva* (New York: Ballantine Books, 1992), 93.

5. Steven Bach, *Marlene Dietrich: Life and Legacy* (New York: William Morrow, 1992), 119–20.

6. Letter from Rudolf Sieber to Dietrich, Paris, February 14, 1932, in Riva, *Marlene Dietrich by Her Daughter Maria Riva*, 131–32.

7. Proddow, Healy, and Fasel, *Hollywood Jewels*, 145.

8. Marion Fasel, "At Auction: Marlene Dietrich's Van Cleef & Arpels Jewel," *The Adventurine*, March 16, 2023, https://theadventurine.com/culture/jewelry-history/all-about-marlene-dietrichs-colossal-bracelet-in-stage-fright/.

9. Riva, *Marlene Dietrich by Her Daughter Maria Riva*, 182. Interestingly, that same year she was photographed wearing a long diamond and emerald necklace in a publicity still for the film *Song of Songs* (1933).

10. The firm also had shops in resort areas such as Atlantic City and Miami. For a history of the company, including its collaboration with the French jewelry house Mauboussin, see Yvonne J. Markowitz et al., *The Jewels of Trabert & Hoeffer-Mauboussin* (Boston: MFA Publications, 2014).

11. Riva, *Marlene Dietrich by Her Daughter Maria Riva*, 308.

12. Irene Maud Lentz designed outfits for lead star Joan Bennett, while the couturier for the fashion finale was Alexander "Omar" Kiam. Furs, an important glamour signifier, were on loan from Jaeckel.

13 Costuming for the lead actresses was created almost exclusively by Adrian, MGM's celebrated couturier. A graduate of what is now Parsons School of Design, he worked briefly as a set and costume designer on Broadway before moving to Hollywood in 1924.

14 Crawford also wore part of the suite in the romantic comedy *When Ladies Meet* (1941).

15 A similar bracelet using rubies in lieu of aquamarines, now part of the Neil Lane collection, was made by Verger Frères and retailed by Boucheron. It was not uncommon during the nineteenth and twentieth centuries for high-end jobbers to supply similar designs to competing firms and/or retailers.

16 Axel Madsen, *Stanwyck* (New York: HarperCollins, 1994), 3.

17 Al DiOrio, *Barbara Stanwyck: A Biography* (New York: Coward-McCann, 1983), 124.

18 Frank Capra, quoted in Madsen, *Stanwyck*, 56.

19 William Ruser began his jewelry career in sales at the Trabert & Hoeffer-Mauboussin boutiques in Atlantic City and Palm Beach. In 1937, he was transferred to the Beverly Hills branch, where he became a favorite among the Hollywood set. After World War II, he opened a store under his own name. Markowitz et al., *The Jewels of Trabert & Hoeffer-Mauboussin*, 43–44.

20 Joy Jorgensen, *Edith Head: The Fifty-Year Career of Hollywood's Greatest Costume Designer* (Philadelphia and London: Running Press, 2010), 134.

21 Charles Eckert, "The Carole Lombard in Macy's Window," in *Movies and Mass Culture*, ed. John Belton (New Brunswick, NJ: Rutgers University Press, 1996), 103, reprinted with permission from *Quarterly Review of Film Studies* 3, no. 1 (Winter 1978): pages unknown.

CHAPTER 6

WHO I AM

Yvonne J. Markowitz

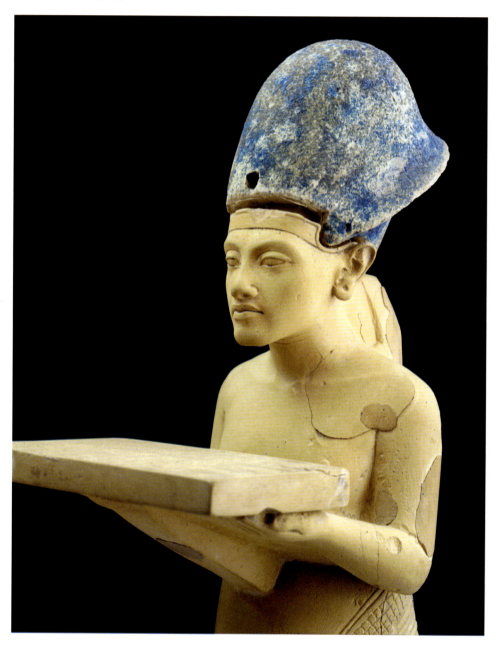

FIGURE 113 • Statue of King Akhenaten presenting an offering (detail), Egyptian, New Kingdom, 18th Dynasty, reign of Akhenaten, 1353–1336 BCE. Painted limestone, 43 cm (17 in.) in height. Cairo, Egyptian National Museum, JE 43580

AT ITS MOST BASIC LEVEL, JEWELRY FULFILLS an urge to decorate the body. It is no surprise that its crafting is among the oldest of the decorative arts—in fact, objects identified as ornaments have recently been discovered at sites inhabited by humans more than one hundred thousand years ago.[1] Even at that point, it is likely that wearers already attached layered meanings to items that served as extensions of their bodies. Made primarily of organic materials adapted to conform to the human figure, these objects protected, empowered, and helped define their owners.

One way to understand how jewelry is intertwined with identity is to examine how personal adornment is represented in works of art. In some instances, the jewelry depicted readily embodies the identity of the sitter, as the blue *kepresh* crown worn in ancient Egypt's New Kingdom (1539–1077 BCE) established the wearer as both pharaoh and warrior (fig. 113). In another work, a circa 1920 portrait of Edith Bolling Galt Wilson by Seymour M. Stone (1877–1957), the sitter—the second wife of President Woodrow Wilson—wears a large brooch at the waist whose symbolism was well understood in her day (fig. 114). Made of gold, enamel, diamond, and cast glass, the ornament was designed by the French jeweler René Lalique (1860–1945) and features eight doves perched on diamond-set olive branches (fig. 115).[2] Presented to Wilson by the citizens of France while she and her husband were in Paris at the close of World War I, the brooch identified the First Lady as one of the actors on an international stage gathered in the hope that the recent carnage would be the "war to end war." Little did she know that within a year, following her husband's crippling stroke, she would be acting as the de facto president. And, sadly, the dream of forestalling future wars proved woefully wrong; the brooch she proudly wore in her portrait was later described as "a symbol that failed."[3]

In some ways, this chapter is about journeying backward, as in the skit introduced in the 1960s by Johnny Carson on the *Tonight Show* in which Carnac the Magnificent (played by Carson) holds to his forehead a sealed envelope containing a written question. Carnac then magically provides the answer before opening the envelope. In identifying the subject in a portrait, if the answer is "The Order of the Society of the Cincinnati," the question would be: "What historic jewel is uniquely associated with George Washington?" In the examples presented in the vignettes that follow, the ornament in question is so closely aligned with an individual or class of individuals that it identifies or defines the wearer or wearers.

WHO I AM

130

CHAPTER 6

FIGURE 114 • Seymour M. Stone (American, 1877–1957), *Mrs. Woodrow Wilson*, ca. 1920. Oil on canvas, 182.8 × 137.1 cm (72 × 54 in.). Washington, DC, Woodrow Wilson House collection, White House, Library of Congress LCCN 2016823425

FIGURE 115 • René Lalique, designer (French, 1860–1945), *Doves on Olive Branches*, 1906. Gold, enamel, diamond, and cast glass, 15.5 × 6.5 cm (6⅛ × 2½ in.). Washington, DC, National Museum of American History, Smithsonian Institution

A NUBIAN KING'S NECKLACE

8TH–6TH CENTURY BCE

IN SOME REPRESENTATIONS OF THE HUMAN FIGURE, the jewelry worn by the subject provides important clues as to the social or political role of the wearer. This is especially true for royalty, heads of state, and high officials whose public and ceremonial activities require attire and ornamentation symbolic of their rank, position, or cultural affiliation. This was the case for a series of Nubian kings who ruled the Nile Valley during the eighth, seventh, and sixth centuries BCE (the Napatan period). Like the Egyptian pharaohs who preceded them, these mighty rulers wore jewels that symbolized their dominion over a kingdom that stretched from Khartoum, Sudan, in the south to the Mediterranean Sea in the north.

Most notable among their adornments was a lanyard-type necklace with three golden ram's head pendants, each a manifestation of the powerful state god, Amun, whose temple at Gebel Barkal, near modern Karima, Sudan, was the most important religious center in all of Nubia. Known exclusively from royal sculpture and relief representations, this ornament is believed to have been secured to the body by a thick cord

FIGURE 116 • Statue of Tanwetamani from Doukki Gel (detail), Sudan, Napatan period, 25th Dynasty, reign of Tanwetamani, 664–657 BCE. Granite, 218 cm (85⅞ in.) in height. Sudan National Museum 7

FIGURE 117 • Ram's head pendant, Sudan, Napatan period, ca. 712–657 BCE. Gold, 4.2 × 3.6 × 2 cm (1⅝ × 1⅜ × ¾ in.). New York, Metropolitan Museum of Art, 1989.281.98

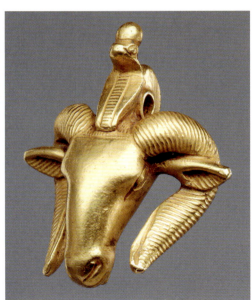

CHAPTER 6

PORTRAIT OF ELIHU YALE

1708

or heavy chain draped around the neck (fig. 116). The largest pendant—a ram's head with a sun disk and a rearing cobra—was worn in the center of the body close to the neckline, while two smaller versions, minus the sun disk, rested on the shoulders (fig. 117). There are no known instances in which non-royals are depicted wearing this adornment; likewise all representations of figures wearing the necklace are assumed to be those of Nubian kings.[4] This use of jewelry is all the more significant in light of the fact that Nubian kings were always depicted in a highly idealized state rather than possessing unique, realistic features.[5] These kings who ruled the Nile Valley often appropriated sculptures of prior kings, removed existing inscriptions, and presented them as their own visages. The ram's head necklace—a manifestation of the king's identification with the all-powerful Amun—was the ultimate symbol of his rulership.

A MORE SUBTLE USE OF JEWELRY to establish identity is found in a circa 1719 group portrait titled *Portrait of Elihu Yale with Members of His Family and an Enslaved Child* (fig. 118). In the painting, Elihu Yale (1649–1721), an early benefactor of Yale University,[6] is shown seated at a table between two British noblemen in a scene described as a commemorative signing of a marriage contract between Yale's daughter, Anne, and James Cavendish (left, seated), son of William Cavendish, first Duke of Devonshire. In the distance at upper right, the duke's children are shown frolicking in the garden with their music teacher. It has been suggested that the inclusion of all these elements was made upon Yale's request "so that it might be more immediately known where and with whom he was sitting."[7]

Yale, who was born into humble circumstances in Boston and raised in London, acquired his great wealth during his time in India, where he served as governor of the East India Company settlement in Fort William at Madras (modern Chennai) (fig. 119). His tenure there was far from illustrious, and in 1692, after five years at the post, he was removed from office for "self-aggrandizement" and illicit profiteering at company expense.[8] Also adding to his personal coffers were the large sums he acquired as a participant in the lucrative slave trade that flourished in late eighteenth-century Madras. But the greatest bulk of his fortune was the result of his exploits as a diamond dealer. India, at the time, was the world's most important source for the gem, and Yale's tenure in the East coincided with an increased demand for the stone due to advances in diamond cutting.[9] Like many in the gem trade, Yale would purchase rough diamonds from a variety of sources and send the stones to England to be cut. Upon his return to London in 1699, he continued as a power broker in the diamond

FIGURE 118 • Attributed to John Verelst (Dutch, 1648–1734), *Elihu Yale with Members of His Family and an Enslaved Child*, ca. 1719. Oil on canvas, 201.3 × 235.6 cm (79¼ × 92¾ in.). New Haven, CT, Yale Center for British Art, gift of Andrew Cavendish, eleventh Duke of Devonshire, B1970.1

FIGURE 119 • Jan Van Ryne, engraver (Dutch, 1712–1760), *Fort William in the Kingdom of Bengal Belonging to the East India Company of England*, 1754. Original hand-colored copper engraving on paper, 25.5 × 39 cm (10 × 15⁵⁄₁₆ in.). London, British Library Board, P462

During the seventeeth and eighteenth centuries, the British government established defensive coastal forts in India that were also trading centers. Among them were Fort Saint George and Fort William.

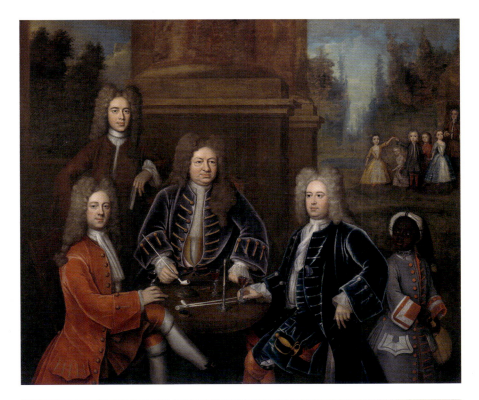

industry. His identification with the gem is evident in the aforementioned group portrait, where he is shown wearing a diamond ring on his right hand, a symbol of his wealth, influence, and entrepreneurial accomplishments. Yale lived during an era when most diamond adornments were worn by royals,

aristocrats, and wealthy merchants. It is as if in the portrait, the principal subject is proclaiming, "See this ring, it is who I am—a self-made man whose wealth is rooted in the acquisition of the most prized gem in the West."

Yale's role in the slave trade has recently been scrutinized by contemporary historians and activists as they spearhead a national reexamination of the racist legacies of a number of historical, military, and philanthropic icons.[10] There has been a similar spotlight on diamonds—a gem whose sourcing has had a disastrous impact on the environment (thanks to groundwater contamination, the use of cyanide in the dissolution of ore, wildlife deaths, and more) and fueled terrible conflicts in parts of Africa.[11] The glittering stones Marilyn Monroe described as "a girl's best friend" in *Gentlemen Prefer Blondes* (1953) have lost some of their brilliant gleam as consumers become increasingly aware of their dark side.

WALKING BEAR'S GRIZZLY BEAR CLAW NECKLACE

EARLY 19TH CENTURY

JEWELRY CAN SERVE AS A SYMBOL of an individual's prowess, accomplishments, and/or social standing in a community. Among early examples are the ancient Greek laurel-leaf chaplets of gold that were bestowed on exceptional athletes, military leaders, poets, and musicians. Recipients of the golden crown were recognized for their real-life achievements by the glimmering wreaths awarded by an admiring citizenry. So powerful was the imagery of these crowns that references to the ornament—for instance "resting on one's laurels," or "poet laureate"—remain in popular parlance.

Indigenous peoples of the Americas likewise use ornaments that not only elevate their status in the community but also embody their identities. For example, distinctive clothing and jewelry are often associated with a specific tribe or regional group. In this capacity, aspects of a person's appearance reflect their community's shared beliefs, traditions, roles, and ties to the land. During the late eighteenth and early nineteenth centuries, several artists fascinated by Native American cultures set out to explore and document their unique costumes and customs. Among them was George Catlin (1796–1872, fig. 120), a Pennsylvania artist who traveled extensively throughout the US Northwest during the 1830s, painting more than five hundred portraits and scenes of daily life amid the frontier lands, especially the Great Plains.[12]

One of Catlin's most celebrated portraits is that of Joc-O-Sot (Walking Bear), a chief of the Meskwaki nation of Iowa (fig. 121). The chief, who was wounded in the Black Hawk War against the United States in 1832 and later toured the country and traveled to England, where he met Queen Victoria, is depicted by Catlin in a three-quarter standing position wearing a necklace fashioned from grizzly bear claws. The ornament is

FIGURE 120 • William Fisk (British, 1796–1872), *George Catlin*, 1849. Oil on canvas, 158.8 × 133.4 cm (62½ × 52½ in.). Washington, DC, National Portrait Gallery, Smithsonian Institution, NPG.70.14

FIGURE 121 • George Catlin (American, 1796–1872), *Joc-O-Sot (Walking Bear), A Sauk Chief from the Upper Missouri, U.S.A.*, ca. 1844. Color lithograph, 40.6 × 29.2 cm (16 × 11½ in.). Madison, Wisconsin Historical Society, Rare Books PH 348.26

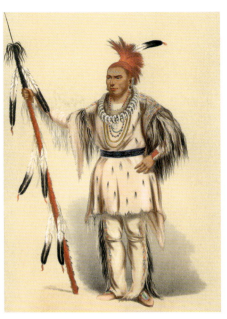

FIGURE 122 • Lewis and Clark's grizzly bear claw necklace, probably Upper Missouri River, early 1800s. Bear claws, rawhide, sinew, otter hide/fur, and mineral pigment, 63.5 cm (25 in.) long, longest claw 8.7 cm (3⅜ in.). Cambridge, Massachusetts, Peabody Museum, Harvard University, gift of Mrs. Henry C. Grant, 1941, 41-54-10/999700

This necklace was recently "rediscovered" in the Peabody Museum Collection at Harvard University and has been reconstructed and conserved.

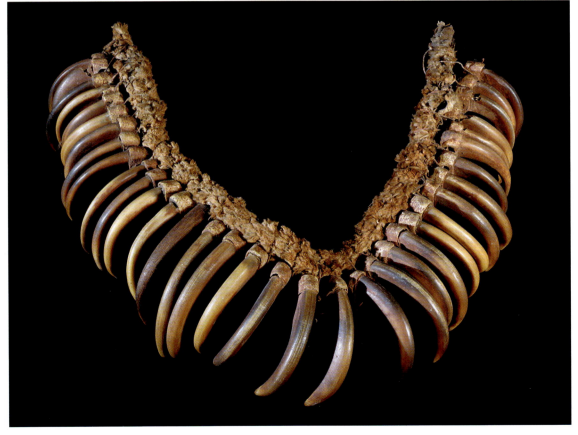

WHO I AM

composed of an inner ring of otter hide, multiple claw pendants pierced through the center and separated by glass trade beads, and a counterpoise (a decorative counterweight at the back of a neck ornament) in the form of a tapering otter-pelt strip (fig. 122). Such necklaces were worn by chiefs or respected elders of Northwest tribes who acquired the large, three-to-four-inch claws during winter bear hunts—dangerous pursuits that required courage, skill, and persistence. The ornaments usually incorporate thirty to forty claws harvested from the three middle digits of the bear's front paws. Extant examples indicate that the typical necklace represents death-defying encounters with five to eight grizzlies.

The grizzly bear is a fearsome mammal that weighs up to eight hundred pounds and looms about seven feet tall when standing. It is considered one of nature's most formidable predators and, for the Plains Indians, the ultimate symbol of strength and power. The appropriation and use of its lethal claws not only conferred superhuman capabilities on the owner but also inspired awe and reverence. Made part of a bold and commanding adornment, these sacred trophies identified the wearer as an individual of power, wisdom, and cunning. Early travelers in the Western territories Meriwether Lewis and William Clark acquired a grizzly claw necklace for their collection of Native American artifacts—possibly a high-value gift from a chief or prominent elder.[13]

ALICE PAUL'S "JAILED FOR FREEDOM" BROOCH

1909

ANOTHER ADORNMENT THAT SPEAKS TO the character, accomplishments, and unique social standing of the wearer is the "Jailed for Freedom" brooch worn by the US suffragist Alice Paul (1885–1977) in a posthumous sculpture by Avard Fairbanks (1897–1987, fig. 123), an artist best known for his three-dimensional posthumous representations of Abraham Lincoln.[14] Paul, the daughter of activist Hicksite Quakers, was an articulate and extraordinarily well-educated woman for her day. She was a graduate of Swarthmore College, attended the New York School of Philanthropy, spent a year studying social science at the Quaker Woodbrooke Study Center in Birmingham, England, and was one of the few women of her time awarded a PhD in political science, from the University of Pennsylvania. She and her mother, Tacie Stokes Paul, were already advocates of gender equality, but it was during a 1907–10 sojourn in England that she was exposed to the radical elements of the British suffrage movement, a group spearheaded by Emmeline Pankhurst (1858–1928), a women's rights organizer who promoted militant rather than passive protest.[15]

Paul was galvanized by the speeches, demonstrations, and processions she witnessed, and joined the group's ranks in 1908. The following year, she was part of a team of women who

were arrested and imprisoned for disrupting a London speech by a prominent politician. At Holloway Gaol, she and her fellow arrestees were handled roughly and placed in solitary confinement. Denied their request to be treated as political prisoners, they went on a hunger strike and were released on medical grounds. Following a similar protest, imprisonment, and hunger strike in Dundee, Scotland, Paul was honored by local suffragettes at a dinner, where she was presented with a silver and enamel brooch designed by Sylvia Pankhurst, Emmeline's mother.[16] The pin, in the form of a grilled, medieval gateway similar in shape to the UK Parliament portcullis, symbolized the dehumanizing conditions women had endured over the ages (fig. 124).[17] After several more arrests, including a month's detention again at Holloway, where she was force-fed, Paul returned home, now radicalized and on a mission.

FIGURE 123 • Avard Tennyson Fairbanks (American, 1897–1987), *Bust of Alice Stokes Paul*, 1981. Marble. Washington, DC, National Women's Party Fine Art Collection, 1981.001

FIGURE 124 • Estelle Sylvia Pankhurst, designer (British, 1882–1960), Holloway Prison Brooch, 1909. Silver and enamel, 2.5 × 2.5 × 0.6 cm (1 × 1 × ¼ in.). London, UK Parliamentary Collections, WOA S694

FIGURE 125 • Alice Paul (American, 1885–1977) and Nina Allender (American, 1873–1924), designers, Jailed for Freedom brooch, 1917. Silver, 3.8 × 3.8 × 0.6 cm (1½ × 1½ × ¼ in.). Washington, DC, National Museum of American History, Smithsonian Institution, 1987.0165.025

FIGURE 126 • Harris & Ewing Studio (American, active 1905–45), *Alice Paul Raises a Glass in Front of the Ratification Banner*, August 26, 1920. Gelatin silver print, 18 × 13 cm (7⅛ × 5⅛ in.). Washington, DC, National Woman's Party

Alice Paul wears at her waist the prison pin she helped design during the 19th Amendment ratification celebration.

During her three years in England, Paul had become increasingly aware of the powerful visual messaging that British suffragists communicated to both the general public and the press. Their well-organized pageants and parades were theatrical spectacles in which hundreds of women, clad in white dresses and carrying flags, pennants, and sashes in the suffrage colors of green (hope), white (purity), and violet (loyalty), marched to advance their cause.[18] Paul became immersed in US suffrage activities shortly after she returned to the States,

and by early 1913 had abandoned the traditional approach of genteel lobbying and petitioning. Drawing on the British suffrage playbook, she organized widely publicized events, including a parade in Washington, DC, held one day before president-elect Woodrow Wilson's inauguration. Five thousand to eight thousand suffragists participated, including several women mounted on horses and eight floats featuring tableaux vivants based on women's historical experiences.[19] They followed up this dramatic event with regular picketing of the White House, a strategy designed to embarrass Wilson, who enthusiastically supported democratic ideals in war-torn Europe while denying it to half the population at home. The picketing so angered the president that he did what Paul secretly hoped—he had the women arrested and imprisoned. This was covered in the national news, and the public outcry of injustice it aroused recruited many to the cause.

On December 9, 1917, ninety-seven members of the Congressional Union, who had been arrested during the preceding five months, were invited to a celebratory event held at the Belasco Theater in Washington, DC, where they were honored and awarded silver pins designed by Paul together with Nina Allender (1873–1924), the official artist of the National Woman's Party. The design differed from the British brooch in that it was a realistic rendition of a typical US prison door (fig. 125).[20] Its symbolism, however, resonated with the British ornament in that it embodied the dedication and courage of a cadre of women willing to endure public criticism, personal sacrifices, and physical hardships in the pursuit of deeply felt beliefs.

Paul's suffrage activities are well documented in contemporary newspaper accounts and photographs (fig. 126). The sculpture by Fairbanks, however, is unique in that it is a three-dimensional work of art created several years after the suffragist's death. It depicts a mature, determined Paul devoid of personal adornment save for the prominent prison-door brooch suspended from a neck chain as a pendant.[21] It identifies her uniquely, serving as a visual record of her major life achievement.

FRIDA KAHLO'S THORN NECKLACE
1940

AN UNUSUAL ORNAMENT—ONE BELIEVED TO BE the fantastical product of the artist's imagination—is the neckpiece featured in Frida Kahlo's *Self-Portrait with Thorn Necklace and Hummingbird* (1940, fig. 127). The ornament is unique and multilayered in its symbolism and capacity to tell something about the identity of the sitter. The portrait, one of many self-representations created during the artist's prolific career, was painted shortly after a traumatic divorce from her artist husband, Diego Rivera (1886–1957). As with many of her works, it reveals the fertile and anguished inner life of the painter through a complex melding of Aztec mythology, Christian iconography, Mexican

140

CHAPTER 6

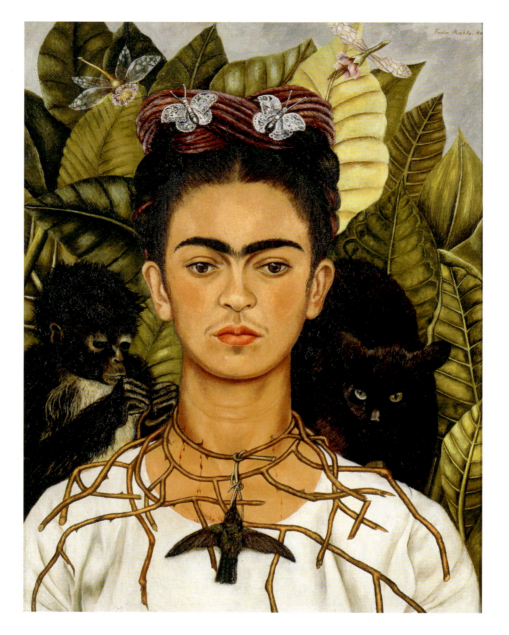

FIGURE 127 • Frida Kahlo (Mexican, 1907–1954), *Self-Portrait with Thorn Necklace and Hummingbird*, 1940. Oil on canvas on Masonite, 61.3 × 47 cm (24⅛ × 18½ in.). Austin, Nickolas Muray Collection of Mexican Art, Harry Ransom Humanities Center, University of Texas, 66.6

folklore, and the artist's personal lexicon of symbolic objects, animals, and flora. It also reflects the emergent influence of Sigmund Freud and theories of the unconscious, gender ambiguity (Kahlo sometimes donned traditional male attire), an obsession with the female body and its functions, and a unique capacity to artistically negotiate varying levels of reality.

Kahlo was born on the outskirts of Mexico City at a momentous and tumultuous period in the country's history, as it was in the throes of a civil war pitting an entrenched dictatorship aligned with an upper-class minority of Spanish descent against the mestizos, a mixed Indigenous-Spanish people who favored a constitutional republic. As a young woman, Kahlo embraced Mexican nationalism, combining her love for native culture with a passion for revolutionary politics. She was also fascinated with science and the visual arts, hoping to combine both interests in the specialized field of medical illustration. But a devastating bus accident when Kahlo was eighteen dramatically altered those plans. She sustained considerable injuries that would require numerous treatments and surgeries

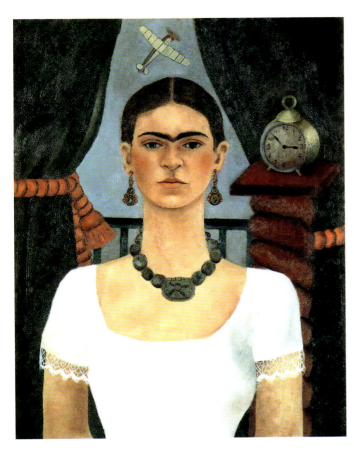

FIGURE 128 • Frida Kahlo (Mexican, 1907–1954), *Self-Portrait (Time Flies)*, 1929. Oil on canvas on Masonite, 80.6 × 69.9 cm (31¾ × 27½ in.). Collection of Bryan Anthonys

FIGURE 129 • String of jade beads with a Mayan carved fist pendant, probably assembled by Frida Kahlo (Mexican, 1907–1954). Mayan, Classic period, about 250–900 CE. Jade, 35.5 cm (14 in.) in length. Mexico City, Museo Frida Kahlo

Frida Kahlo owned and wore a number of necklaces made of irregularly shaped ancient jade beads and amulets.

over the course of her life. During her lengthy recuperation, she turned to art.

As she recovered, Kahlo became active in leftist politics, joining Mexico's Young Communist League in 1927. It was around that time that she met Rivera, an established artist twenty years her senior who was one of the founders of the muralist movement, a government-sponsored program that supported the ideals of the Mexican Revolution. Kahlo expanded her range of subjects to include portraits, hybrid images of plants and humans, sensual still-life representations, and fantastical flora. Self-portraits dominated, and within this genre, jewelry often played a prominent role. Some items, such as the artist's pre-Columbian jade beads (figs. 128, 129) and the long *torzales* chains (long, precious-metal chains with various pendants) worn with Tehuana dress, pay homage to Mexican culture,[22] while other adornments evidence Kahlo's support of contemporary Mexican silversmiths.

Her most compelling ornaments, however, are those that are the products of her vivid imagination and that externalize her inner suffering. Probably the most famous example is depicted in *Self-Portrait with Thorn Necklace and Hummingbird*, in which a prominent choker-like neckpiece composed of a leafless, thorny vine bites at the sitter's flesh. She is frozen in place, as any movement will only enhance the agony. Like Kahlo's body, many of the twigs are jagged and broken, while a continuous stream of blood droplets suggests that the damage is fresh, raw, and ongoing. Suspended in the center of the neckpiece is a dark, dead hummingbird with outstretched wings—a love token in Mexican folklore here serving as a symbol of her failed marriage. High on her head are two silver butterfly ornaments, while dragonflies encircle the lush foliage in the background. These short-lived insects are universal symbols of metamorphosis, transcendence, and resurrection.

Kahlo would live the rest of her life as a celebrity, exhibiting her work in Mexico, Paris, and the United States and teaching at the Education Ministry's School of Painting and Sculpture (La Esmeralda). While the artist is not especially known for creating three-dimensional jewelry with a message, the ornaments depicted in her paintings are often indicative of the physical and mental suffering she experienced throughout her adult life.

RUTH BADER GINSBURG'S COLLARS

2005–2016

WOMEN FIRST JOINED THE ESTEEMED RANKS of the US Supreme Court when Sandra Day O'Connor (1930–2023) was appointed to the court by President Ronald Reagan in 1981. While often siding with her conservative colleagues, O'Connor was a moderate and a consensus builder who often wrote concurring opinions rather than establishing sweeping precedents.

On gender issues, she was ardent in her belief that the sexes were equal in their capacity to reason but "was hands off when it came to creating the conditions that would help women achieve equality, believing they had the potential to accomplish anything they wanted and did not need assistance from the law."[23]

Ruth Bader Ginsburg (1933–2020) became the second woman to sit on the US Supreme Court after she was nominated

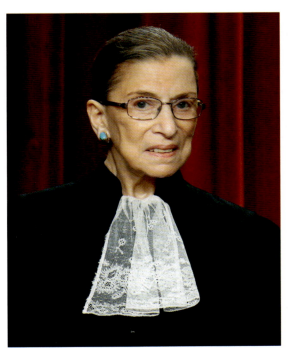

FIGURE 130 • Mark Wilson (American, 1955–2020), Ruth Bader Ginsburg in a white lace jabot fashion statement she began early in her career on the bench, December 5, 2003. Color photograph

FIGURE 131 (TOP AND BOTTOM) • Elinor Carucci (Israeli, b. 1971), photographs of a selection of Ruth Bader Ginsburg's messaging collars in *Time* magazine, 2020

Ginsburg had numerous collars, including the South African Collar (top) and the Pride Collar (bottom).

by President Bill Clinton in 1993. Her most significant contributions to national jurisprudence would lie in the area of remedying sex discrimination, applying the Fourteenth Amendment's equal-rights clause to issues such as same-sex marriage, the admission of women to all-male institutions, and access to safe abortions. By the time she was appointed to the Supreme Court, she was responsible for removing dozens of discriminatory laws from the books.

On the lighter side, Ginsburg was regarded as a pop-culture icon and fashion pioneer, bringing her unique sense of humor, purpose, and style to the unisex judicial attire donned by the high court's judges. In this regard, she is best known for her lacy jabots (an ornamental frill on the front of a shirt or blouse) (fig. 130) and decorative collars (fig. 131).[24] She is often quoted as saying, "The standard robe is made for a man because it has a place for the shirt to show and the tie…so Sandra Day O'Connor and I thought it would be appropriate if we included as part of our robe something typical of a woman. So, I have many, many collars."[25]

One of Ginsburg's favorite neck ornaments was the Dissent Collar, a scalloped, bib-style neckpiece designed by Banana Republic and composed of faux gems and pearls secured to a dark-toned textile base. Ginsburg received it in a promotional goodie bag upon receiving one of *Glamour* magazine's Woman of the Year awards in 2012. Later, in a 2014 interview with Katie Couric that included a tour of her office armoire,[26] she commented, "It looks fitting for dissents."[27] She did, in fact, wear it during her later years on the bench when she disagreed with a Supreme Court decision and, as a matter of principle, the day after Donald Trump was elected president in 2016. Other collars were gifts from colleagues, students, and admirers. An example is the Pride Collar, a traditional broad collar (symmetrical, wide, with multiple registers or rows) made of woven glass beads arranged in a rainbow of hues. A gift from a colleague at Georgetown University Law Center, this colorful adornment was crafted by a bead weaver in Ecuador and first worn on the bench in 2016. Ginsburg was a champion of LGBTQ rights during her career, and deemed this collar the perfect vehicle to communicate her support of the cause.

Ginsburg's favorite collar, a woven South African creation of small white glass beads, can be found in the official portrait of the justice that currently hangs in the Supreme Court (fig. 132). It is also the neckpiece she selected to wear to Barack Obama's first address before a joint session of Congress on December 31, 2005. Elegant and refined, it harkens back to the jabot made of openwork, machine-made lace worn during her earliest days on the bench,[28] years before she had amassed a diversity of neckpieces to choose from.

FIGURE 132 • Steve Petteway (American, b. 1955), *Ruth Bader Ginsburg*, 2013. Color photograph. Washington, DC, Collection of the Supreme Court of the United States

For several of her official Supreme Court portraits, Ginsburg wore her favorite white beaded openwork collar.

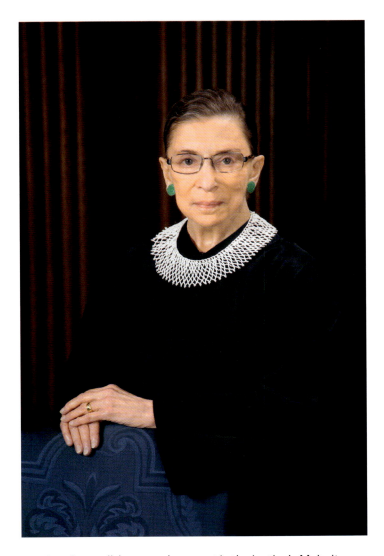

Another well-known adornment is the justice's Majority Opinion Collar, an elaborate object composed of purple ribbon, bright yellow beads, and "amethyst" pendant drops. This eye-catching ornament, purchased at the retail shop Anthropologie, was a gift from her law clerks in 2006 and worn when she announced a majority opinion from the bench. Festive and glimmering, she also wore the collar over her judicial robe while attending President Obama's State of the Union address at the US Capitol on February 12, 2013.

Why did Ginsburg adopt the decorative collar as part of her official wardrobe? At first glance, it appears contrary to her role as a women's rights advocate—a frilly, nonfunctional adornment for a fiery, no-nonsense champion of equal rights for women. Yet it accomplished a good deal in messaging a

woman's choice to celebrate and define her femininity within an ever-expanding set of roles, options, and opportunities. According to *New York Times* writer Vanessa Friedman, "The collars served as both semiology and semaphore: they signaled her positions before she even opened her mouth, and they represented her unique role as the second woman on the country's highest court. Shining like a beacon amid the dark sea of denaturing judicial robes, Justice Ginsburg's collars were unmistakable in photographs and from the court floor."[29]

The 2018 documentary film *RBG*, directed by Julie Cohen and Betsy West, was promoted with a poster that demonstrates the power and capacity for signification that can be embodied in a single personal adornment. It features an intricate lace collar surmounted by the words "HERO. ICON. DISSENTER." above the initials "RBG," with Ginsburg's full name in small print below. There is no need for an image of the woman herself, as the eye-catching lace collar and epithet say it all: brilliant, innovative, persistent, thoughtful, feminine—multiple characteristics that made up this individual's identity.

NOTES

1. Susanne Gänsicke and Yvonne J. Markowitz, *Looking at Jewelry: A Guide to Terms, Styles, and Techniques* (Los Angeles: J. Paul Getty Museum, 2019), 9.

2. The brooch was based on a 1906 design in which the birds are described as pigeons. See Yvonne Brunhammer, ed., *The Jewels of Lalique* (Paris and New York: Flammarion, 1998), 92–93.

3. Edward Park, "A Symbol That Failed," *Smithsonian Magazine*, February 1998, 20–22.

4. Neck ornaments with ram's head pendants continued to be worn by Nubian rulers during the subsequent Meroitic period (ca. 300 BCE–350 CE).

5. On the appearance of Napatan or Kushite kings, see Denise Doxey et al., *Arts of Ancient Nubia* (Boston: Museum of Fine Arts, Boston, 2018); Charles Bonnet and Dominique Valbelle, *The Nubian Pharaohs: Black Kings on the Nile* (Cairo: American University in Cairo Press, 2006).

6. Yale donated 417 books, a portrait of King George I by Sir Godfrey Kneller, and numerous art objects that were auctioned to raise funds for the construction of a new campus building. The school, originally located in Old Saybrook, Connecticut, and known as the Collegiate School, was renamed Yale College in 1718. Diana Scarisbrick and Benjamin Zucker, *Elihu Yale: Merchant, Collector and Patron* (London and New Haven, CT: Thames and Hudson, 2014), 137.

7. Alexander O. Vietor, "An Elihu Yale Conversation Piece," *Yale University Library Gazette* 35, no. 4 (April 1961): 158–60.

8. Scarisbrick and Zucker, *Elihu Yale*, 33–35.

9. Brazilian diamonds were the most important source of the gem from the 1720s onward, as fewer stones of significance were exported from India. South African diamonds did not become available until the 1860s.

10. See for instance "An Astounding Tale of Slavery and Deceit: Yale University's Madras Connection," *News Minute* (Yale University), February 13, 2017, https://www.thenewsminute.com/article/astounding-tale-slavery-and-deceit-yale-universitys-madras-connection-57228.

11. On "blood diamonds," see Bieri Franziska, *From Blood Diamonds to the Kimberly Process: How NGOs Cleaned Up the Global Diamond Industry* (Oxfordshire, UK: Routledge, 2010).

12. For a description of George Catlin's experiences during his eight years of travel in the US Northwest, see George Catlin, *My Life among the Indians* (1909; repr., Morrisville, NC: Lulu Press, 2017).

13. This necklace is now part of the collection of Native American artifacts at the Peabody Museum of Archaeology and Ethnology, Harvard University. See "Awakening the Bear" in *Discovering Lewis & Clark*, http://lewis-clark.org/article/3043.

14. See Eugene Fairbanks, "Sculptural Commemorations of Abraham Lincoln by Avard Fairbanks," *Journal of the Abraham Lincoln Association* 26, no. 2 (Summer 2005): 49–74.

15. Emmeline Pankhurst founded the radical Women's Social and Political Union in 1903.

Their motto, "Deeds Not Words," became a feminist outcry after her famous "Freedom or Death" speech in 1913. For further information on the activities of this organization, see Helen Pankhurst, *Deeds Not Words: The Story of Women's Rights, Then and Now* (London: Hodder & Stoughton, 2018).

16. For a lively account of Alice Paul's activities in England, see J. D. Zahniser and Amelia R. Fry, *Alice Paul: Claiming Power* (Oxford: Oxford University Press, 2014), 65–104.

17. Paul wore this brooch in 1912 at her graduation from the University of Pennsylvania. Personal correspondence with Paul biographer Amelia Roberts Fry, February 25, 1996. For additional information on the British suffragettes, see Elizabeth S. Goring, "Suffragette Jewellery in Britain," *Journal of Decorative Arts Society, 1850–Present* (2002): 84–99.

18. For the role of color symbolism in the British suffrage movement, see Diane Atkinson, *Suffragettes in the Purple, White and Green: London 1906–14* (London: Museum of London, 1992).

19. For photographs of this extraordinary event, see Kate Clarke Lemay, *Votes for Women: A Portrait of Persistence* (Princeton, NJ: Princeton University Press, 2019), 166–86.

20. For a firsthand account of the activities of the Congressional Union and the women who were imprisoned, see Doris Stevens, *Jailed for Freedom: American Women Win the Vote* (1920; repr., Troutdale, OR: New Sage Press, 1995).

21. Paul was photographed on numerous occasions wearing the ornament, often in novel ways, including an image where it is worn at the waist (see fig. 126). See *Alice Paul Raises a Glass in Front of the Ratification Banner*, which appears in Lemay, *Votes for Women*, 221, cat. 123.

22. The traditional outfits worn by Indigenous women in Oaxaca, consisting of colorful floor-length skirts, embroidered blouses, woven shawls, and elaborate headdresses (*huipil grande*), were for Kahlo the epitome of national identity in post-revolutionary Mexico. See Claire Wilcox and Circe Henestrosa, eds., *Frida Kahlo: Making Herself Up* (London: V&A Publishing, 2018), 67–95.

23. Linda Hirshman, "Women of the Court," in *Time Commemorative Edition: Ruth Bader Ginsburg, A Principled Life, 1933–2020* (New York: Meredith Corporation, 2020), 57–58.

24. Her signature style also included oversize glasses, black mesh gloves, and fabric hair ties to secure her low ponytail.

25. Irin Carmon and Shana Knizhnik, *Notorious RBG: The Life and Times of Ruth Bader Ginsburg* (New York: HarperCollins, 2015), 160. For an overview of Ginsburg's most famous collars, see Elinor Carucci and Sarah Bader, *The Collars of RBG: A Portrait of Justice* (New York: Clarkson Potter Publishers, 2023).

26. Andrew Hamm, "Justice Ruth Bader Ginsburg Talks with Katie Couric," SCOTUSblog, July 31, 2014, https://www.scotusblog.com/2014/07/justice-ruth-bader-ginsburg-talks-with-katie-couric/, last accessed December 2023.

27. Tessa Berenson, "Portraits of Ruth Bader Ginsburg's Favorite Collars and the Stories behind Them," *Time*, December 3, 2020, https://time.com/5914834/ruth-bader-ginsburg-collars/.

28. According to lace scholar Doris May, the lace component of the jabot probably dates to the late nineteenth or early twentieth century and is most likely based on Hinton English handwrought lace. Personal communication with the author, March 25, 2021.

29. Vanessa Friedman, "Ruth Bader Ginsburg's Lace Collar Wasn't an Accessory, It Was a Gauntlet," *New York Times*, September 20, 2020, https://www.nytimescom/2020/09/20/style/rbg-style.html.

THE THEATER OF EVERYDAY LIFE: DRESSING THE PART

Emily Stoehrer

> All the world's a stage,
> And all the men and women
> merely players;
> They have their exits and their entrances,
> And one man in his time plays many parts.
>
> —WILLIAM SHAKESPEARE, *As You Like It*

IN THE FAST-PACED TWENTY-FIRST CENTURY, image is everything. Social media has made people highly aware of the art of self-fashioning. But long before the now-ubiquitous self-portrait known simply as a selfie fueled a culture acutely aware of sartorial style, poses, and backgrounds, there was the portrait. While selfies posted by individuals to social media sites like Instagram may seem to casually depict one's daily reality, they are highly constructed to present a certain version of the truth. Portraiture—whether taking the form of smartphone self-portraits, traditional camera photographs, paintings painstakingly toiled over by fine artists, or painted coffins intended to carry one's remains into the afterlife—is complex. For thousands of years, imagery of human figures was crafted using paint, pencil, clay, eventually cameras, and everything in between. Like the selfie, the point of these depictions was to create a lasting memory and to communicate something about the subject. Portraits have a way of embedding themselves in our visual language, and as a result they affect a culture's ideals of beauty. Intentionally or unintentionally, such images capture the imagination and influence how people want to be seen.

Little has been written about the role jewelry plays in understanding identity in the twentieth and twenty-first centuries, and even less has been said about how jewelry fits into the larger theoretical framework of identity and material culture. Inherently interdisciplinary, this book examines the intersection of art and jewelry. Borrowing concepts from material culture—a field that studies objects and the larger meaning behind their creation, production, and consumption within a society—it offers a model for examining the important role of jewelry in self-fashioning. Offering a new way to approach the history of jewelry, this book considers art, history, economics of production, and the social life of things, alongside culture's structural shaping forces.

Beyond Adornment is part of a burgeoning body of literature that considers jewelry theory. This is important because while jewelry is related to fashion, decorative arts, metalwork, material culture, and many other fields of study, it is also distinct and deserving of independent consideration. Its association with any one of these areas only tells part of its story. Considering why people wear jewelry, and why it is important within a culture, is worthy of its own intensive research. Recent publications like the Dutch art historian and jewelry collector Marjan Unger's dissertation turned book *Jewellery in Context: A Multidisciplinary Framework for the Study of Jewellery*, published in English in 2020, offer a framework for thinking about the subject. Broadly seeking a definition of jewelry, Unger describes it as "an object that is worn on the human body, as a decorative and symbolic addition to its outward appearance."[1] Its wearability is an essential feature. Jewelry requires the body to function; meaning that self-presentation plays a vital role in understanding jewelry's power. Applying Unger's ideas to imagery and individual works of art, Gänsicke and Markowitz here offer an illustrated companion as they build upon Unger's concepts of jewelry and identity in their consideration of jewelry as an object that is simultaneously a decorative art, an object of adornment, and a communication device.

In the late twentieth century, scholars on both sides of the Atlantic took a closer look at material culture and identity. Important contributions from disparate disciplines explored how modernity, power relations, and capitalism have impacted the formation of individuals as cultural subjects. Similarly, material culture provided a framework for many of these theories to be considered alongside objects of daily life. Key concepts within this body of work include how material culture impacts class, status, gender, and the formation of taste. These emergent fields of study insisted on the importance of daily practices in the construction of one's self-image. Much of this research makes up the canon of the material culture discipline, and scholars of fashion and other design fields have since adopted these seminal theories and applied them to their own work, but jewelry has been neglected. In recent history, jewelry is often thought to exist in the feminine sphere, and like other subjects associated with women's studies, it has not been given the attention it deserves. But, as you have read and seen in this book, jewelry has been worn by both men and women in cultures around the globe.

In making choices about what to buy and what (or how much) jewelry to wear, individuals participate in a form of self-production. Psychologist Mihaly Csikszentmihalyi and sociologist Eugene Halton describe identity as triadic: how one sees oneself, how one is actually seen, and how one wishes to

150

THE THEATER OF EVERYDAY LIFE

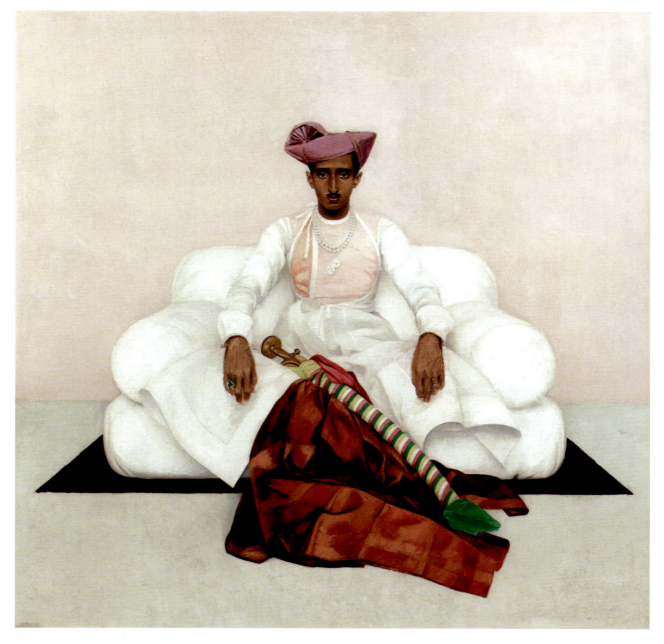

FIGURE 133 · Bernard Boutet de Monvel (French, 1881–1949), portrait of the Maharaja of Indore, Yashwant Rao Holkar II, 1934. Oil on canvas, 181.5 × 181.5 cm (71 7/16 × 71 7/16 in.). Paris, Al-Thani Collection

be seen by others.² This third element, how one wishes to be seen, is aspirational and closely connected to the consumption of images. Today this might mean adjusting one's appearance using filters on an iPhone or "curating" the images one chooses to post on social media, but in the past this would be the way an artist alters a sitter's appearance to align with the way they wish to present themselves to the world. That ideal image envisioned by the subject may have come from their consumption of other images, which will have formed preferences for the look they wish to emulate. The presentation of self is central to the understanding of the subjective, and this is a key feature in what has been termed "self-fashioning"—the crafting of a personal style.³

Early publications on self-fashioning included Erving Goffman's 1956 *Presentation of the Self in Everyday Life*. The book explored the performative nature of identity and borrowed language from theater to describe how individuals craft their personas. This seminal work emphasized self-control and the performative aspects of daily life. Goffman described private (backstage) preparation, where individuals construct their public appearance and craft their routine, for public (onstage) performance. In this way, identity is largely performative, and Goffman sees one's audience, the friends and strangers with whom one interacts, as an important factor of one's performance. Fluid and often situational, one person can play varying roles in a day, a year, or a lifetime. Individuals read verbal and social cues as signs, constantly analyzing the world around them as their performance evolves. Goffman's scholarship is useful in understanding how fashion—and jewelry as an element of fashion—relates to ideas about the self. While clothes are changed daily, some jewelry is worn regularly, forming a deep connection between object and wearer. Jewelry saved for a special occasion is no less meaningful, sometimes handed down through generations and holding deeply personal and/or cultural significance.

The jewelry one chooses to wear has many stories to tell. Displaying power, communicating religious beliefs or romantic attachment, or highlighting the beauty of the wearer, portraits feature jewelry as a key part of the overall image. Its inclusion begs the question: Why do people wear jewelry? Not only that, but what personal meaning does it hold for the wearer? What do they hope it will convey to the people they encounter, or those viewing their image decades, even centuries, later?

To be fully understood, jewelry's function must be studied in relation to art, clothing, and culture. The 1934 portrait of the Maharaja of Indore, Yashwant Rao Holkar II, by Bernard Boutet de Monvel offers insight into the way a portrait can function as both a display of taste *and* an expression of power (fig. 133). Here the Maharaja is depicted in mostly traditional Indian

garments, but cloaked behind a gigantic double strand of pearls is a diamond and platinum necklace by the French jewelry house Chaumet. The necklace offers a lightness that is at odds with its two massive pear-shaped diamond drops. The design seems to emulate a silk cord and tassel, but with 46.7 carat and 46.95 carat diamonds. The impressive necklace was purchased by Holkar's father in 1911.[4] Inextricably linked to the Maharaja of Indore, the two large pear-shaped diamonds have since become known as the Indore Pears.

At the time, Indian maharajas were selling off their collections of traditional (for them) jewelry featuring colorful, carved gemstones and buying pieces with a more modern, monochromatic Western aesthetic. The practice had a profound effect on jewelers like Cartier, who purchased the carved gemstones and used them to create bold, colorful bracelets and necklaces in floral and vegetal designs (later termed tutti-frutti) that grew to define the late art deco period and became very popular among US and European clients.

Educated at Oxford, Holkar II succeeded his father in 1926, at the age of seventeen. He was a connoisseur of art deco design and intensely interested in bringing Western design aesthetics to India. He had an eye for sartorial style and was thoughtful about the way he presented himself to the world in terms of the clothing and jewelry he chose and what they would convey. His home, Manik Bagh Palace in Indore, was built by the German architect Eckart Muthesius in the art deco style. Together with his wife, Maharani Sanyogita Bai Devi, he filled it with extraordinary examples of European art deco design.[5] And in contemporaneous portraits of the couple, they represented the pinnacle of French fashion and jewelry. The Boutet de Monvel portrait demonstrates this preference for European finery, with the diamonds immortalized in their Chaumet setting.

Ever modern, Holkar II and his wife had the Indore Pears reset around the time the Maharaja's portrait was completed. The artist later painted a fashionable Maharani wearing a sumptuous white silk dress with the newly set diamonds, now with emeralds, in a necklace by the French designer Mauboussin (fig. 134). Subsequently, the Indore Pears were purchased by the luxury jeweler Harry Winston and recut. They no longer exist. But these portraits forever associate the couple with these famous diamonds. This is but one example of the way jewelry and portraiture together create an image that connects a person to their jewelry in a particular time and place. Jewelry, like portraits, has stories to tell. The Indore Pears offer a story of wealth and power, art and fashion, but all jewelry holds secrets, or at least memories of birthdays, anniversaries, or celebrations of love, and can serve as remembrances of those no longer with us. Each piece of jewelry featured in this

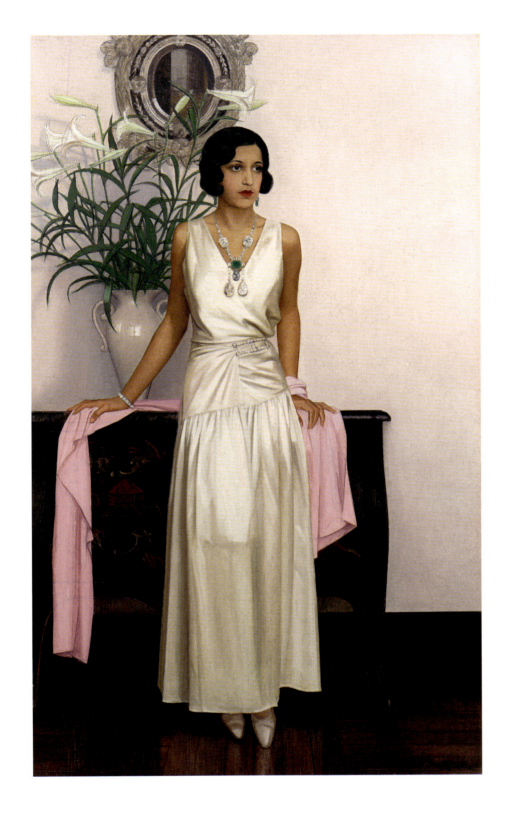

FIGURE 134 • Bernard Boutet de Monvel (French, 1881–1949), portrait of Maharani Sanyogita Devi of Indore, ca. 1931–38. Oil on canvas, 190 × 112 cm (74 3/16 × 44 1/16 in.)

book was chosen for a reason by its wearer. It carries stories both personal and collective, from wealth and power to love and loss.

Jane Lathrop Stanford was a passionate collector of high-style jewelry, and is believed to have had the most important collection of gem-set jewelry in the nineteenth-century United States. Many of her jewels were gifts from her husband, Leland Stanford, and had sentimental meaning. For example, a gold, enamel, and diamond timepiece manufactured by the Swiss firm Patek Philippe and retailed by the San Francisco jeweler J. W. Tucker & Co. bears the inscription "J. Lathrop Stanford / from Leland / Jan. 1st 1968." At the time of the gift, Stanford was pregnant with her son, Leland Jr., who died as a youth, and in whose memory Stanford University was founded. Another ornament Jane Lathrop Stanford owned that served more as an example of wealth and power than of personal sentiment is a historically significant diamond necklace and earrings that were featured in the Tiffany & Co. display at the Philadelphia Centennial Exposition of 1876. Tiffany historian John Loring describes the neck ornament as being composed of "thirteen perfectly-matched pairs of old Indian diamonds" with one enormous gem in the center. This attention-grabbing jewel was priced at the then-astronomical sum of $80,000, and the earrings at $16,000.[6] Stanford's husband died in 1893, and afterward she struggled to furnish the money needed to expand Stanford University's campus and fund its upkeep. She proposed selling her jewelry, valued at $500,000.[7] Shortly before her death, she wrote, "I now request the Trustees to establish and maintain a library fund, and upon the sale of said jewels, after my departure from this life, I desire that the proceeds…be used exclusively for the purchase of books and other publications."[8]

Before the sale, Stanford had her jewelry photographed by I. W. Tabor, a California photography firm with an international reputation. Stanford was closely involved throughout the process and at some point decided to commission a more elaborate record of her prized collection—a portrait depicting an artistic arrangement of the most outstanding pieces. In 1899, she hired local artist Astley David Middleton Cooper to create a realistic rendition of the jewels, taking into account their size, color, and radiance (fig. 135). Stanford died in 1905, and in 1908 the university trustees indeed established the Jewel Fund, an endowment for the library seeded using the monies from the sale of Stanford's jewelry. Today Stanford's collection is immortalized at the Cantor Art Center at Stanford University, where the large painting of the jewelry, in an impressive gilded frame, is frozen in time as if the jewelry itself were there in a vitrine. Stanford understood that the painting would likely outlast her actual jewels, which would inevitably be

FIGURE 135 • Astley David Middleton Cooper (American, 1856–1924), portrait of the Stanford jewels, 1899. Oil on canvas, 127 × 190.5 cm (50 × 75 in.). Palo Alto, California, Cantor Art Center at Stanford University, JLS.16294

turned into new pieces to reflect changing tastes as they dispersed into the world—the gemstones reset, the gold melted down, and the history lost. The Stanford jewelry offers a love story—gifts from husband to wife and, through the sale of jewelry, to the university that bears her son's name.

In the painting, this jewelry has been removed from the market and its meaning has shifted to become singular, special, sacred. In "being pulled out of their usual commodity sphere," these portraits become what Igor Kopytoff describes as "singularized." They operate outside the traditional system of commercial exchange and, as a result, their value becomes impossible to determine.[9] Singularized objects such as the British crown jewels, church relics, or museum collections are in a way priceless. Like other works of art, much of the jewelry described in this book has moved from the world of commodity to that of the sacred. With the exception of Stanford's pocket watch, which is exhibited in a case beside the painting, most of Stanford's jewelry is indeed lost today. The painting memorializes a collection that history might likely otherwise forget and demonstrates Stanford's devotion to the college and her family's legacy.

FIGURE 136 • Jean-Auguste-Dominique Ingres (French, 1780–1867), preparatory pencil drawings for the portrait of Madame Moitessier, 1851. Graphite on tracing paper, squared in black chalk, 35.4 × 16.8 cm (14 × 6⅝ in.). Los Angeles, J. Paul Getty Museum, 91.GG.79

FIGURE 137 • Jean-Auguste-Dominique Ingres (French, 1780–1867), portrait of Madame Moitessier, 1851. Oil on canvas, 147 × 100 cm (57⅞ × 39⅜ in.). Washington, DC, National Gallery of Art, 1946.7.18

In both of these examples, paintings are used to document jewelry's provenance and history. But who determines what we—the viewers—actually see? The idea of "projecting a powerful presence," as elucidated by the chapter of the same name in this book, is quintessentially illustrated in the royal portraits that circulated through the courts of Europe in centuries past. But even more modest portraits offer insights into an individual's tastes. Often created under the close watch of the subject, some portraits, especially if accompanied by surviving documentation, offer insight into the back-and-forth that takes place between an artist and their subject regarding clothing and jewelry choices.

The act of dressing is a complex daily ritual that deeply relates to one's understanding of oneself. Sometimes others, including artists, photographers, or stylists, are integral to the presentation process. Once a portrait is finished, it remains difficult, if not impossible, to know whose choices

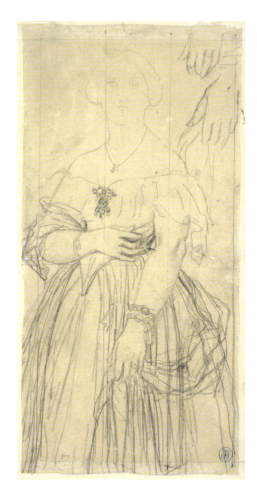

FIGURE 138 • Julien Hudson (American, 1811–1844), *Portrait of a Young Woman in White*, ca. 1840. Oil on canvas, 73 × 60.3 cm (28¾ × 23¾ in.). Cambridge, Massachusetts, Harvard Art Museums, 2017.229

we are seeing. The known backstory of the portrait of Madame Moitessier, completed by the French artist Jean-Auguste-Dominique Ingres in 1851, offers rare insight into the portrait-making process (fig. 136). In correspondence between Ingres and Marie-Clotilde-Inès Moitessier, the artist instructed her to "bring on Monday your jewel chest, bracelets, and the long pearl necklace, and we will choose what to represent."[10] Pencil drawings in the Getty Museum collection capture the choice of jewels as Ingres worked out different options before settling on the final composition (fig. 137). The artist was fastidious in his desire to paint Moitessier's reality in painstaking detail. Yet, despite this care, Moitessier was unhappy with her physical appearance in the painting, and it never hung in the public spaces in her home. In this example, the related documentation greatly aids in understanding what is realized in the final painting.

Jewelry is not neutral; it is a visual marker that assists in quickly gathering "who's who" and "what's what."[11] This is the case with an anonymous woman in white in a portrait made around 1840 (fig. 138). The painting was acquired by Harvard

Art Museums in 2017, and as curators sought to learn more about who this young woman was, they considered her clothing and jewelry. The painting is by Julien Hudson, who had a studio in the French Quarter of New Orleans. Hudson studied in Paris with a former student of the massively successful neoclassicist French painter Jacques-Louis David, and is among the earliest known professional US painters of African descent.[12] Hudson's untimely death at the age of thirty-three meant that he left relatively few artworks behind, and much is still being learned about his life and career. In Harvard's painting, the sitter is unknown but is thought to be a free woman of color.[13] Yet, while the young woman remains anonymous, her jewelry reveals an important detail of her life. She is wearing a fine gold chain with a pendant featuring a diving bird with outstretched wings. The pendant represents the *esprit d'esprit*, or Holy Spirit, a religious symbol shown as a bird, often a dove, diving down from Heaven. Such necklaces were worn by Catholics in France, as well as in Quebec and New Orleans.[14]

Anthropologist Daniel Miller explains that "things make people just as much as people make things."[15] This thing, this necklace, identifies the wearer as Catholic. Its inclusion in the painting offers insight into the values of this anonymous subject. The wearing of this necklace means that this woman was comfortable being Catholic during a moment when Catholics were not necessarily welcome. At a time when much of the country harbored anti-Catholic and anti-Irish sentiments, such that it would have been unusual for one to flaunt their Catholicism in such a visible manner, New Orleans, with its strong ties to French and Spanish culture, had a religious history more welcoming of Catholics, and it was not uncommon for Catholic Creole women to wear necklaces like this.[16] In nineteenth-century US society, this necklace held deep spiritual meaning, and for us, more than one hundred and fifty years later, the jewelry arguably offers more insight into the sitter's identity than any other element depicted.

On the other hand, historian Susan Vincent offers that our analysis of someone else's adornment might say "more about our values than what the wearer of these garments necessarily felt."[17] Jewelry choices can at once reveal and conceal one's identity, offering opportunities for both authenticity and artifice. The items we wear might be expressions of truest selves, but conversely they might "act as disguises rather than as reflections."[18] In this way, jewelry can express our truest selves or generate a fantasy about who someone is.

In Gustav Klimt's 1907 portrait of Adele Bloch-Bauer, the artist intentionally blurs reality and fantasy (fig. 139). Klimt captures the Viennese hostess and collector, the only person Klimt painted more than once, in an ostentatious display of

FIGURE 139 • Gustav Klimt (Austrian, 1862–1918), *Portrait of Adele Bloch-Bauer I*, 1907. Oil, gold, and silver leaf on canvas, 140 × 140 cm (55⅛ × 55⅜ in.), Neue Galerie New York, acquired through the generosity of Ronald S. Lauder, the heirs of the Estates of Ferdinand and Adele Bloch-Bauer, and the Estée Lauder Fund

finery in which she arguably both wears and becomes jewelry. Encircling her throat is a necklace given to her by her husband, Ferdinand, on their wedding day, and on her left wrist, three gold bracelets are stacked. Her head, neck, chest, and arms float against a gold background. In 1903, while Klimt was working on this painting, he visited Ravenna, Italy, and saw the lustrous mosaic of Empress Theodora at the Church of San Vitale.[19] His painting was no doubt influenced by his time spent looking at and thinking about those wall mosaics. It is hard to tell where Bloch-Bauer's body ends and the background begins. Whereas Empress Theodora, who glimmers in her jeweled finery, is presented in a way that indicates her elevated status, Klimt's rendering of Bloch-Bauer is avant-garde by comparison.

In the 1930s and first half of the 1940s, a time of crisis and desperation in the United States and elsewhere, cinema became an imaginative reprieve, and women especially watched and afterward fantasized about wearing similar clothing or jewelry or behaving in a kindred way to the film stars. For actresses, wearing jewelry has long been an essential part of being a movie star. Unlike clothing, which was (and still is) dictated by costume designers, actresses such as Joan Crawford and Marlene Dietrich sometimes wore their own jewelry on-screen, and they favored sculptural ornaments with large gemstones, which were fashionable during this period. Paired with shimmering costumes, the bold and glittering jewels created an otherworldly effect. The chapter "Fantasizing the Present" outlines how jewelry's allure played directly into Hollywood glamour and had a key role in raising morale during the Great Depression and World War II.

In 1935, after winning an Academy Award for the role of Ellie Andrews in *It Happened One Night*, Claudette Colbert became Hollywood's highest-paid actor, the second-highest-paid person in Hollywood behind Metro-Goldwyn-Mayer cofounder Louis B. Mayer, and the fourth-highest-paid luminary in the United States.[20] A few years later, she told the *Boston Globe*: "Being French I am conservative.... But when you become a motion picture star, you have to behave like one."[21] A famous starfish brooch she owned was designed by Juliette Moutard and fabricated in the Parisian workshop of Charles Profilet (fig. 140). By the time Colbert bought it in 1938, it had been illustrated in both French and American *Vogue*, but she is still said to have been surprised by its sensual nature. Unlike many of the jewels discussed here, this brooch still exists and is today part of the collection of the Museum of Fine Arts, Boston. It is four inches wide, and its arms bend and sway with the help of many small hinges. The portrait in figure 141 is one of just two known photographs of Colbert wearing the brooch. Here is a motion picture star at the height of her acting career, wearing a star.

As Hollywood's manufacture of glamour crept into daily life, the mental pictures received came to inform our understanding of how clothing and jewelry should be worn and the gestures that should accompany such styles. In our postmodern era, where history is often reconsidered through a contemporary lens, artists have crafted new images of the past to question social structures and provoke conversation. The Haitian-born artist Fabiola Jean-Louis seeks to redress the absence of Black women in visual culture. Among her numerous works in an array of media is the photographic series *Rewriting*

FIGURE 140 • Juliette Moutard (French, 1900–1990) for René Boivin (French, founded 1890), starfish brooch, 1937. Gold, ruby, and amethyst, 10.8 × 10.2 cm (4¼ × 4 in.). Museum of Fine Arts, Boston, museum purchase with funds donated by the Rita J. and Stanley H. Kaplan Family Foundation, Monica S. Sadler, Otis Norcross Fund, Helen and Alice Colburn Fund, the Curators Circle: Fashion Council, Nancy Adams and Scott Schoen, Seth K. Sweetser Fund, Theresa Baybutt, Emi M. and William G. Winterer, and Deborah Glasser, 2019.654.1

FIGURE 141 • Alfred Eisenstaedt (German, 1898–1995), photograph of Claudette Colbert (pictured in 1938) wearing her starfish brooch designed by Juliette Moutard for René Boivin, 1937. Gelatin silver print, ferrotyped, 25.4 × 20.6 cm (10 × 8⅛ in.). Museum of Fine Arts, Boston, Frank M. and Mary T. B. Ferrin Fund, 2021.610

History (2015–17), historical-looking photographs modeled after extant eighteenth-century paintings, replacing the elite white women who were the focus of the paintings with Black subjects. For instance, François Boucher's *Madame de Pompadour* (1756) sparked *Marie Antoinette Is Dead* (2016), featuring a Black subject wearing a *robe a la française* carefully crafted out of paper that is nearly identical to the pink-and-blue dress worn by Pompadour; other changes include a faceless Black doll dressed in a yellow and purple printed African textile. Jewelry is part of nearly every work in the series, but it is most powerfully present in *Madame Leroy* (2017, fig. 142), in which the subject wears an oversize pendant featuring a lynching scene of a Black man hanging from a pink cherry blossom tree set against a bright blue sky. The subject stares out at the viewer as if saying, "Let me tell you about this." As with everything else in the portrait, Jean-Louis created the jewelry as part of the composition. In this series, the artist thinks about the histories that people carry internally, noting, "We'll always look to the past for guidance. That's why we keep memories and have mementos. It's why we look at old photos and we love them so much. We look to the past for some sort of comfort, to help us answer 'how did we get here?'"[22] Her work reminds the viewer that "history is not immutable. Like memory, it must be constantly recalled, re-evaluated and re-integrated into the present."[23] Jean-Louis's photographs aim to provoke questions and challenge us to confront history.

 Jewelry communicates. Its language can resonate across a room, projecting something about the wearer, or across time, as someone looks at an ancient jewelry artifact to better understand the culture that produced it. For former US secretary of state Madeleine Albright, jewelry was part of her "diplomatic arsenal."[24] Her landmark book and exhibition, *Read My Pins: Stories from a Diplomat's Jewel Box* (2009), shared with a broad audience the ways jewelry can function as a language. Albright's pins are not so different in nature or communicative power from the famous eighteenth-century Wedgwood anti-slavery medallions featuring a slave on bended knee under the question: "Am I not a man and a brother?" Or, as we learned in the chapter "Who I Am," Alice Paul's 1909 "Jailed for Freedom" brooch, a version of which was proudly worn by members of the National Woman's Party who were imprisoned after protesting outside the White House in 1917. The brooch went on to become a symbol of women's suffrage.

 While jewelry can function on its own, this book has demonstrated that it is more powerful when worn on the body. Looking side by side at jewelry objects and imagery of jewelry being worn, Gänsicke and Markowitz have offered insight and visual indicators of the role jewelry plays in self-presentation. Offering a framework for approaching the

FIGURE 142 • Fabiola Jean-Louis (Haitian, b. 1978), *Madame Leroy*, 2017, from the series Rewriting History. Archival pigment print, 78.7 × 61 cm (31 × 24 in.)

study of jewelry through the lenses of decorative arts, adornment, and messaging—where one object or image can tell multiple stories simultaneously—they have demonstrated that, like so many other art forms, jewelry speaks loudly and has much to say. The authors hope that the present book provides many ideas for future scholars to build upon as they continue to explore the multifaceted world of jewelry.

NOTES

1. Marjan Unger, *Jewellery in Context: A Multidisciplinary Framework for the Study of Jewellery* (Stuttgart, Germany: Arnoldsche Verlagsanstalt, 2020), 18.

2. Mihaly Csikszentmihalyi and Eugene Halton, *The Meaning of Things: Domestic Symbols and the Self* (Cambridge: Cambridge University Press, 1981). See also Richard Jenkins, *Social Identity* (New York: Routledge, 2008).

3. On self-fashioning, see Stephen Greenblatt, *Renaissance Self-Fashioning: From More to Shakespeare* (Chicago: University of Chicago Press, 1980).

4. Amin Jaffer, "Indian Princes and the West," in *Maharaja: The Splendor of India's Royal Court* (London: Victoria & Albert Museum, 2009), 217.

5. The couple's visionary project was celebrated in the 2019 exhibition *Moderne Maharajah, un mécène des années 1930*, Musée des Arts Décoratifs, Paris.

6. John Loring, *Tiffany Jewels* (New York: Harry N. Abrams, 1999), 62–63.

7. Both a widespread economic depression in the United States (known as the Panic of 1893) and a $15 million government suit against Leland Stanford's estate significantly impacted ongoing support of the nascent university. See Bertha Berner, *Mrs. Leland Stanford: An Intimate Account* (Stanford, CA: Stanford University Press, 1934), 102–3.

8. Stanford University, The Founding Grant with Amendments, Legislation, and Court Decrees (Palo Alto, CA: Stanford University, 1987), 27.

9. Igor Kopytoff, "The Cultural Biography of Things: Commodity as Process," in *The Social Life of Things: Commodities in Cultural Perspective*, ed. Arjun Appadurai (Cambridge: Cambridge University Press, 2015), 73–74, 68–70.

10. From the audio under "Related Content" at "Madame Moitessier, Ingres," National Gallery of Art, https://www.nga.gov/collection/art-object-page.32696.html#related-pages, accessed April 6, 2022.

11. Richard Jenkins, *Social Identity* (New York: Routledge, 2008), 5. Jenkins is not speaking of jewelry here, but this concept and his discussion of identity applies to an understanding of jewelry.

12. See Erin N. Greenwald, ed., *In Search of Julien Hudson: Free Artist of Color in Pre–Civil War New Orleans* (New Orleans: Historic New Orleans Collection, 2010).

13. Ethan Lasser, "The Unknown Sitter," *Index*, Harvard Art Museums, March 15, 2018, https://harvardartmuseums.org/index-magazine; and Julien Hudson, gallery text for *Portrait of a Young Woman in White*, Harvard Art Museums, https://harvardartmuseums.org/collections/object/359903.

14. A necklace bearing the same symbol is worn in an 1841 painting by Luigi Marie Sotta of Mademoiselle Lezin Becnel II (née Marie Josephine Lennen) of New Orleans and today resides in the collection of the Louisiana State Museum, New Orleans. Unlike this anonymous sitter, Becnel's Catholic heritage is well documented. See "Marie Josephine Lennen Becnel: A Portrait," Evergreen Plantation, May 5, 2020, https://www.evergreenplantation.org/evergreen-blog/2020/5/2/marie-josephine-lennen-becnel-a-portrait.

15. Daniel Miller, *Stuff* (Cambridge: Polity, 2010), 135.

16. Little is yet known about what types of jewelry were worn and sold in New Orleans during the nineteenth century. Martha Gandy Fales's seminal book *Jewelry in America* (Suffolk, England: Antique Collectors Club, 1995) used public collections to research jewelry as far south as Charleston, South Carolina, but did not include New Orleans.

17. Susan J. Vincent, *The Anatomy of Fashion: Dressing the Body from the Renaissance to Today* (London: Berg, 2009), xv.

18. Csikszentmihalyi and Halton, *The Meaning of Things*, 15.

19. Gustav Klimt's "Portrait of Adele Bloch-Bauer I," https://artsandculture.google.com/story/gustav-klimt's-"portrait-of-adele-bloch-bauer-i-quot-neue-galerie-new-york/fQWRgy-UV1Ge2g?hl=en.

20. "My Income: One Minute with Claudette Colbert," *Photoplay*, October 1940, 73.

21. Mayme Peak, "Hollywood's $1,000,000 Girl: Claudette Colbert, Highest Paid Star, Receives More Money Than Her Bosses, but She Can Only Save a Little of It," *Boston Globe*, July 21, 1940, C5.

22. Andrea Bell, "The New Narratives of Fabiola Jean-Louis," *Whitehot Magazine of Contemporary Art*, September 2018, https://whitehotmagazine.com/articles/new-narratives-fabiola-jean-louis/4034.

23. "About *Rewriting History*," http://www.fabiolajeanlouis.com/aboutrewritinghistory.

24. "Read My Pins: The Madeleine Albright Collection," Museum of Arts and Design, New York, https://madmuseum.org/exhibition/read-my-pins.

ABOUT
THE
AUTHORS

YVONNE J. MARKOWITZ is the Rita J. Kaplan and Susan B. Kaplan Curator Emerita of Jewelry at the Museum of Fine Arts, Boston. She is also the cofounder/codirector of the Association for the Study of Jewelry and Related Arts and the author of several books on ancient Egyptian and Nubian adornment.

SUSANNE GÄNSICKE is the senior conservator of antiquities at the J. Paul Getty Museum. She was objects conservator at the Museum of Fine Arts, Boston, from 1990 to 2016. Her research interests include manufacturing techniques of ancient and historic metalwork, and the intersection of traditional craftsmanship and conservation. She is the coauthor, with Yvonne J. Markowitz, of *Looking at Jewelry* (2019).

EMILY STOEHRER is the Rita J. Kaplan and Susan B. Kaplan Senior Curator of Jewelry at the Museum of Fine Arts, Boston.

ACKNOWLEDGMENTS

The authors would like to thank our colleagues at Getty Publications: senior editors Ruth Evans Lane and Linda Lee, graduate interns Chloe Millhauser and Kate Justement, freelance copy editor Lindsey Westbrook, rights assistant Danielle Brink, senior production coordinator Michelle Woo Deemer, and lead designer Jeffrey Cohen. Special thanks are due to former editor in chief Karen Levine, who initiated the discussions that led to the conception of this volume, and to Tim Potts, Maria Hummer-Tuttle and Robert Tuttle Director of the J. Paul Getty Museum, for his support.

Many jewelry scholars and specialists graciously assisted in the publication of this book, among them Anne Bentley, Ali Cervellero, Beatriz Chadour-Sampson, Jeannine Falino, Biri Fay, Tom Heyman, Elizabeth Karcher, Elyse Zorn Karlin, Peter Lacovara, Doris May, Jack Ogden, and Beth Wees.

We would like to convey our gratitude to Emily Stoehrer for her contribution to this publication. She is an innovator at the forefront of jewelry research and scholarship.

ILLUSTRATION CREDITS

Page i; Fig. 80: philadelphiamuseum.org; Page ii; Fig. 89: © Dahesh Museum of Art, New York / Bridgeman Images; Page iv; Fig. 90: Photo: John Kobal Foundation / Getty Images; Page v; Fig. 86: © Musée du Louvre, Dist. RMN-Grand Palais / Photo: Angela Dequier / Art Resource, NY; Page vi; Fig. 19: Cartier Paris Documentation; Page vii; Fig. 121: Wisconsin Historical Society; Page viii; Fig. 75: © RMN-Grand Palais / Photo: Franck Raux / Art Resource, NY; Page x; Fig. 12: From the Woburn Abbey Collection; Page xii; Figs. 7, 11, 46, 82, 83: © The Trustees of the British Museum / Art Resource, NY; Fig. 1: The Society of the Cincinnati, Washington, DC; Figs. 2, 138: © President and Fellows of Harvard College; Fig. 3: CC BY-SA 2.0 / © Carole Raddato / Wikimedia Commons; Figs. 4, 96: Photo 12 Collection / Alamy Stock Photo; Fig. 5: © Araldo de Luca; Fig. 6: © SMB Ägyptisches Museum und Papyrussammlung / Photo: Margarete Büsing; Fig. 8: Photo: Tahnee Cracchiola; Fig. 9: Photo: GNM / Dirk Messberger; Figs. 10, 34, 36, 81, 87, 117: metmuseum.org; Figs. 13, 45: Victoria and Albert Museum, London; Fig. 14: Image © Museo Nacional del Prado / Art Resource, NY; Fig. 15: © RMN-Grand Palais / Photo: Herve Lewandowski / Art Resource, NY; Figs. 16, 18, 88: Royal Collection Trust / © His Majesty King Charles III, 2024 / Bridgeman Images; Figs. 17, 58: Royal Collection Trust / © His Majesty King Charles III, 2024; Fig. 21: © Liu Chunhua, 1968 / Album / Alamy Stock Photo; Fig. 22: VisualHongKong / Alamy Stock Photo; Fig. 23: © Miho Museum; Fig. 25: Jennifer Graylock / Alamy Stock Photo; Fig. 26: CC BY-SA 4.0 / State Museums of Berlin, Egyptian Museum and Papyrus Collection / Photo: Sandra Steiß; Fig. 27: Sipan Archaeological Project - Walter Alva / Photo: Juan Pablo Murrugarra; Fig. 28: Jose Lucas / Alamy Stock Photo; Fig. 29: © Musée du quai Branly - Jacques Chirac, Dist. RMN-Grand Palais / Photo: Jean-Gilles Berizzi / Art Resource, NY; Fig. 30: © The Trustees of the British Museum. All rights reserved.; Fig. 31: Walters Art Museum, Baltimore; Figs. 32, 39, 44, 51, 64–69, 140, 141: Photo: © 2025 Museum of Fine Arts, Boston; Fig. 33: Craig Lovell / Eagle Visions Photography / Alamy Stock Photo; Fig. 35: Photo: Paul Popper / Popperfoto via Getty Images; Fig. 37: Leiden University Libraries; Fig. 40: Swiss National Museum / Alice and Louis Koch Collection; Fig. 41: Vidimages / Alamy Stock Photo; Fig. 42: © 2009 Christie's Images Limited; Fig. 43: Rijksmuseum, Amsterdam; Figs. 47, 48: Cranach Digital Archive (lucascranach.org); Fig. 59: Oscar Heyman; Fig. 60: Courtesy of the National Archives, Eisenhower Presidential Library, Abilene, KS; Fig. 61: Cecil Beaton Archive © Condé Nast; Fig. 62: © Cartier / Photo: Louis Tirilly; Fig. 63: Peter Morgan / Reuters Pictures; Fig. 70: Fabeldier Looman / Alamy Stock Photo; Fig. 71: © Musée de l'Armée, Dist. RMN-Grand Palais / Photo: Emilie Cambier / Art Resource, NY; Fig. 72: © RMN-Grand Palais / Photo: Jean-Gilles Berizzi / Art Resource, NY; Fig. 73: © RMN-Grand Palais / Photo: Jean-Pierre Lagiewski / Art Resource, NY; Fig. 74: gallica.bnf.fr / Bibliothèque nationale de France; Fig. 76: Peter Horree / Alamy Stock Photo; Fig. 78: © Museo Nazionale Etruscan of Villa Giulia. Photographic archive / Giuseppe Moretti Fund; Fig. 79: © National Portrait Gallery, London; Fig. 85: American School of Classical Studies at Athens, Archives, Carl W. Blegen Papers; Fig. 91: From the Neil Lane Collection; Fig. 92: PictureLux / The Hollywood Archive / Alamy Stock Photo; Figs. 93, 110: Allstar Picture Library Ltd / Alamy Stock Photo; Fig. 94: Photo: © Christie's Images / Bridgeman Images; Fig. 95: From Penny Proddow, Debra Healy, and Marion Fasel, *Hollywood Jewels: Movies, Jewelry, Stars* (Abrams, 1992), 88; Fig. 97: From Yvonne. J. Markowitz, *The Jewels of Trabert & Hoeffer-Mauboussin: A History of American Style and Innovation* (Museum of Fine Arts, Boston, 2014), fig. 1; Figs. 98, 108: Photo: Hulton Archive / Getty Images; Fig. 99: Photo: MGM Studios / Archive Photos / Getty Images; Fig. 100: Pictorial Press Ltd / Alamy Stock Photo; Fig. 101: Heritage Auctions / HA.com; Fig. 102: From the Neil Lane Collection / Photo: Lendon Flanagan; Fig. 103: Topfoto; Fig. 104: M.G.M / Album / Alamy Stock Photo; Fig. 106: Album / Alamy Stock Photo; Fig. 107: Everett Collection Inc / Alamy Stock Photo; Fig. 109: Photo: David Behl © 1992; Fig. 111: Moviestore Collection Ltd / Alamy Stock Photo; Fig. 112: Photo: Ewing Galloway/UIG / Bridgeman Images; Fig. 113: © Sandro Vannini / Bridgeman Images; Fig. 114: *Portrait of Edith Wilson by Elizabeth Karcher, May 2024*, Executive Director, Woodrow Wilson House, National Trust for Historic Preservation. Reprinted with Permission.; Fig. 115: Division of Political History, National Museum of American History, Smithsonian Institution; Fig. 116: © Swiss-French-Sudanese mission at Kerma – Dukki Gel / Photo: Nicolas Faure; Fig. 119: The Picture Art Collection / Alamy Stock Photo; Fig. 122: Courtesy of the Peabody Museum of Archaeology and Ethnology, Harvard University; Fig. 123: NPS / Victoria Stauffenberg; Fig. 124: © The Artist or their estate / Photo: Parliamentary Art Collection WOA S694; Fig. 125: Division of Political History, National Museum of American History, Smithsonian Institution; Fig. 126: Chronicle / Alamy Stock Photo; Fig. 127: © 2024 Banco de México Diego Rivera Frida Kahlo Museums Trust, Mexico, D.F. / Artists Rights Society (ARS), New York / Erich Lessing / Art Resource, NY; Fig. 128: © 2024 Banco de México Diego Rivera Frida Kahlo Museums Trust, Mexico, D.F. / Artists Rights Society (ARS), New York / The Artchives / Alamy Stock Photo; Fig. 130: Photo: Mark Wilson / Getty Images; Fig. 131: © Elinor Carucci / top: Favorite: South African Collar, Ginsburg's Favorite Collar, Work in her Official Portrait, 2020; bottom: Pride: Pride Collar (2016), 2020; Fig. 132: The Syndicate / Alamy Stock Photo; Fig. 133: © 2024 Artists Rights Society (ARS), New York; Fig. 134: © The Al Thani Collection 2019. All rights reserved. Photo: Prudence Cuming Associates Ltd / © 2024 Artists Rights Society (ARS), New York; Fig. 135: © Ron Henggeler; Fig. 136: Penta Springs Limited / Alamy Stock Photo; Fig. 137: Courtesy National Gallery of Art, Washington, DC; Fig. 139: Neue Galerie, New York; Fig. 142: © Fabiola Jean-Louis / Courtesy artist Fabiola Jean-Louis and Galerie Myrtis

INDEX

Page numbers in *italics* refer to illustrations.

ACHAEMENID EMPIRE, *6*, 26, 102
Achilles, 32, *33*
Adams, Abigail, 65–68, *66*, *67*, 80n21, 80n23
Adams, John, 65–68, *66*, *67*, 80n23
Adrian, 109, 127n13
Akhenaten (Egyptian king), 7–9, *128*, 129
Albert, Prince (consort of Victoria), 27, *27*, 29
Albright, Madeleine, 162
Allender, Nina, *138*, 139
Amanishakheto (Nubian queen), 89, *90*
amethysts, 16, 74, *75*, *102*, *161*
amulets, 17, 44–47, *44*, *45*, 58, 141
Amun (Egyptian-Nubian deity), 4, 9, 83, 131–32
animal parts, 44, 81n31, 134–36, *135*, 142
Apadana relief, Persepolis, *6*, 7
aquamarines, 74, *75*, 120, *120*, *121*
armlets
 ancient depictions of, 14
 on Buddhist sculpture, 47
 on Hindu sculpture, 50
 Koh-i-Noor diamond, *28*, 29, 37nn41–42
 revival jewelry, 94, 97, 102
Arobe, Francisco de, 23–24, *23*
art deco, 32, *109*, 112, 116, 152
Ashurbanipal (Assyria king), 11–12, *11*
Assyria, ancient, 11–12, *11*, 83, 95–97
Aton (Egyptian deity), 9
Aurangzib spinel, 26

BADGES, 1–2, *2*, *3*, 32, 34, *35*, 48, 69
Bahubali (Jain *siddha*), 53
Banana Republic, 144
Banton, Travis, 109, 111, *111*
Barna da Siena, *The Mystic Marriage of Saint Catherine*, *54*, 55
Baugrand, Gustave, 93
Beaton, Cecil, portrait of Wallis Simpson, *74*
Beauty of Palmyra, 12–14, *13*
Benin, Kingdom of
 bronze oba head, 17, *18*
 coral crown and fly whisk, 17, *19*
 leopards' significance in, 19, 36n19
 loss of cultural heritage, 19–20
Bennet, Joan, 117, 126n12
Berlioz, Hector, 77–79
betrothal rings. *See* wedding rings
Bhupinder Singh (maharaja of Patiala), 30–32
Biennais, Martin-Guillaume, regalia for Napoleon I, 84–85, *85*
Bloch-Bauer, Adele, 158–60, *159*
Blyth, Benjamin
 Abigail Adams, *66*
 John Adams, *66*
Bonaparte, Napoleon. *See* Napoleon I
Bora, Katharina von, 63–65, *64*
Borghese, Pauline (Bonaparte), 86–89, *88*
Boucheron, 81n35, 127n15
Boutet de Monvel, Bernard
 portrait of Maharaja Yashwant Rao Holkar II, *150*, 151–52
 portrait of Maharani Sanyogita Devi, 152, *153*
bracelets
 amulets, 44
 ancient depictions of, 6, 11, 12, 14
 Assyrian revival, *96*, 97
 on Buddhist sculpture, 48
 Byzantine, 102, *102*
 charm bracelets, 71–76, *71*–*73*, *75*, 81n34
 diamond, art deco, *109*
 diamond and ruby, *122*
 Egyptian revival, 94
 emerald, 112–13, *114*
 gold, aquamarine, and diamond, 120, *121*, 127n15
 gold and citrine, 118, *119*
 on Hindu sculpture, 50
 jarretière, 81n35, 112, *113*
 Nubian, 89, *90*
 stacked, 118, *119*
 See also armlets
Brady Studio, Mathew, *Mary Todd Lincoln*, *70*
British crown jewels, 20, 28–30, 37nn41–42
bronzes, Benin, 17–19, *18*
bronzes, Hindu, 50–52, *51*
brooches
 American Requiem series, by Jocz, 76–79, *77*–*79*
 ancient depictions of, 14
 detachable, from necklaces, 112, 118, 122–23, *123*
 dove mosaic, 91–93, *92*
 doves on olive branches, by Lalique, 129, *130*, 146n2
 emerald, of Marlene Dietrich, 112–13, *114*
 gold, aquamarine, and diamond, 120, *121*
 with hair encased, 67–68, *67*
 Koh-i-Noor diamond, 29–30
 Star of Burma ruby, *117*
 starfish, 160, *161*
 of suffragists, 136–39, *137*, *138*, 147n17, 147n21, 162
Browning, Elizabeth Barrett, 91–93, *92*, 94
Browning, Robert, 91–93, 94
Buddhism, 47–49, *47*–*49*, 50, 59n19
Burton, Harry, *82*
Byzantine jewelry, 16, 102, *102*

CABOCHON GEMSTONES, 16, 67–68, 113
calibré-cut gemstones, 74, *75*, 81n34
Cambodia, 50, *50*, 59n26
cameos
 on crown for Napoleon I, 85, *85*
 of Elizabeth I, 22
 on *fede* ring, 62, *62*
 French revival of, 86–89, *88*
 of Tiberius (Great Cameo of France), 87, *87*
Cameré, Henri, Nubian revival bracelet, 89, *90*
Camilla, Queen (consort of Charles III), 30
Canova, Antonio, 86
Capra, Frank, 122
carnelian, 9, 44
Carson, Johnny, 129
Carter, Howard, *82*
Cartier
 charm bracelets, 72, 74, 75
 as Duke of Windsor's jeweler, 81n35
 and Hollywood trends, 109
 Patiala necklace, 30–32, *31*
 tutti-frutti designs, 152
Carucci, Elinor, *143*
Castellani family (Italian jewelers), 89–91, *91*
Catherine of Alexandria, Saint, *54*, 55
Catlin, George
 Fisk's portrait of, *135*
 Joc-O-Sot (Walking Bear), 134–36, *135*
champlevé enamel, 16
Charlemagne (Holy Roman emperor), *15*, 16, 36n14, 84–86
Charles III (British king), 20, 30
Charles V (French king), 84
charm bracelets, 71–76
 diamond (Oscar Heyman & Brothers), 72, *72*
 of Duchess of Windsor (Cartier), 73–76, *75*, 81n34
 of Mamie Eisenhower, 72–73, *73*
 popularization of, 71–72
 of Queen Victoria, 71, *71*
Chassériau, Théodore, *The Toilette of Esther*, 100–102, *101*
Chaumet, 152
China, 17, 24, 32–34, *34*, *35*, 37n45, 48
Christ
 adornments worn by, 39, 45–47
 as child, 27, 45–47, *46*, 55
 crown with images of, 16
 and Lincoln, 69
 and Saint Catherine, *54*, 55
 and Saint Peter, 56
Christianity
 Catholic symbols on necklaces, 158, 164n14
 crosses, 39, 44, 57, 74, *75*, 79
 crowns, 16, 39, 57
 and Kahlo's imagery, 139
 marriage traditions, *54*, 55, 63–65
 papal insignia, 55–57, *56*
 in pop culture or fashion, 39–40, *40*
 requiems, 76–78
 See also Christ; Virgin Mary
Cima da Conegliano, Giovanni Battista, *St. Peter Enthroned with St. John the Baptist and St. Paul*, 56–57, *56*
Cincinnatus, Lucius Quinctius, 2
citrine, 118, *119*, 127n14
claws, 44, 81n31, 134–36, *135*
Cleopatra (Egyptian queen), 93–94, *94*
Colbert, Claudette, 120, 160, *161*

167

collars
 of Benin oba, 17
 of Justice Ginsburg, 142–46, *143*, *145*
 of Order of the Garter, 5n4
 of Order of the Legion of Honor, 84–85
 ruffs, 21, 24
 torque, 47
colonialism
 British intervention in Africa, 19
 British intervention or rule in India, 28, 30, 132–33, *133*
 French rule in Cambodia, 50
 and jewels as symbols of power, 2, 7, 21–22
 and Orientalist paintings, 105
 Spanish rule in Americas, 23–24
 and Suez Canal, 93
Cooper, Astley David Middleton, portrait of Stanford jewels, 154–55, *155*
Copley, John Singleton, *Mrs. James Warren (Mercy Otis)*, 67
coral, 17–20, *19*, 45–47, 49, 91
Cortelazzo, Antonio, 95
Cranach, Lucas, the Elder
 gimmel ring designed by, 63
 Portrait of Katharina von Bora, *64*, 65
 Portrait of Martin Luther, *64*, 65
Crawford, Joan, 116–20, *118–21*, 127n14, 160
crosses, Christian, 39, 44, 57, 74, 75, 79
crown jewels
 British, 20, 28–30, 37nn41–42
 French, 84–86
 Persian, 26
 Russian, 7, *7*, 36n2
crowns and royal headgear
 of Assyrian rulers, 12
 of Benin obas, 17, *19*
 of British rulers, 26–27, 30, 37n37
 in Buddhism, 48–49
 of Cambodian rulers, 50, *50*, 59n26
 of Charlemagne and his successors, *15*, 16, 85–86
 in Christianity, 16, 39, 57
 diadem from Gold of Priam, 99, *99*
 of Egyptian rulers, 9–12, *41*, 42, 93, *128*, 129
 golden laurel wreaths, 84, 86, *87*, 134
 of Napoleon I, 84–86, *85*

of Nubian (Kushite) rulers, 83
of Persian shahs, 26
crystal, rock, 37n41, 39, 67–68
Cupid, *60*, 61
cylinder seals, Assyrian, *96*, 97

DE BEERS DIAMOND, 32
democracy, 1, 2, 32, 139
Desire (1936 film), 115–16, *115*
diadems, 10, 12, 26, 27, 99, *99*
Diallo, Ayuba Suleiman, 57–58, *57*, 59n36
diamonds
 bracelets, 81n35, *109*, 112–13, *114*
 brooch with ruby, *117*
 in Buddhist mosaic, 49
 on cameo parure, *88*, 89
 on charm bracelets, *72*, 72, 74, 75
 cutting of, 29–30, 74, 132
 eagle badge for Society of the Cincinnati, 1–2, *2*
 on Fath Ali Shah's finery, 24–26
 gardenia necklace, 122–23, *123*, *124*
 on Heneage Jewel, 22
 Hollywood stars pictured with, *108*, *115*, *117*, *120*, *123*, *124*
 Indore Pears, 152
 international diamond trade, 132–34, 146n9
 Koh-i-Noor, 28–30, *28*, 37nn41–42
 on mourning ring, 69
 Patiala necklace, 30–32, *31*, 37n42
 of Queen Victoria, 26–27, 37n42
 Tiffany necklace and earrings, 154
 value of, across cultures, 17
 on wedding rings, 63–65, *125*
Dietrich, Marlene, 110–16, *111*, *113–15*, 126n3, 160
diplomacy, 6, 7, 24, 162
Duleep Singh (maharaja of Punjab), 28, 30
Dumuzi (Sumerian deity), 61, 80n7
Dürer, Albrecht, *Emperor Charlemagne*, *15*, 16, 36n14
Duval, Claude Jean Autran, 2

EARRINGS
 ancient depictions of, 11, 12
 Assyrian revival, *96*, 97
 on Buddhist sculptures, 47, 48–49
 diamond, 26, 37n42, *124*, *125*, 154

gold, on Ecuadorians, 24
gold, on wooden sculpture, 42
gold and citrine, 118
from Gold of Priam, 99–100, *99*
on Hindu sculpture, 50
in Orientalist painting, 102
earspool, Moche, 43, *43*
East India Company, 22, 28, 132
Eckert, Charles, 126
Ecuador, 23–24, 144
Egypt, ancient
 Akhenaten statue, *128*, 129
 amulets, 44, *44*
 crowns and royal headgear, 9–12, *41*, 42, 93, *128*, 129
 Horus cult figure, *38*, 39
 love poetry, 61
 messaging of adornments, 1
 modern depictions of, 93–94, *94*, *104*, 105
 modern jewelry inspired by, 83, 93–94, 105, 107n41
 Nefertiti bust, 9–10, *10*
 Nubian rule of, 83, 131
 Tiye portrait head, 40–42, *41*
 Tutankhamun's tomb, 7–9, *8*, 44, *44*, 65, 80n19, *82*
Eisenhower, Dwight D., 72–73, 81n33
Eisenhower, Mamie, 72–73, *73*
Eisenstaedt, Alfred, *161*
Elizabeth I (British queen), 20–23, *21*, *22*
Elizabeth II (British queen), 20, 37n37
emeralds
 in Buddhist mosaic, 49
 on charm bracelets, *72*, 74, 75
 on crowns, 16, 26
 on diamond necklaces, 32, 126n9, 152
 Dietrich's emerald jewelry, 112–16, *114*, *115*, 126n9
 on wedding rings, 63
Empire style, 86
enameled works
 armlet with diamonds, 28, *29*
 brooches, 129, *130*, 137, *137*
 champlevé plaques on crown, 16
 charms on bracelets, *71*, 73
 Cupid pendant, *60*
 eagle badge for Society of the Cincinnati, 2, *3*
 gimmel ring, *63*
 Heneage Jewel, 22, *22*
 Lincoln memorabilia, *70*
 miniatures of Fath Ali Shah, 24
 Nubian bracelets, 89, *90*
 pocket watch, 154
 revival jewelry, *90*, 95, 105

Esarhaddon (Assyrian king), 97
Esther (biblical heroine), 100–102, *101*, 107n41
Etruscan jewelry, 89

FAIRBANKS, Avard Tennyson, *Bust of Alice Stokes Paul*, 136, *137*, 139
Fairbanks, Douglas, Jr., 118
Fales, Martha Gandy, 164n16
Fath Ali Shah (Persian shah), 24–26, *25*
fede rings (clasped hands), 62, *62*
Federalist style, 67
Ferlini, Giuseppe, 89
Fisk, William, *George Catlin*, 134, *135*
fly whisk, coral, 17, *19*
Francastel, Nicolas Jean, 2
Francis, Pope, 56
Franklin, Benjamin, 2
French crown jewels, 84–86
French Revolution, 66, 83, 86, 106n4

GAULTIER, Jean Paul, *Ex-Voto* evening ensemble, 39–40, *40*
Gemma Constantiniana, 87, 106n11
Gentile da Fabriano, *Coronation of the Virgin*, 39, *39*
George IV (British king), 26
George V (British king), 30
George VI (British king), 30
gimmel rings, 63–65, *63*, 80n11, 80n13
Ginsburg, Ruth Bader, 142–46, *143*, *145*, 147n24
Goffman, Erving, 151
gold
 aquamarine, diamond, and gold suite, 120, *120*, *121*
 Assyrian revival ensemble, *96*, 97
 bracelet, Byzantine, 102, *102*
 bracelets, Nubian, 89, *90*
 on brooches by Jocz, 77–79, *79*
 brooches with doves, 92, *92*, 129, *130*, 146n2
 in Buddhist traditions, 48–49
 charm bracelets, *71*, 71, 72–73, *73*
 citrine and gold suite, 118, *119*, 127n14
 coffin of Tutankhamun, *8*, 9
 earrings on wooden sculpture, 42
 earspool, Moche, 43, *43*

Ecuadorian facial ornaments, 23, *24*
Egyptian symbolism of, 44
Etruscan techniques, 89
hair encased in gold ornaments, 67–68, *67*
Hindu sculptures adorned with, 52
laurel wreaths, 84, 86, *87*, 134
moderne style, 116
Napoleon's coronation regalia, 83–86, *87*
paintings of gold jewelry, gilded, 39, *39*, *159*, 160
papal rings, 56, *56*
ram's head necklace, Nubian, 4, 83, 131–32, *131*, 146n4
treasure of Priam, 97–100, *98*, *99*
value of, across cultures, 17
wedding rings, 62–64, *62*, *63*
Gomateshwara statue, India, 53
Gordigiani, Michele, *Elizabeth Barrett Browning*, 91–92, *92*
Great Depression, 4, 109, 116, 122, 160
Great Exhibition (London, 1851), 27, 93
Greece, ancient
 Achilles and jewelry, 32, *33*
 coral's significance, 47
 Gold of Priam, 97–100, *98*, *99*
 golden laurel wreaths, 84, 86, 134
 love, deities relating to, 61
grizzly bear claws, 134–36, *135*

HAIR ENCASED IN ORNAMENTS, 65–68, *67*, 80nn19–20
hamsa (hand of Fatima), 44, *44*
Harris & Ewing Studio, *Alice Paul Raises a Glass in Front of the Ratification Banner*, 138–39, *138*, 147n21
Head, Edith, 109, 124–25
Helen of Troy, 102, *103*
Heneage Jewel, 22–23, *22*
Hilliard, Nicholas, Armada Jewel (Heneage Jewel), 22–23, *22*
Hinduism
 adornment of temple sculptures, 48, 50–52, *52*
 amulets, 44
 King Sisowath as Vishnu, 50, *50*
 Nandi (sacred bull), 14
 Vishnu, bronze, 50, *51*
historical revival jewelry. *See* revival jewelry

Hitchcock, Alfred, 112, 113
Hoare, William, *Portrait of Diallo*, 57–58, *57*
Hoeffer, William Howard, 109, 112
Holkar, Sanyogita Devi (maharani of Indore), 152, *153*, 164n5
Holkar, Yashwant Rao II (maharaja of Indore), *150*, 151–52, 164n5
Hollywood glamour, 108–27
 about the topic, 4, 109–10
 Colbert's starfish brooch, 160, *161*
 Dietrich's image and jewelry, 110–16, *111*, *113–15*, 126n3
 jewelry in *The Women*, 116–20, *118–20*
 jewelry in *Vogues of 1938*, 116, *117*
 merchandising of film fashions, 125–26
 Stanwyck's image and jewelry, 110, 120–25, *122–24*
Holy Roman Empire, 16
Homer, 98, 100
Horus (Egyptian deity), 7, *38*, 39
Hudson, Julien, *Portrait of a Young Woman in White*, 157–58, *157*

IDENTITY, jewelry as an expression of, 128–47
 about the topic, 4, 129
 British trader's diamond ring, 132–34, *133*
 Catholic Creole woman's necklace, 157–58, *157*
 Justice Ginsburg's collars, 142–46, *143*, *145*
 Kahlo's thorn necklace, 139–42, *140*
 Nubian king's ram's head necklace, 131–32, *131*
 self-fashioning, 148–51
 suffragist's "Jailed for Freedom" brooch, 136–39, *138*, 147n21, 162
 Walking Bear's claw necklace, 134–36, *135*
Illescas, Alonso de, 23
Inanna (Sumerian deity), 61, 80n7
India
 amulets, 44, 47
 British intervention or rule in, 28, 30, 132–33, *133*
 diamonds, 17, 28–32, *31*, 132, 146n9, 152, 154
 Holkar II and wife as paragons of style, *150*, 151–52, *153*
 Jainism, 53, *53*
 and revival jewelry, 102, 105
 See also Hinduism

Indigenous peoples of the Americas, 23, 134–36, *135*, 141–42, 147n22
Indore Pears (diamonds), 152
Ingres, Jean-Auguste-Dominique
 Chassériau as student of, 100
 Napoleon I on His Imperial Throne, 83–85, *84*
 portrait of Madame Moitessier, 156–57, *156*
inscriptions on jewelry, 34, 56, 62–65, *62*, *63*, 69, 74
Isabey, Jean-Baptiste, 86, *87*
Islam
 kitab (amulets), 44–45, *45*, 58
 portrait of Islamic scholar, 57–58, *57*
Isma'il Pasha (khedive of Egypt), 93

JABOTS (neckwear), *143*, 144, 147n28
jade, 17, 141, *141*, 142
Jainism, 48, 50, 53, *53*
jarretière bracelets, 81n35, 112, *113*
Jean-Louis, Fabiola
 Madame Leroy, 162, *163*
 Rewriting History series, 161–62
Jefferson, Thomas, 2
jewelry boxes, 27, 47, 89, 102
jewelry theory, 148–49
Joc-O-Sot, or Walking Bear (Meskwaki chief), 134–36, *135*
Jocz, Daniel
 American Requiem: 3047.9.11.2001 series, 76–79, *77–79*
 career, 81n39
John the Baptist, Saint, 56, *56*
Jones, Owen, 93
Josephine, Empress (consort of Napoleon), 86
Jowo Shakyamuni statue, Tibet, 48–49, *48*

KAHLO, Frida
 and Oaxacan dress, 147n22
 Self-Portrait (Time Flies), 141, *141*, 142
 Self-Portrait with Thorn Necklace and Hummingbird, 139–42, *140*
Kiam, Alexander "Omar," 116, 126n12
Klimt, Gustav, *Portrait of Adele Bloch-Bauer I*, 158–60, *159*
Koh-i-Noor diamond, 28–30, *28*, 37nn41–42
Kunz, George F., 64–65

LACE, 91–92, *124*, 125, *143*, 144, 146, 147n28
Lalique, René, *Doves on Olive Branches* brooch, 129, *130*, 146n2
lapis lazuli, 9, 39, 42, 44, 49, 61
laurel wreaths, 84, 86, *87*, 134
Layard, Enid (Guest), Lady, 95–97, *95*, *96*
Layard, Sir Austen Henry, 83, 95–97
Lefèvre, Robert, *Portrait of Pauline Bonaparte in Her Cameo Parure*, *88*, 89
L'Enfant, Pierre Charles, Diamond Eagle of the Society of the Cincinnati, 1–2, *2*
Lewis and Clark (explorers), *135*, 136
Libbali-Sharrat (Assyrian queen), 11–12, *11*
Lincoln, Abraham, 69–70, *69–70*, 80n29, 136
Lincoln, Mary, 69–70, *70*
Liu Chunhua, *Chairman Mao Goes to Anyuan*, 32–34, *34*
locket, enameled gold, 22, *22*
Long, Edwin Longsden
 Love's Labour Lost, 104, 105
 Queen Esther, 107n41
looting, 7, 19–20, 43, 100, 105
lost-wax casting, 19, 50
love and friendship, jewelry as an expression of
 about the topic, 3–4, 61
 charm bracelets, 71–76, *71–73*, *75*, 81n34
 classical symbols of love, 60, 61, 80n3
 hair encased in ornaments, 65–68, *67*, 80nn19–20
 See also mourning or memorial jewelry; wedding rings
Luther, Martin, 63–65, *64*

MACY'S DEPARTMENT STORE, *125*, 126
magic, 1, 17, 44–47, 48
Maitreya (Bodhisattva), 47, *47*, 59n19
Mao Zedong, 32–34, *34*, 35
Marcel Jewelers, 73
Marie Antoinette (French queen), 86, 162
marriage traditions, 4, 48, *54*, 55, 61–65, 132
material culture, 4, 65, 148–49
Mauboussin, 109, 126n10, 152.
 See also Trabert & Hoeffer-Mauboussin

169

INDEX

INDEX

Maximinus (Roman emperor), 55
Mayan pendant, jade, *141*
medals and medallions, 62, 69, 70, 80n29
Mérimée, Jean-François Léonor, 85
Meru, Mount (India), 50
Mexico, 139–42, 147n22
MGM (Metro-Goldwyn-Mayer) Studios, 109, *118–20*, 127n13, 160
Mihr ʿAli, *Portrait of Fath Ali Shah*, 24–26, *25*
Moche culture (Peru), 43, *43*
moderne style, 116
Moitessier, Marie-Clotilde-Inès, 156–57, *156*
mosaics, 26, 49, *49*, 91, 92, *92*, 160
mourning or memorial jewelry
 about the topic, 3–4, 61
 hair encased in ornaments, 65
 for Lincoln, 69–70, *69–70*, 80n29
 rings, 69, 80n4
 for September 11 victims, 76–79, *77–79*
 for Washington, 80n5
Moutard, Juliette, starfish brooch, 160, *161*
Mozart, Wolfgang Amadeus, 78
Mughal Empire, 26, 28–29, 30
mural crowns, 12
Muthesius, Eckart, 152

NAPOLEON I (French emperor, formerly Napoleon Bonaparte)
 coronation regalia of, 83–86, *84*, *85*, *87*
 Legion of Honor established by, 106n4
 and Persian royal portraits, 24, 37n32
 sister Pauline as trendsetter, 86–89
necklaces
 with amulet cases, 44–46, *45*
 ancient depictions of, 11, 12, 14
 Assyrian revival, *96*, 97
 on Buddhist sculpture, 48
 Catholic symbols on, 158, 164n14
 diamond, gardenia, 122–23, *123*, *124*
 diamond, Indore Pears, 152
 diamond, Patiala, 30–32, *31*
 diamond, Tiffany, 154
 Egyptian revival, 94, 105
 emerald, of Marlene Dietrich, 126n9
 gold, aquamarine, and diamond, 120, *121*
 gold and citrine, 118, *119*
 from Gold of Priam, 99, *99*
 grizzly bear claw, 134–36, *135*
 on Hindu sculpture, 50
 jade beads, pre-Columbian, 141, *141*, *142*
 Kahlo's thorn necklace, 139–42, *140*
 multipurpose, with detachable parts, 112, *117*, 118, 122–23, *123*
 in Orientalist paintings, 102, 105
 pearl, 21, 24, 115, 152, 157
 Timur Ruby, 37n42
 See also pendants
Nefertiti (Egyptian queen), 9–10, *10*
New Orleans, 158, 164n14, 164n16
Nimrud (ancient Assyria), 12, 97
Nineveh (ancient Assyria), 11, 97
Nitot, Marie-Étienne, 86
Norodom Prohmbarirak (Cambodian king), 50
Nubia, ancient
 bracelet of Queen Amanishakheto, 89, *90*
 Kushite rule of Egypt, 83, 131
 ram's head necklace, 4, 83, 131–32, *131*, 146n4
 Tanwetamani statue, *131*

OBAS (Benin rulers), 17–20, *18*, 36n19
O'Connor, Sandra Day, 142–43, 144
Order of the Garter (British), 5n4
Order of the Legion of Honor (French), 84–85, 106n4
Orientalist paintings, 100–105, *101*, *103*, *104*, 107n41
Oscar Heyman & Brothers, charm bracelet, 72, *72*
Osiris (Egyptian deity), 7
Otto I (Holy Roman emperor), 16
Ovonramwen (oba of Benin), 17

PALMAROLI Y GONZÁLEZ, Vicente, *Portrait of Lady Layard*, 95–97, *95*
Palmyra (ancient city), 12–14, *13*, 36n10
Pankhurst, Emmeline, 136–37, 146n15
Pankhurst, Estelle Sylvia, Holloway Prison Brooch, 137, *137*
Paolini, Pietro, *Achilles among the Daughters of Lycomedes*, 32, *33*

papal insignia, 55–57, *56*
Paquet, Anthony C., Abraham Lincoln commemorative medalet, 69, *70*, 80n29
Paramount Pictures, 109, 110, 115, *124*
Patek Philippe, 154
Paul, Alice
 Fairbanks's sculpture of, 136, *137*, 139
 Jailed for Freedom brooch, 136–39, *138*, 147n21, 162
Paul the Apostle, Saint, 56, *56*
pearls
 on brooches, 67–68, *67*
 in Buddhist mosaic, 49
 on Byzantine bracelet, *102*
 on crowns, 16, 26
 cultural value of, 17, 21–22
 on Cupid pendant, *60*
 necklaces, 21, 24, 115, 152, 157
 pectorals, 1, *44*, 57
pendants
 coral branch, 45
 Cupid and billing doves, *60*, 61
 Egyptian revival, 94
 fist, carved jade, 141, *141*
 hamsa (hand of Fatima), 44, *44*
 Heneage Jewel (locket), 22–23, *22*
 Holy Spirit as bird, 158, 164n14
 Indian, in Orientalist painting, 102, *105*
 lynching scene, 162, *163*
 Quran worn as, 57, *57*
 ram's head, gold, 4, 83, 131–32, *131*, 146n4
 watch, 69, *70*
 See also necklaces
Persia (Iran), 6, 24–26, *25*, 28
Peter, Saint, 56–57, *56*
Petteway, Steve, *Ruth Bader Ginsburg*, 144–45, *145*
Philip III (Spanish king), 23–24
Philippe, Émile-Désiré, 105, 107n41
Phillips Brothers, Lady Layard's necklace, 95–97, *96*, 106n31
Pickford, Mary, 118
pilgrim mementos and offerings, 48–49, 55
Pius IX, Pope, *56*
platinum
 charm bracelets, 72, *72*, 74, *75*
 diamond and emerald suite, *114*
 diamond and ruby brooch, *117*
 diamond art deco bracelet, *109*
 diamond gardenia necklace, 122–23, *123*
 diamond Indore Pears necklace, 152

diamond Patiala necklace, 31, *32*
jarretière bracelets, 81n35, 112, *113*
Pliny the Elder, 47
posey rings, 62, *62*
power, jewelry as an expression of, 6–37
 about the topic, 2, 7, 156
 in ancient Assyria, 11–12, *11*
 in ancient Egypt, 1, 7–10, *8*, *10*
 in ancient Nubia, 83, 131–32, *131*
 in ancient Palmyra, 12–14, *13*, 36n10
 in Benin kingdom, 17–20, *18*, *19*
 for Charlemagne and his successors, 15, *16*, 84–86
 in Communist China, 32–34, *35*, 37n45
 in Ecuador under Spanish rule, 23–24, *23*
 in Elizabethan England, 20–23, *21*, *22*
 for Indian maharajas, 30–32, *31*, 150, 151–52
 Koh-i-Noor diamond, 28–30, *28*, 37nn41–42
 for Napoleon, 83–86, *84*, *85*, *87*
 in Persia (Iran), 6, 24–26, *25*
 in Victorian Britain, 26–30, *27*–*29*
 See also crown jewels; crowns and royal headgear
Poynter, Sir Edward John, *Helen*, 102, *103*, 105
Priam, Gold of, 97–100, *98*, *99*
propaganda, 1, 2, 11, 22, 34, 83

QURAN, 44–45, 57–58, *57*

RAM'S HEAD NECKLACE, 4, 83, 131–32, *131*, 146n4
religious or spiritual adornments, 38–59
 about the topic, 3, 39–40
 amulets, 17, 44–47, *44*, *45*, 58
 in ancient Egypt, 38, 39, 40–42, *41*
 in Buddhism, 47–49, *47*–*49*
 in Christianity, 39–40, *39*, *40*, 45–47, *46*, 54, 55–57, *56*, 63–65
 in Hinduism, 50–52, *50*–*52*
 in Islam, 44–45, *45*, 57–58, *57*
 in Jainism, 53, *53*
 in Moche culture (Peru), 43, *43*
revival jewelry, 82–107
 about the topic, 4, 83

Assyrian revival ensemble,
 95–97, *96*
cameos in France, 86–89, *88*
Egyptian revival jewelry, 83,
 93–94, 105, 107n41
and Gold of Priam, 97–100, *99*
Italian archaeological-style
 jewelry, 89–93, *92*
and Luther marriage ring, 80n16
Napoleon's coronation regalia,
 83–86, *84*, *85*, *87*
Nubian revival bracelet, 89, *90*
in Orientalist paintings,
 100–105, *101*, *103*, *104*, 107n41
Revolutionary War, US, 1–2,
 65–68, *69*, 80n22
Reza Shah Pahlavi (Persian
 shah), 26
ribbons, mourning, 69, *69*
Richard I (English king), 62
Richee, Eugene Robert, *111*
rings
 diamond horseshoe, *122*
 in Dietrich's collection, 112
 with hair encased, 67–68, *67*
 mourning, 69, 80n4
 papal rings, 55–57, *56*
 See also wedding rings
Rivera, Diego, 139, 142
Rome, ancient
 Cameo of Tiberius, 87, *87*
 Christians, 55
 Cincinnatus, 2
 funerary traditions, 12–14
 marriage traditions, 55, 61–62,
 62
 mosaics, 92
 and Napoleon, 84, 86–87
rubies
 on bracelets, 74, *75*, 112, *113*,
 127n15
 in Buddhist mosaic, 49
 on crowns, 26
 on Cupid pendant, *60*
 on Heneage Jewel, *22*
 on Patiala necklace, *32*
 Star of Burma brooch, *117*
 starfish brooch, 160, *161*
 Timur Ruby Necklace, 37n42
 on wedding rings, 63–65, *63*,
 80n18
Ruser, William
 career, 127n19
 diamond gardenia necklace,
 122–23, *123*
 and Stanwyck film, 125
Russell, Rosalind, 116, *118*
Russia, 7, *7*, 36n2, 86, 100
Ryne, Jan van, *Fort William in the
 Kingdom of Bengal*, 132, *133*

SÁNCHEZ GALQUE, Andrés,
 *Portrait of Don Francisco
 de Arobe and Sons*, 23–24, *23*
sapphires, 16, 49, 74, *75*, 81n35,
 102, 112, 116
sautoir necklaces, 112
Savage, Edward, *George
 Washington*, 2, *3*
scarabs, 1, 44, *44*, 94, 105
Schiavone, Giorgio di Tomaso,
 *Madonna and Child with
 Angels*, 45–47, *46*
Schliemann, Heinrich, 97–100
Schliemann, Sophia, 98–100,
 99
self-fashioning, 148–51
September 11, 2001, terrorist
 attack, 76–79, *76*
Shah Jahan (Mughal emperor),
 29
Shearer, Norma, 116–18, *118*, *119*
shells, 17, 24, 44, 50, 80n3
Siddhapratima Yantra (Jain
 shrine), 53, *53*
silver
 amulets, 44, *44*
 brooches by Jocz, 77–79, *79*
 brooches of suffragists, 136–39,
 137, *138*, 147n17, 147n21
 gilded crown, 85, *85*
 gilded revival jewelry, 102, 105
 headdress on wooden sculpture,
 42
 Horus cult figure, *38*, 39
 in Treasure of Priam, *98*, *99*
Sipán (Moche site), 43
Sisowath (Cambodian king),
 50, *50*
slavery, 23, 58, 132–34, 162
Society of the Cincinnati, 1–2, *2*,
 3, 129
Sorry, Wrong Number (1948 film),
 110, 123–25, *124*
Stanford, Jane Lathrop, 154–55,
 155
Stanford, Leland, 154–55, 164n7
Stanwyck, Barbara, 110, 120–25,
 122–24
starfish brooch, 160, *161*
Sternberg, Josef von, 110–11, 112
Stone, Seymour M., *Mrs. Woodrow
 Wilson*, 129, *130*
Story, William Wetmore
 and Brownings, 92, 94
 Cleopatra, 93–94, *94*
strap bracelets, 81n35, 112, *113*
suffrage movement, 136–39, *138*,
 146n15, 162
Sully, Thomas, 26
Supreme Court, US, 142–46

TANWETAMANI (Kushite king),
 131
Taylor, Robert, 122–23, *122*
Theodora (Byzantine empress),
 160
Thutmose, bust of Nefertiti, 10, *10*
Tibetan Buddhism, 48–49, *48*
Tiffany & Co., 154
Tiye (Egyptian queen), 40–42, *41*,
 65, 80n19
Tompkins, E. M., 120
Trabert & Hoeffer (later Trabert &
 Hoeffer-Mauboussin)
 emerald jewelry for Marlene
 Dietrich, 112–13, *114*, *115*
 engagement jewelry for Barbara
 Stanwyck, 122, *122*
 and Hollywood trends, 109, 112
 as jewelry supplier for *Vogues
 of 1938* film, 116, *117*
 Ruser as salesperson for, 122,
 127n19
 shop locations, 112, 126n10
 Star of Burma brooch, *117*
Troy (ancient city), 97–100, 105
turquoise, 9, 43, *43*, 44, 49, *90*
Tutankhamun (Egyptian king)
 amulet from tomb of, 44, *44*
 biographical summary, 7–9
 coffin of, 8, *9*, *82*
 lock of hair from tomb of, 65,
 80n19

UNGER, Marjan, 149

VAN CLEEF & ARPELS
 and Hollywood trends, 109
 jarretière bracelets, 81n35, 112,
 113
Verdi, Giuseppe, 77–78, 93
Verelst, John, *Portrait of Elihu
 Yale with Members of His
 Family and an Enslaved Child*,
 132–34, *133*
Verger Frères
 jewelry suite for Joan Crawford,
 120, *120*, *121*
 ruby bracelet, 127n15
Victoria (British queen)
 1838 coronation portrait of, 26
 1851 family portrait of, 26–27,
 27
 1856 portrait of, with Koh-i-Noor
 diamond, 29–30, *29*
 charm bracelets of, 71, *71*
 and exotic materials, 81n31
 and Lady Layard's jewelry, 97
 and Walking Bear, 134

Virgin Mary, 27, 39, *39*, 45, *46*
Vishnu (Hindu deity), 50, *50*, *51*
Vogues of 1938 (1937 film), 116,
 117, 126n12

WALDMAN, Bernard, 126
Warren, James, 66–67,
 80nn22–23
Warren, Mercy Otis, 66–68, *67*,
 80n23
Washington, George, 1–2, *2*, *3*,
 80n5, 129
watches, 69, *70*, 154, *155*
wedding rings, 61–65
 and American female ideal, 110
 with clasped hands, 62, *62*
 and contractual nature of
 marriage, 4, 55, 61–62, 80n9
 diamond, rented for film, 125
 gimmel rings, 63–65, *63*, 80n11,
 80n13
 Luther marriage ring, 63–65,
 80n13, 80n16, 80n18
 posey rings, 62, *62*
 ruby engagement ring, 122
Wencheng, Princess (Chinese), 48
West, Mae, 108, *109*
Wilson, Edith Bolling Galt, 129, *130*
Wilson, Mark, *143*
Wilson, Woodrow, 129, 139
Windsor, Edward, Duke of, 73–76,
 81n35, 81n38
Windsor, Wallis Simpson, Duchess
 of, 73–76, *74*, *75*, 81n34,
 81n38
Winston, Harry, 152
Winterhalter, Franz Xaver
 The First of May 1851, 26–27, *27*
 Portrait of Queen Victoria,
 29–30, *29*
The Women (1939 film), 116–20,
 118–20, 127n13
World Trade Center, New York,
 76–79, *76*
World War I, 7, 30, 36n2, 129
World War II, 4, 100, 109, 116, 160

YADAVINDRA SINGH (maharaja
 of Patiala), 30, *31*
Yale, Elihu, 132–34, *133*, 146n6
Yard, Raymond C., gold and citrine
 jewelry suite, 118, *119*, 127n14

171

INDEX

© 2025 J. Paul Getty Trust

Published by the J. Paul Getty Museum, Los Angeles
1200 Getty Center Drive, Suite 500
Los Angeles, CA 90049-1682
getty.edu/publications

Ruth Evans Lane and Linda Lee, *Project Editors*
Lindsey Westbrook, *Manuscript Editor*
Jeffrey Cohen, *Designer*
Michelle Woo Deemer, *Production*
Danielle Brink, *Image and Rights Acquisition*
Kate Justement and Chloe Millhauser, *Editorial Assistants*

Distributed in the United States and Canada by the University of Chicago Press
Distributed outside the United States and Canada by Yale University Press, London

Printed in Singapore

Library of Congress Cataloging-in-Publication Data
Names: Markowitz, Yvonne J., author. | Gänsicke, Susanne, author. |
 J. Paul Getty Museum, issuing body.
Title: Beyond adornment : jewelry and identity in art / Yvonne J. Markowitz
 and Susanne Gänsicke.
Description: Los Angeles : J. Paul Getty Museum, [2025] | Includes
 bibliographical references and index. | Summary: "This illustrated book
 offers a framework for the history of jewelry and its representations in art,
 showing jewelry's role in constructing and signaling identity across
 centuries and cultures"— Provided by publisher.
Identifiers: LCCN 2024031116 (print) | LCCN 2024031117 (ebook) | ISBN
 9781606069622 (hardback) | ISBN 9781606069639 (adobe pdf) |
 ISBN 9781606069646 (epub)
Subjects: LCSH: Jewelry—Social aspects. | Jewelry in art. | Jewelry—History.
Classification: LCC GT2250 .M37 2025 (print) | LCC GT2250 (ebook) |
 DDC 701/.0457—dc23/eng/20240910
LC record available at https://lccn.loc.gov/2024031116
LC ebook record available at https://lccn.loc.gov/2024031117

Front cover: Bernard Boutet de Monvel, portrait of Maharani Sanyogita Devi
 of Indore, ca. 1931–38, © The Al Thani Collection 2019. All rights reserved.
 Photo: Prudence Cuming Associates Ltd / © 2024 Artists Rights Society (ARS),
 New York (detail, figure 135)
Back cover: Verger Frères, Joan Crawford's three-piece jewelry suite, ca. 1937
 (top, figure 105); Joan Crawford wearing her Verger Frères jewelry suite in
 a publicity still for *The Women*, 1939 (middle, figure 103); Jeweled bracelet
 (one of a pair), Byzantine, ca. 500–700 CE (bottom, figure 87)
Page i: Maker unknown, brooch, ca. 1850 (figure 80)
Page ii: Edwin Longsden Long, *Love's Labour Lost*, 1885 (detail, figure 89)
Page iv: Mae West wearing diamond jewels, 1930s (figure 90)
Page v: Théodore Chassériau, *The Toilette of Esther*, 1841 (detail, figure 86)
Page vi: Sir Yadavindra Singh wearing the impressive Patiala necklace (detail,
 figure 19)
Page vii: George Catlin, *Joc-O-Sot (Walking Bear), A Sauk Chief from the Upper
 Missouri, U.S.A.*, ca. 1844 (detail, figure 121)
Page viii: Robert Jacques François Faust Lefèvre, *Portrait of Pauline Bonaparte
 in Her Cameo Parure*, ca. 1803 (detail, figure 75)
Page x: Unknown English artist, *Armada Portrait*, 1588 (detail, figure 12)
Page xii: Vicente Palmaroli y Gonzélez, *Portrait of Lady Layard*, 1870 (detail,
 figure 82)

The complete manuscript of this work was peer reviewed through a single-masked process in which the reviewers remained anonymous.

Illustration Credits
Every effort has been made to contact the owners and photographers of illustrations reproduced here whose names do not appear in the captions or in the illustration credits listed on p. 166. Anyone having further information concerning copyright holders is asked to contact Getty Publications so this information can be included in future printings.